ACTIVE DESIGN

for Print Design Planning

3

Paisley

KYOTO SHOIN

ACTIVE DESIGN
for Print Design Planning

Produced and Compiled by Akira Nonomura
Edited by H. Tomita, NOVAK fashion
Published by Kyoto Shoin Co., Ltd.
Sanjyo-agaru, Horikawa, Nakagyo-ku, Kyoto 604 Japan
Tel. 075-841-9123 Fax. 075-841-9127

Color plates printed and bound by Daiyo Art Printing Co., Ltd.

Printed in Japan

ACTIVE DESIGN

Material civilization has provided people with affluence. Yet, within this realm, people are now seeking for more comfort and wealth, not materialistically, but spiritually. Today we find there are more than ever professionals engaged in creating designs for people and everyday living.

It must be remembered, however, that whatever the designs may be, they are constantly under close watch by consumers who keep a strict eye on the tangent relationship between man and things.

Without doubt, it is essential that a person must be trained to see things in the right perspective; otherwise it would be impossible for him to distinguish the best and find the beauty that lies in our everyday lives. It is quite natural for man to pursue beauty elsewhere, but far important is to realize that there is beauty all around us in our everyday living. This perception to reconsider our everyday living is required not only of designers but of each and every person.

When a person realizes this, he lays the foundation for the creation of a new idea which in turn helpes to better and enrich our lives.

To date, I have time and again expressed my opinion on designs from various angles. I feel that there are now a great mny ho appreciate and support our policies. Present day designs call for the incorporation of color, shape and function. It is alsso essential for the design to embody what people are looking for, and simultaneously, indicate its direction. Unless these conditions are met, designs cannot or will not be accepted in the market.

We can definitely feel a change has overcome consumers. "The aesthetic feeling" that they search for are becoming distinctively personal. Then again there is a fact that when using things, consumers have a desire to share the same interest with the creators. It is therefore necessary for designers to create designs that will align them with the emotions of the users. We can find many hints for creation of goods to cope with this type of people in our everyday life. Extraordinary ideas, excellent skill and marketing depend solely on the planning ability of the creator. By accurate analysis of information and data, designers will come to understand the latent desire of consumers which enable them to engender an idea. The significance of the whole thing is, the outcome, whether it be good or bad, is contingent on what conclusion the creator will arrive at.

The mental process of planning a project varies depending on a number of factors. The genre the designer is engaged in, his personality, and his way of thinking, his criterion and mlieu certainly bear a distinctive feature.

This book, which compiles five different themes, is a highly practical accumulation of printed designs. Theories and personal experiences indicate the original ideas which makes it well worth reading and an excellent book for the next generation.

Creating fashions is by no means an easy task in that it can be influenced by environment and social backgrounds. There are many types of planners, each with many different ideas.

Personally, I place emphasis on the following three methods. First, to determine from observation, secondly to establish an idea and finally, to wait for a revelation. On the other hand, there is another types, the so-called "left-brain thinkers". They are the logical kinds, calculative to the most minute detail. For them, what they create must "make sense". Their way of thinking is based strictly on accurate information and reeated confirmation. First, they find a reason. Next they build a framework in which they can work on using as much data and knowledge as is available, be it personal experiences, time spent on research or their own speciality. The result of their work stems from careful, theorized planning.

Times, however, are changing. Companies no longer find the conventional method to be advantageous. They find themselves struggling with barriers of overloaded information on what is termed "internationalization". They realize that what they need now is the mental faculty to cope with problems intelligently and that there is an urgent need to change their way of thinking.

Likewise, in the fashion business, too, thinking faculties is now an indispensable factor. If "thinking itself is designing an action", then the roles of planners and designers become highly important.

As I have mentioned before, and if I may quote again, designers must educate themselves to reconsider the fact that discovery of hints and ideas for designs and motifs are frequently obtained in our ordinary everyday living. No matter how excellent the idea may be, without the ability for keen observation and expressiveness, and even before that, a solid formation of the idea itself, success cannot be achieved. In order to develop fresh and new ideas, one must be able to observe and aborb various existing situations at home as well as overseas, have an open mind and an enriched sensivity and accordingly, plan and act.

Akira Nonomura

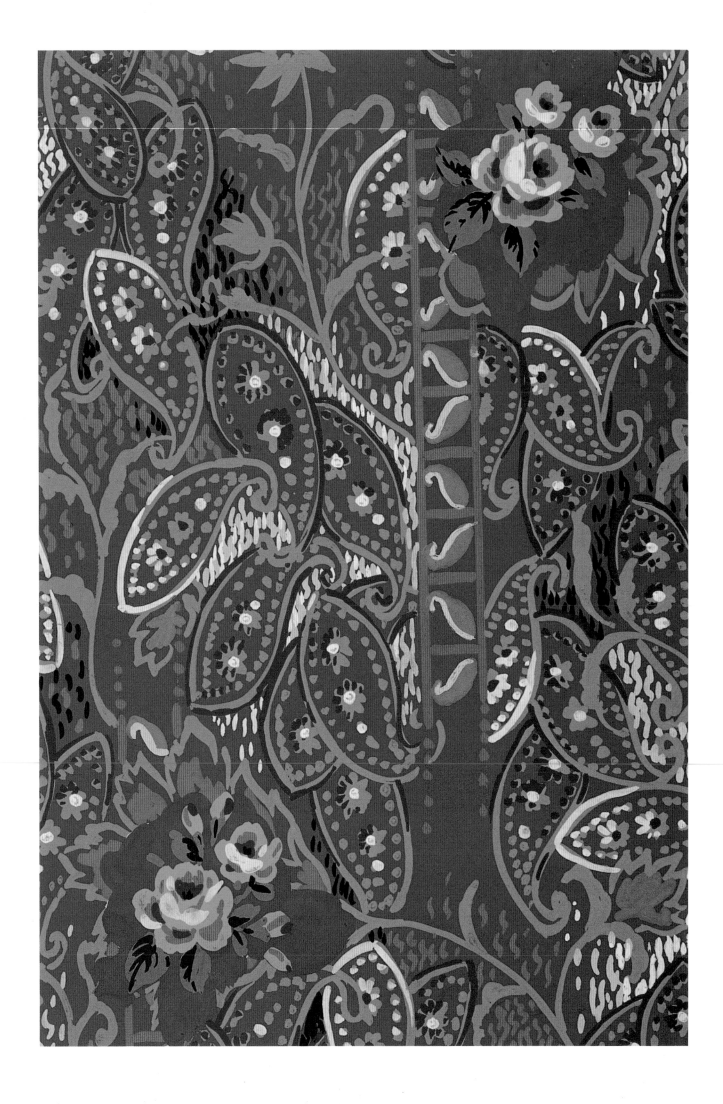

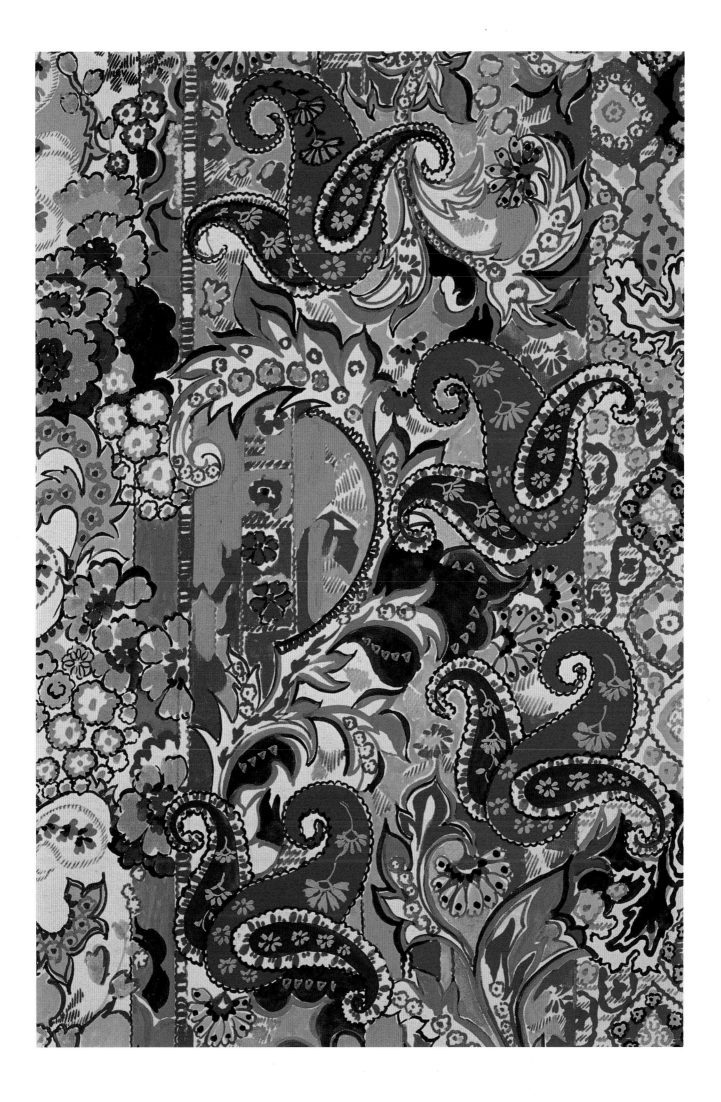

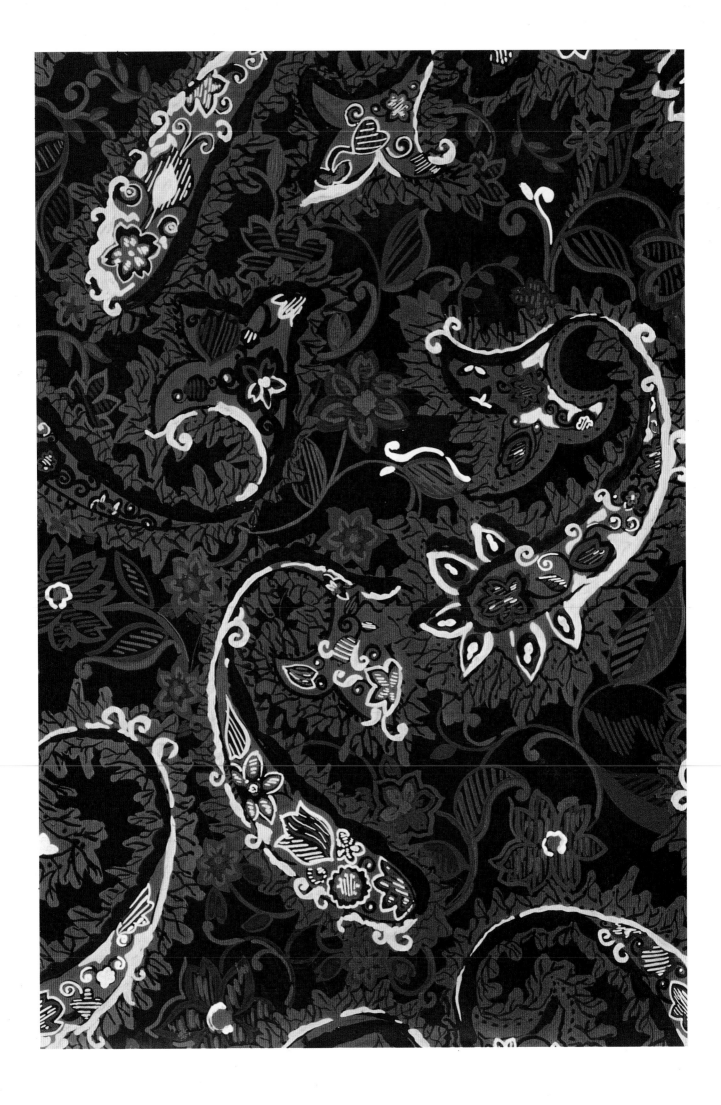

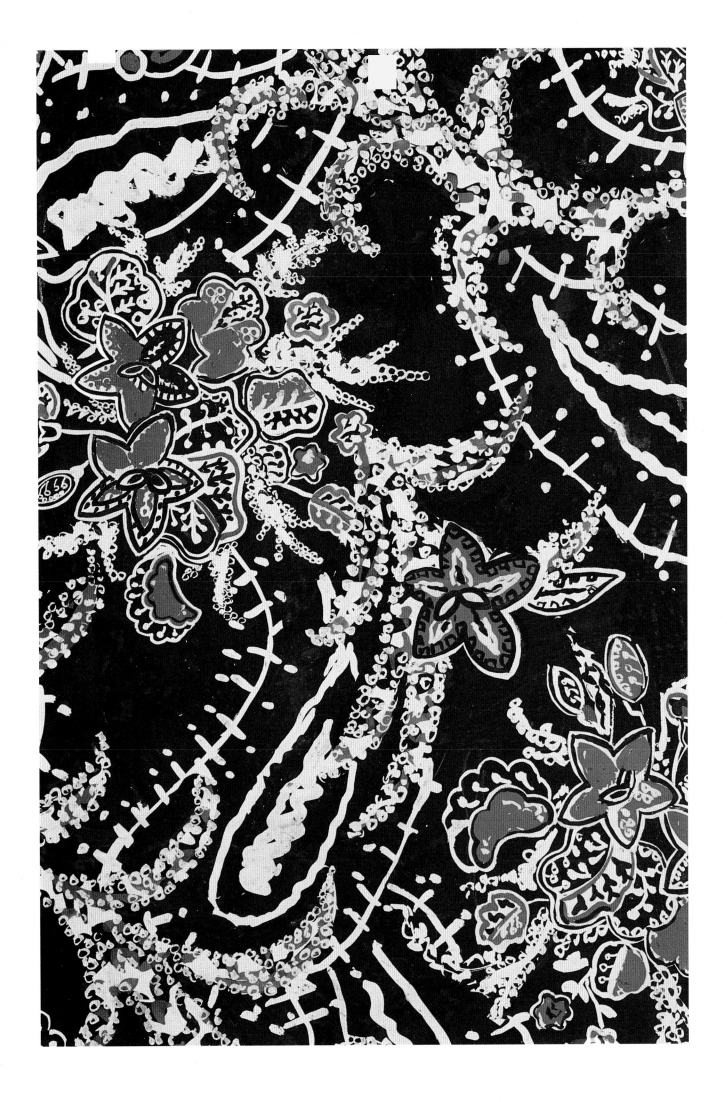

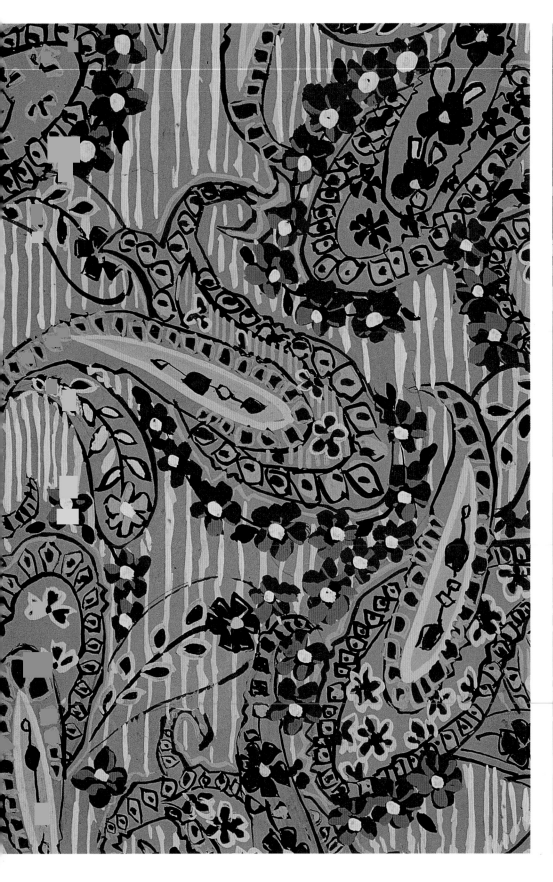
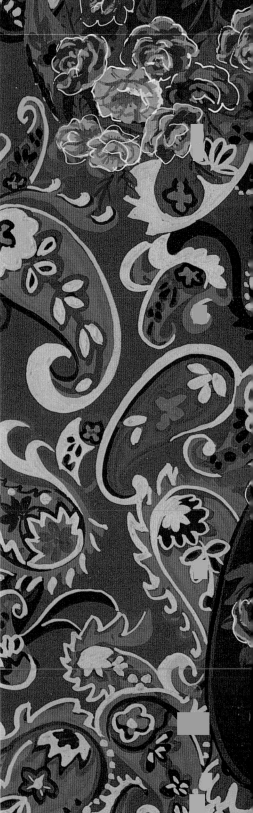

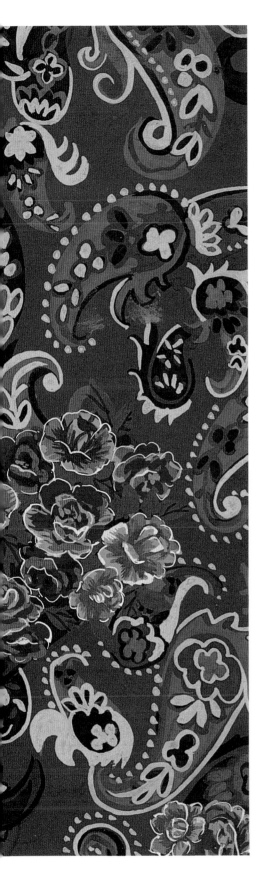
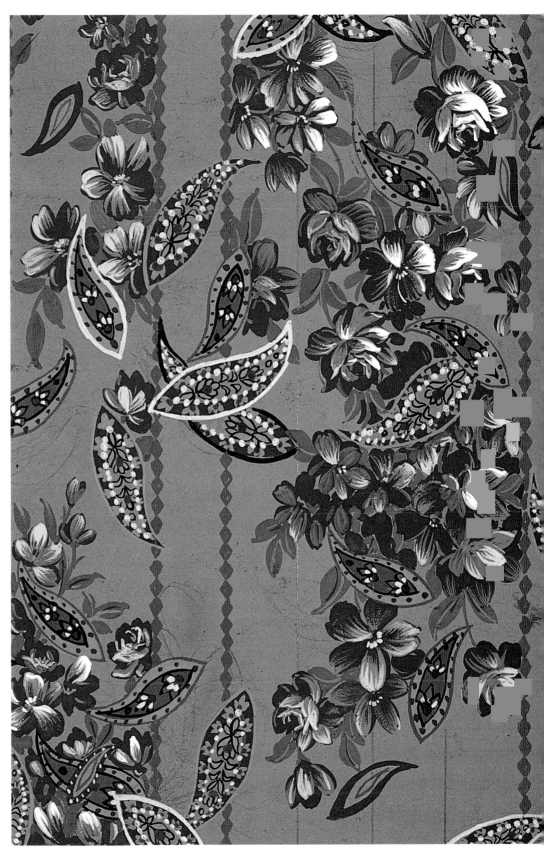

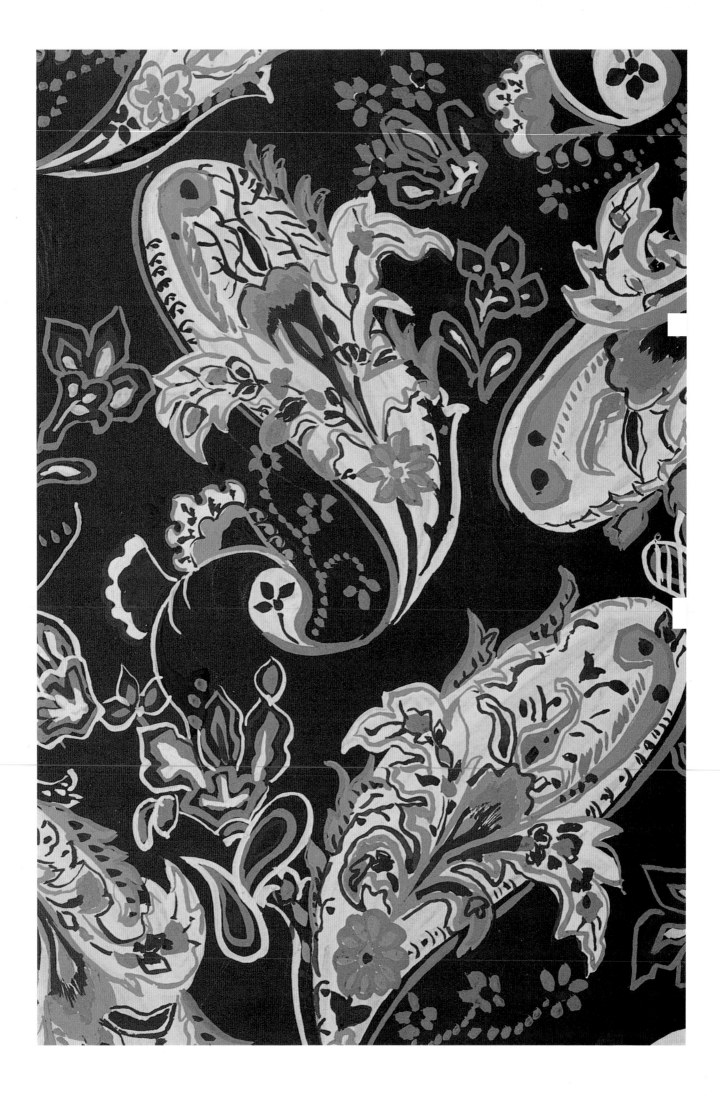

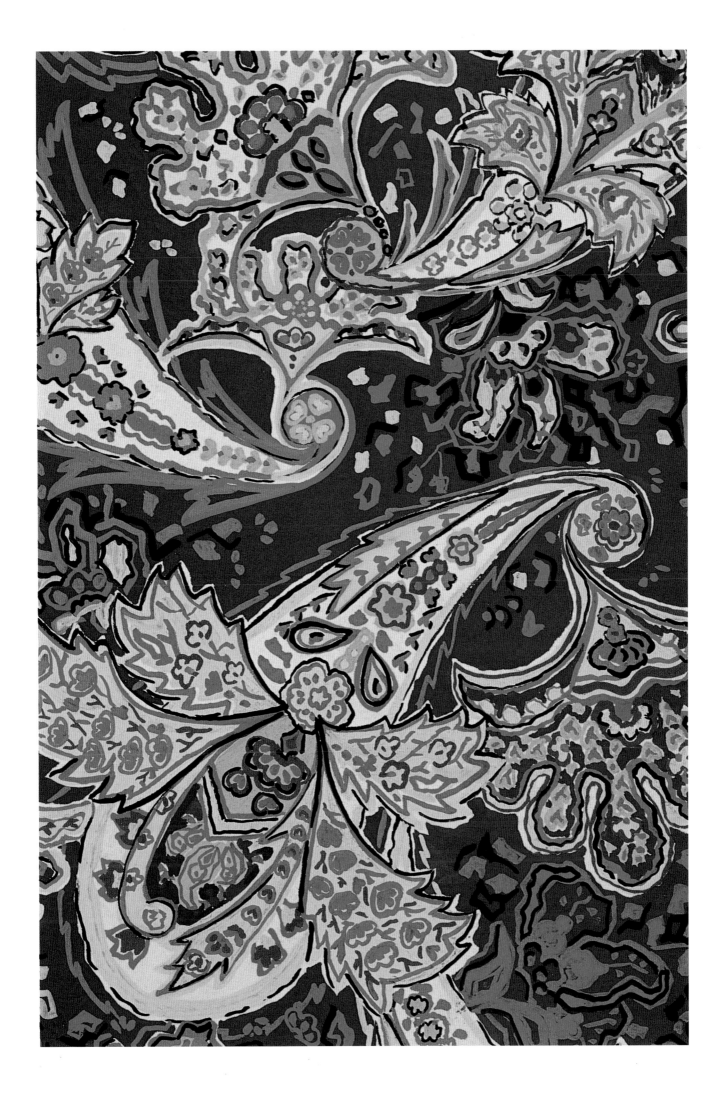

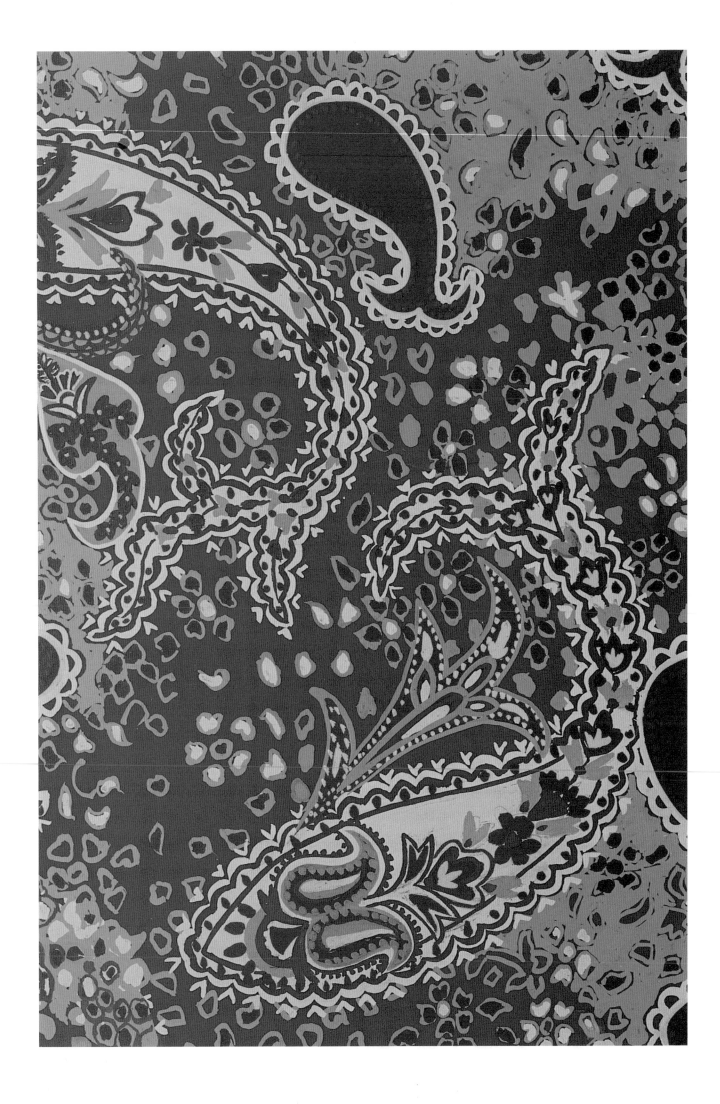

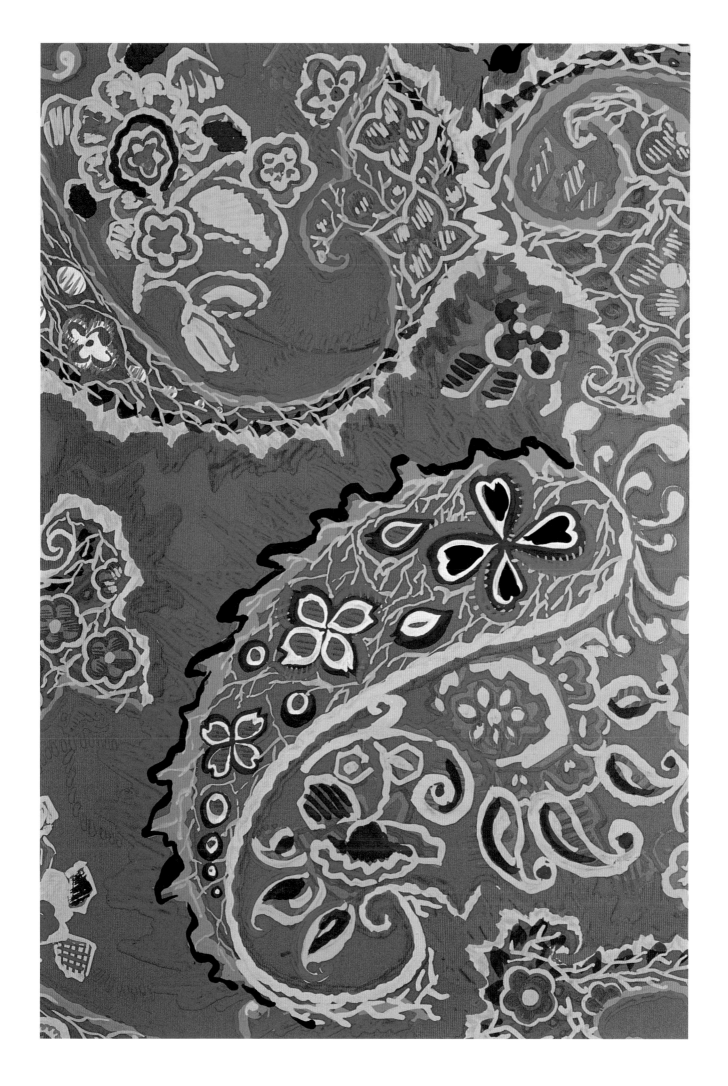

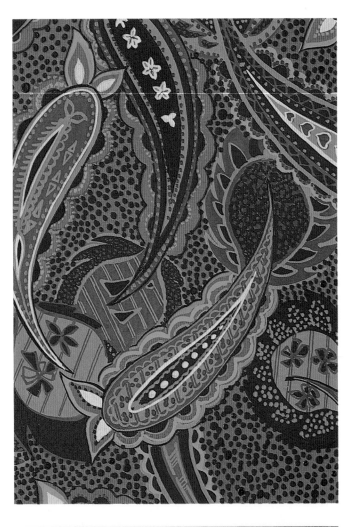
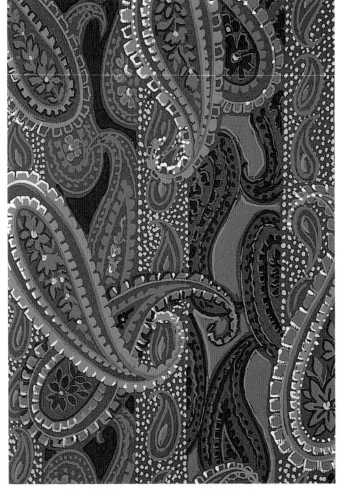
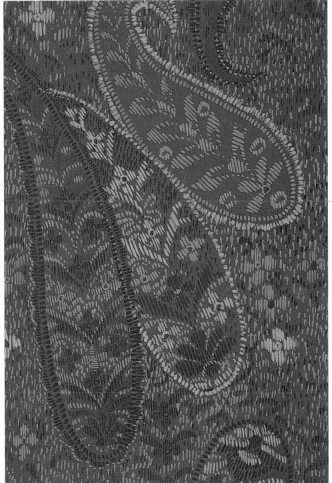
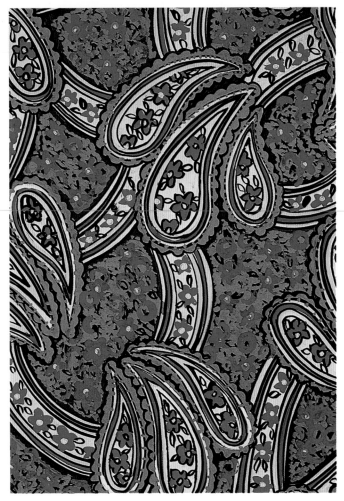

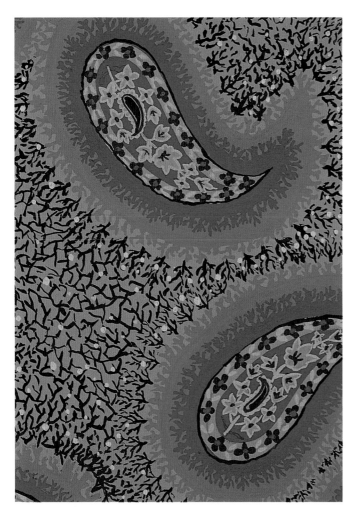
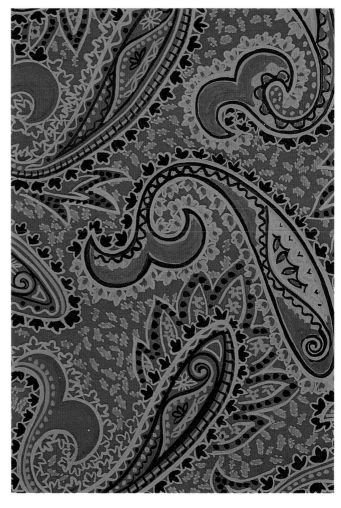
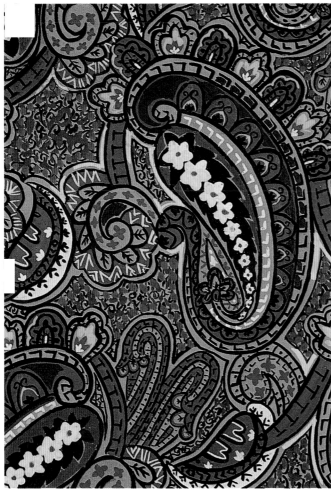
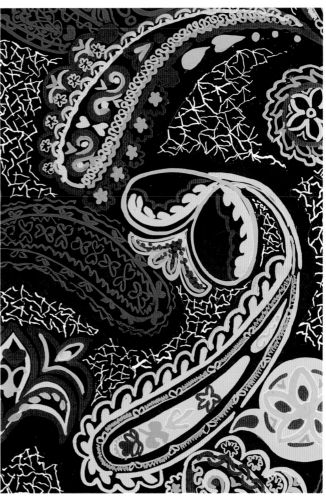

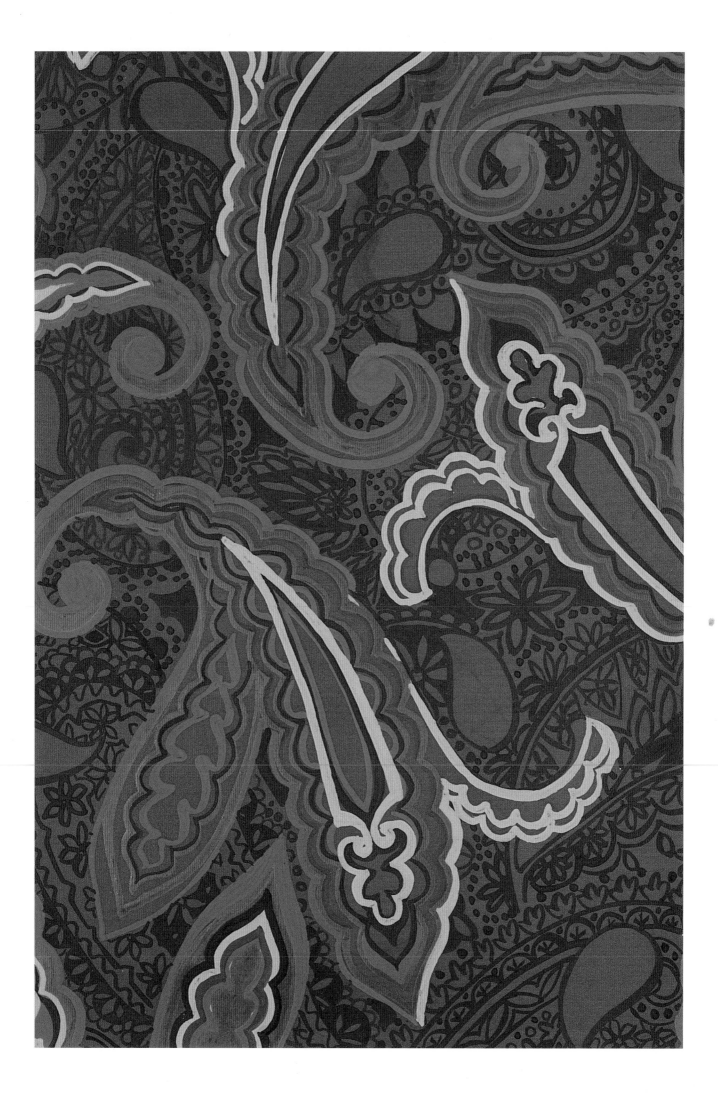

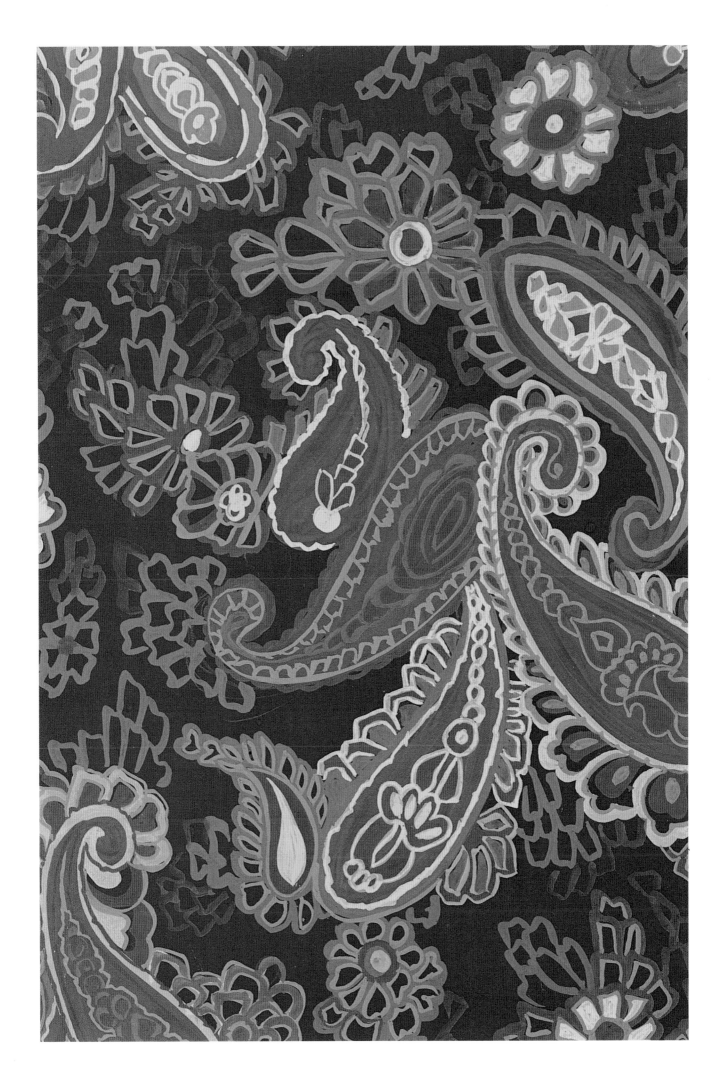

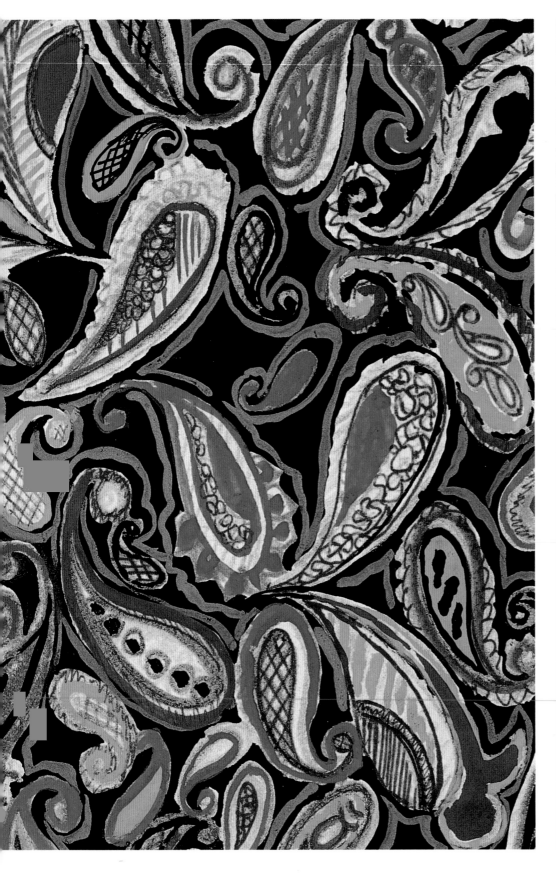
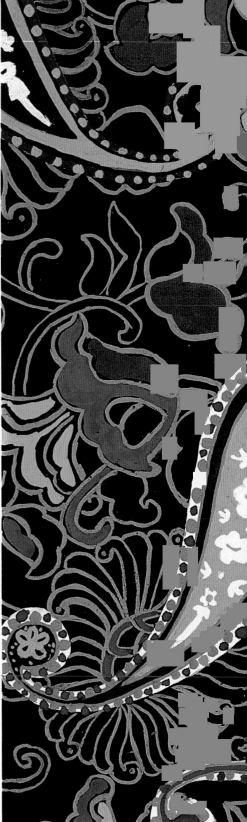

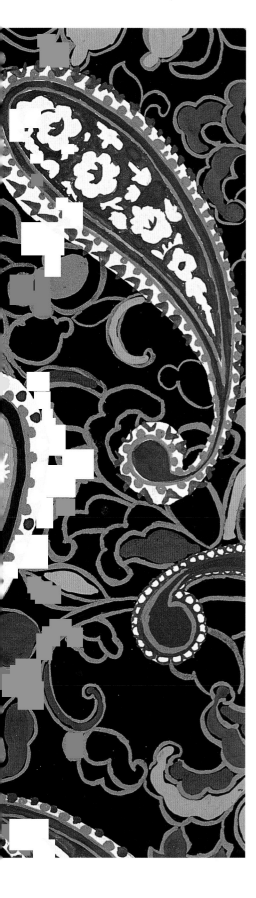

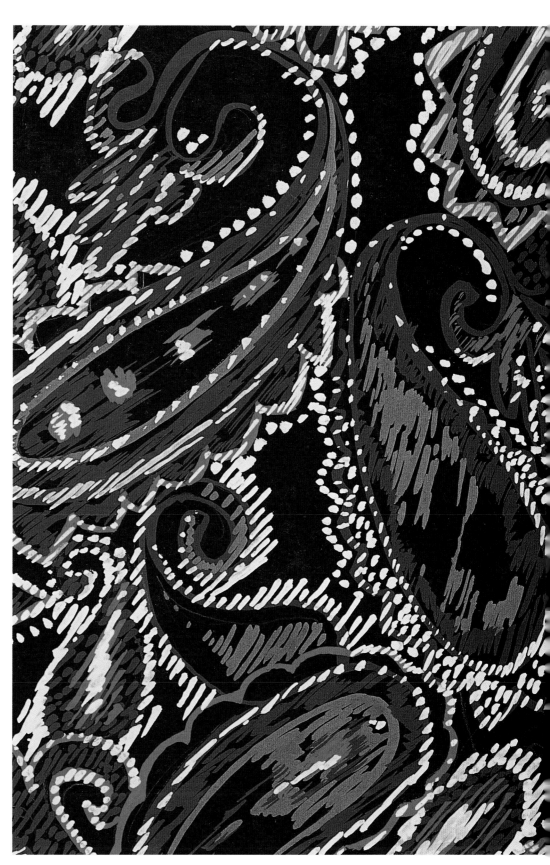

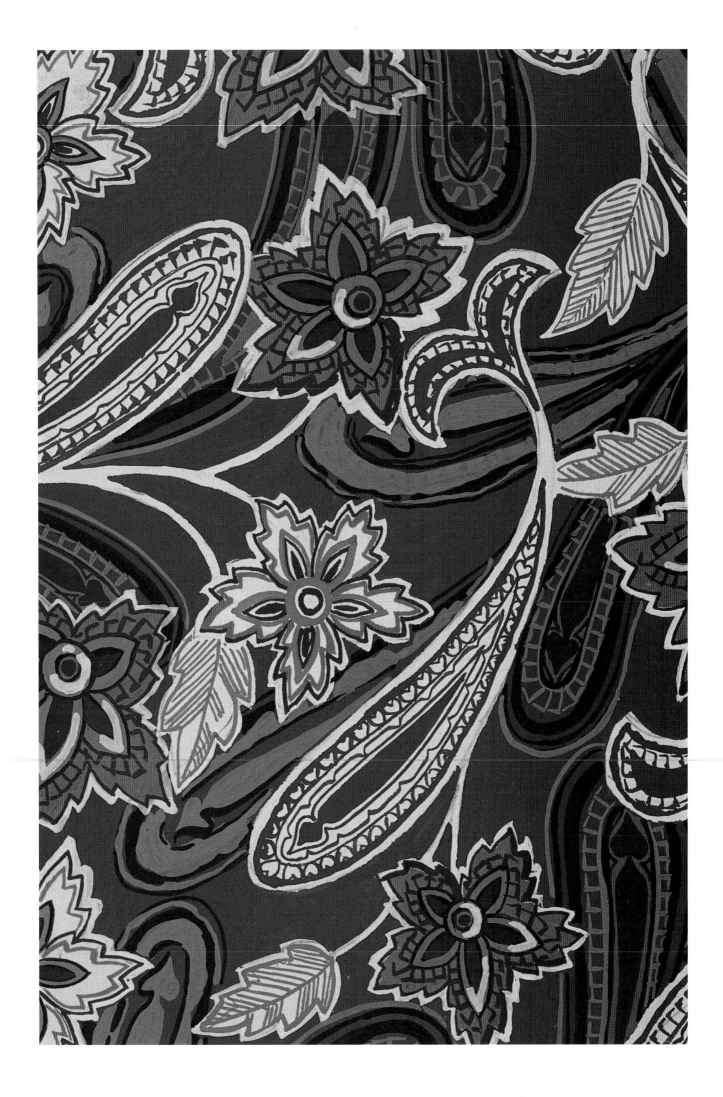

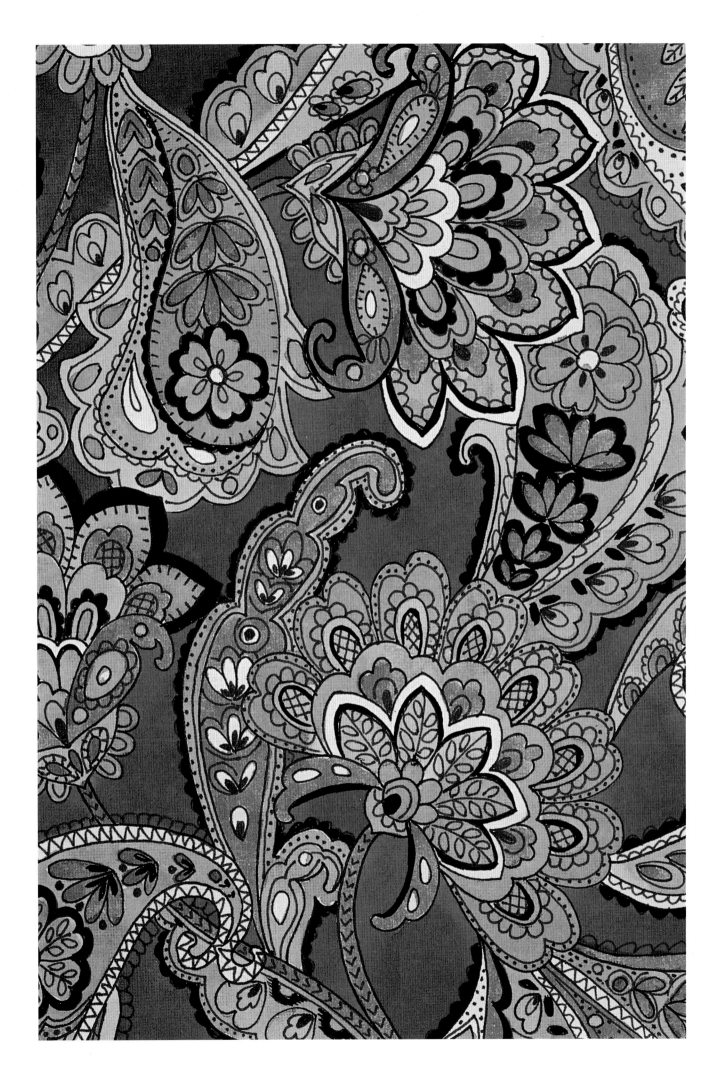

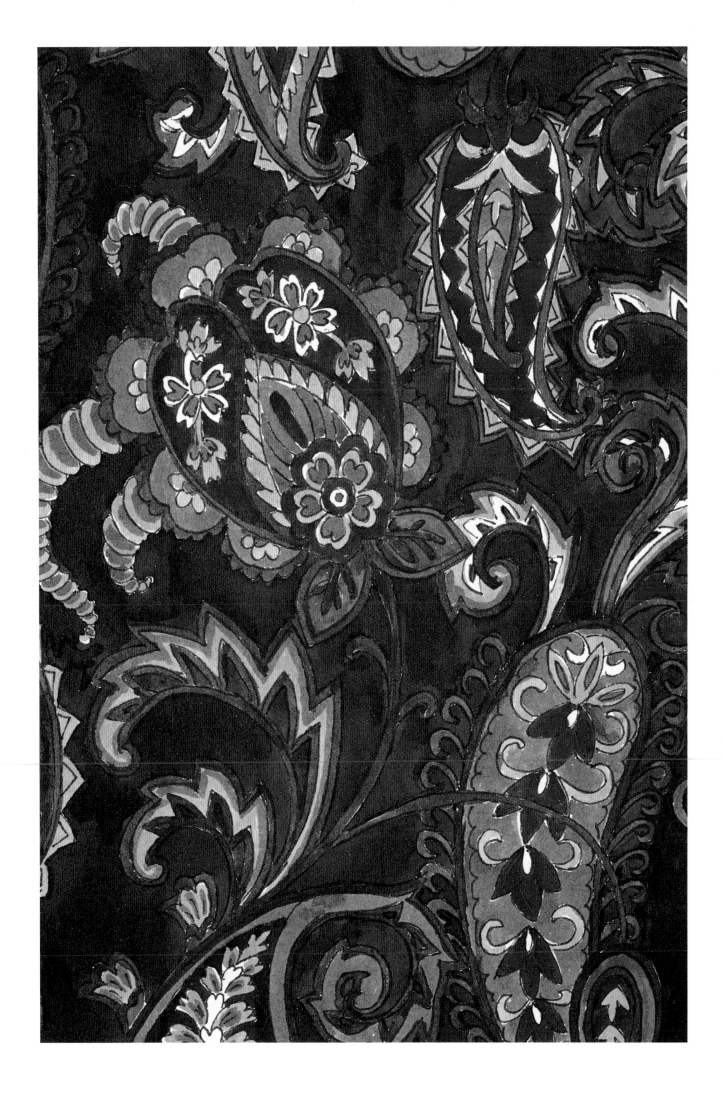

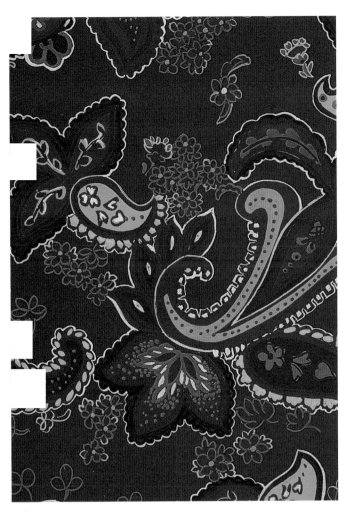
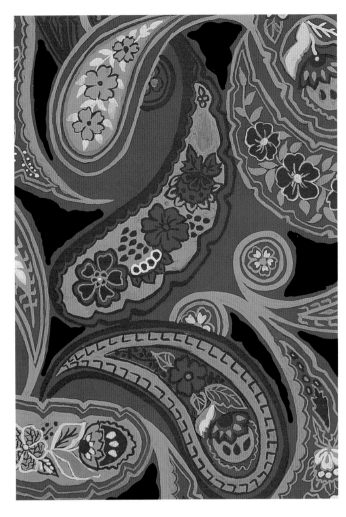
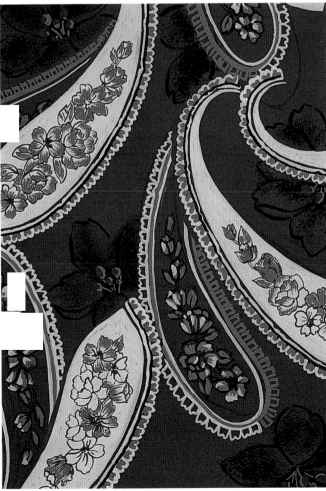
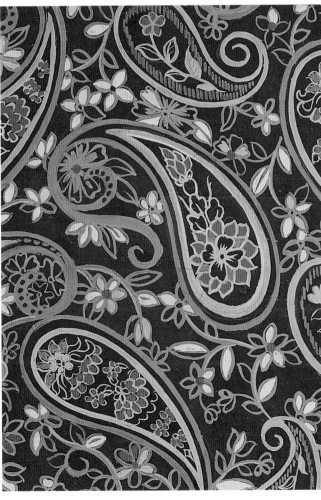

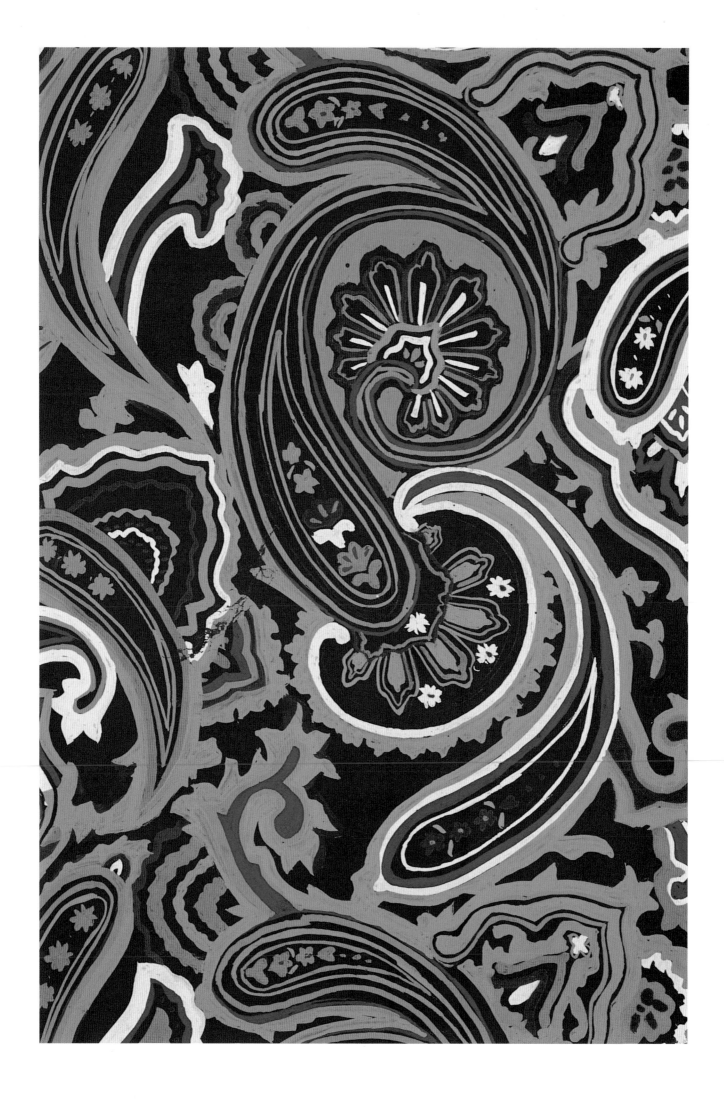

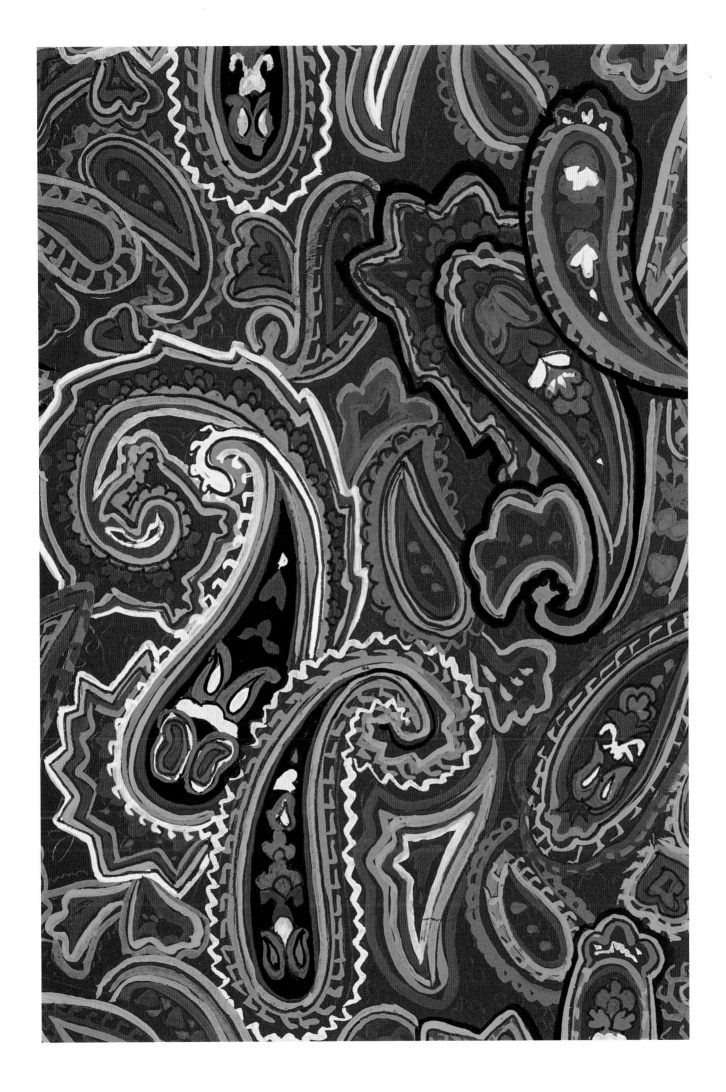

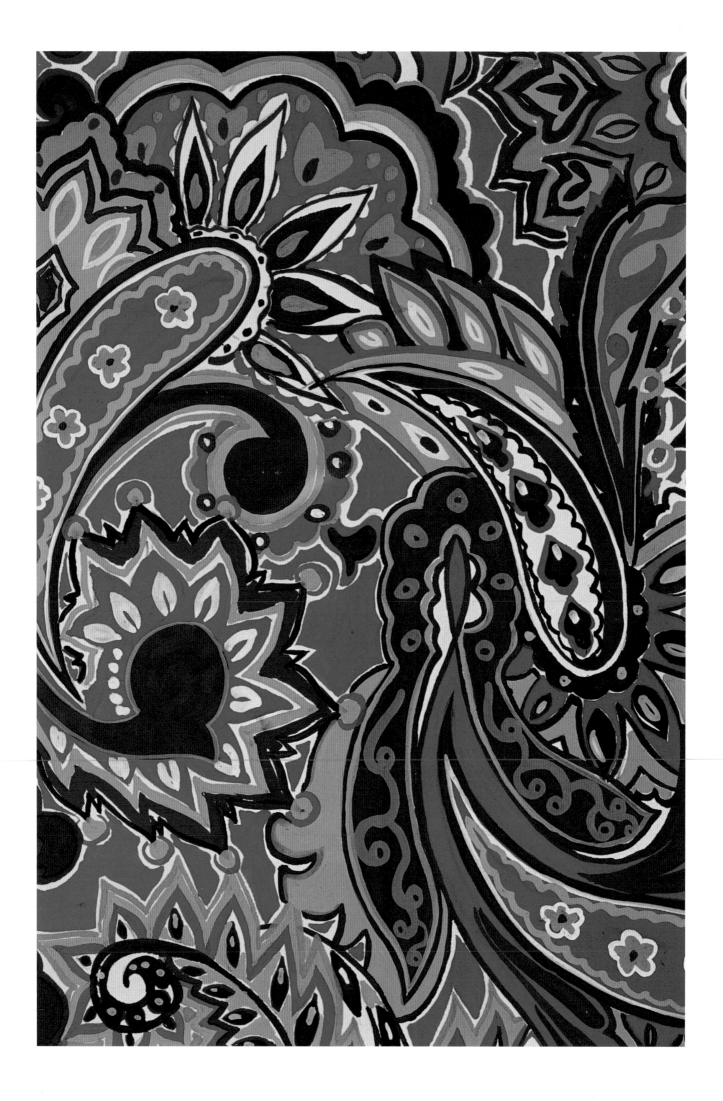

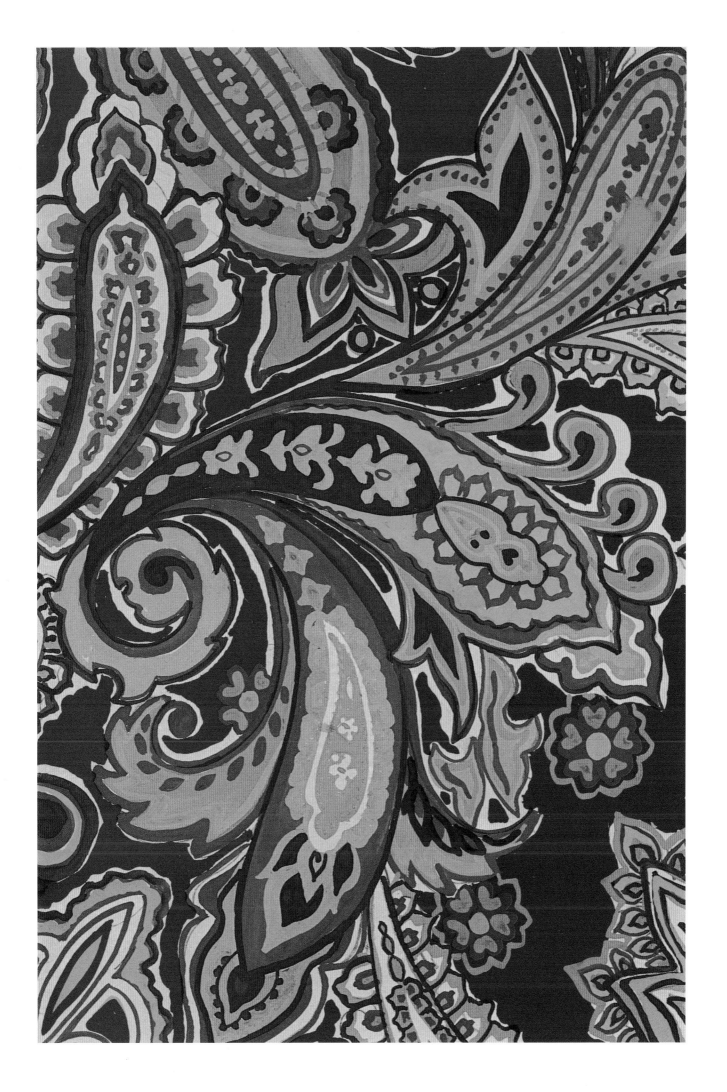

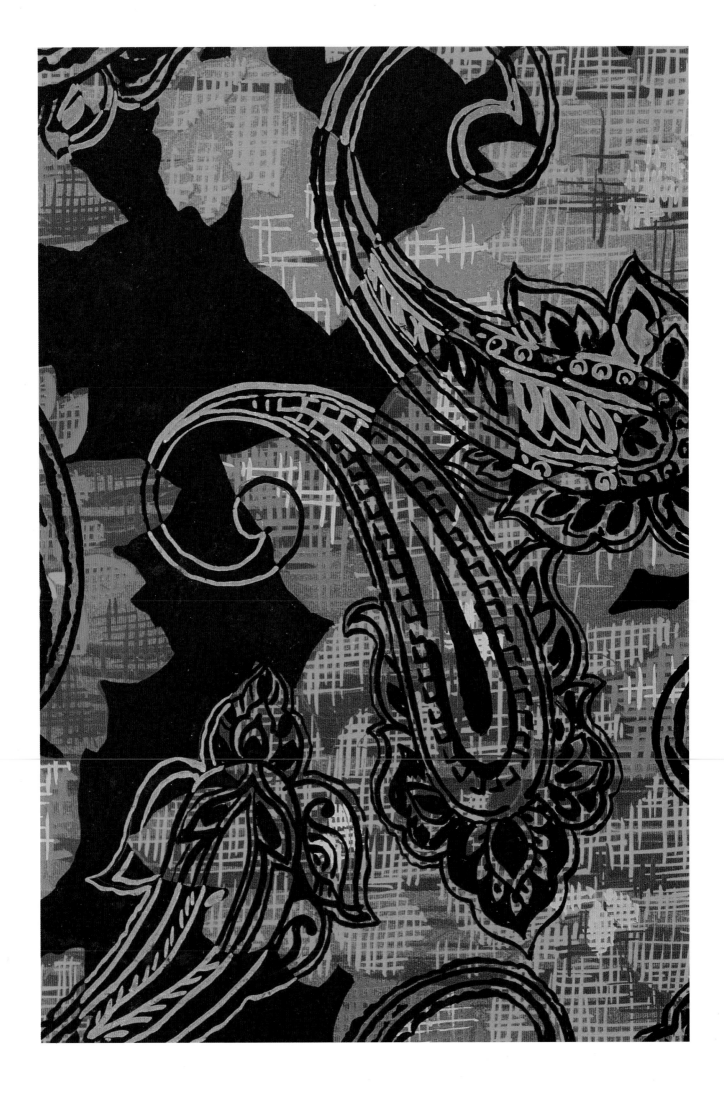

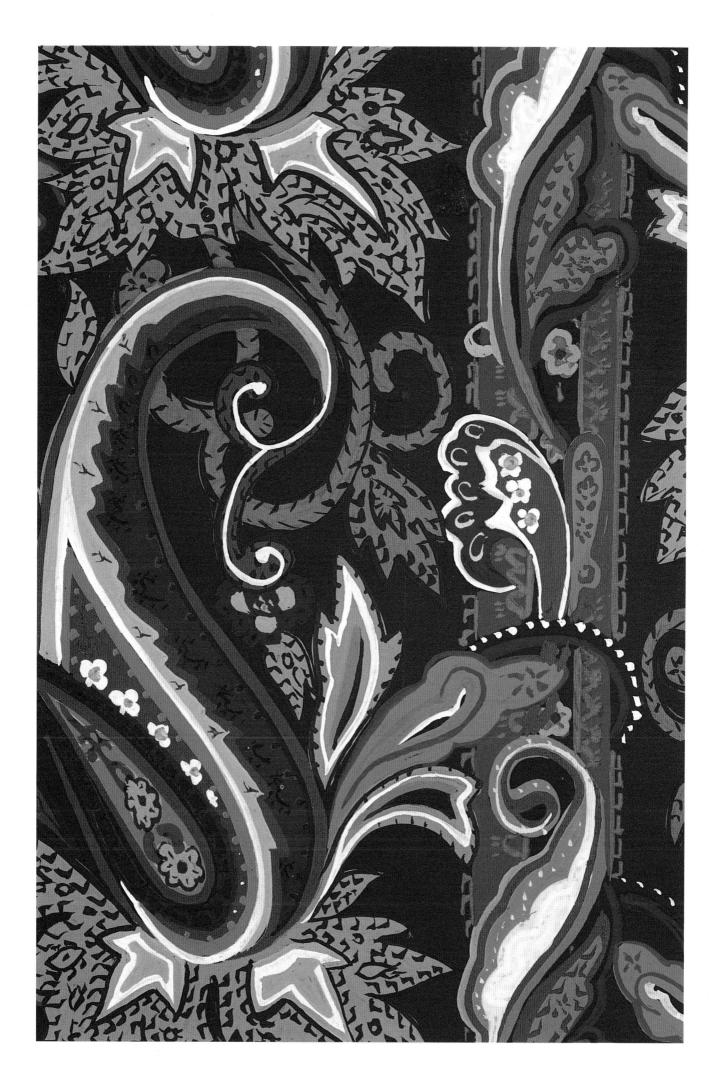

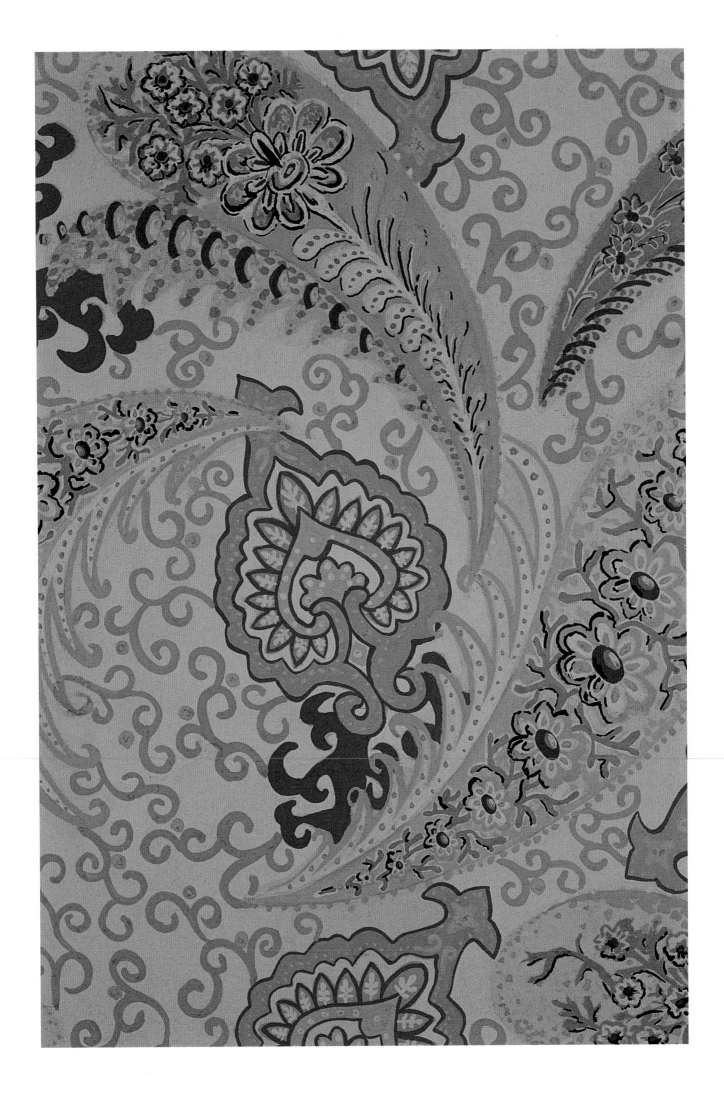

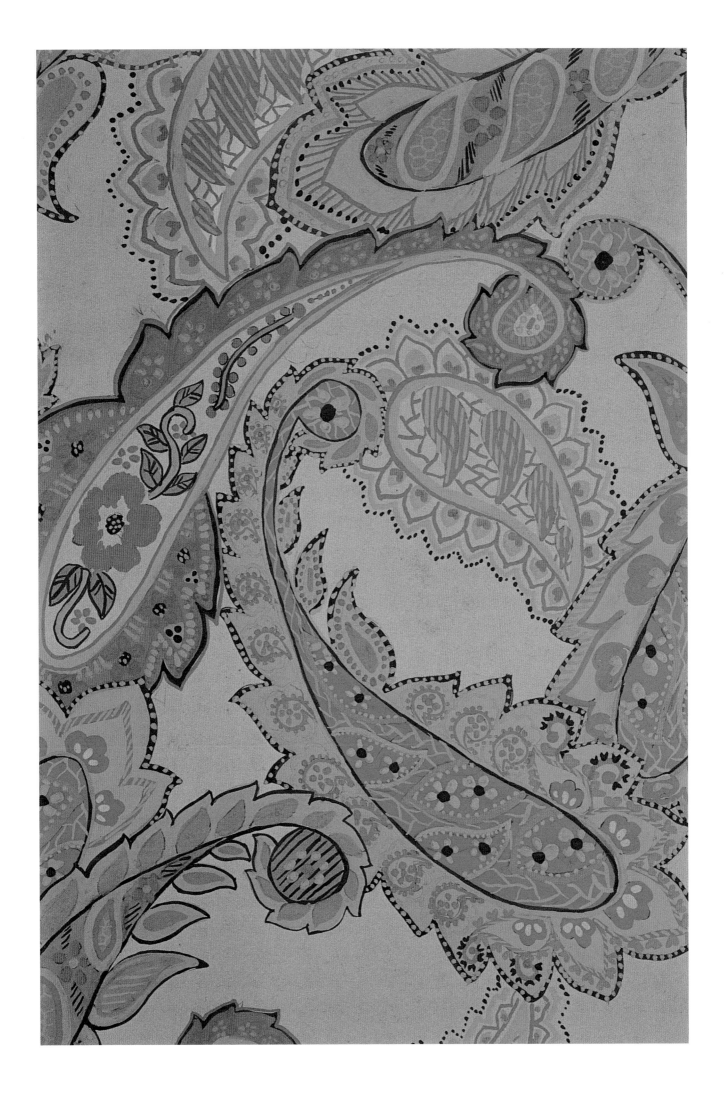

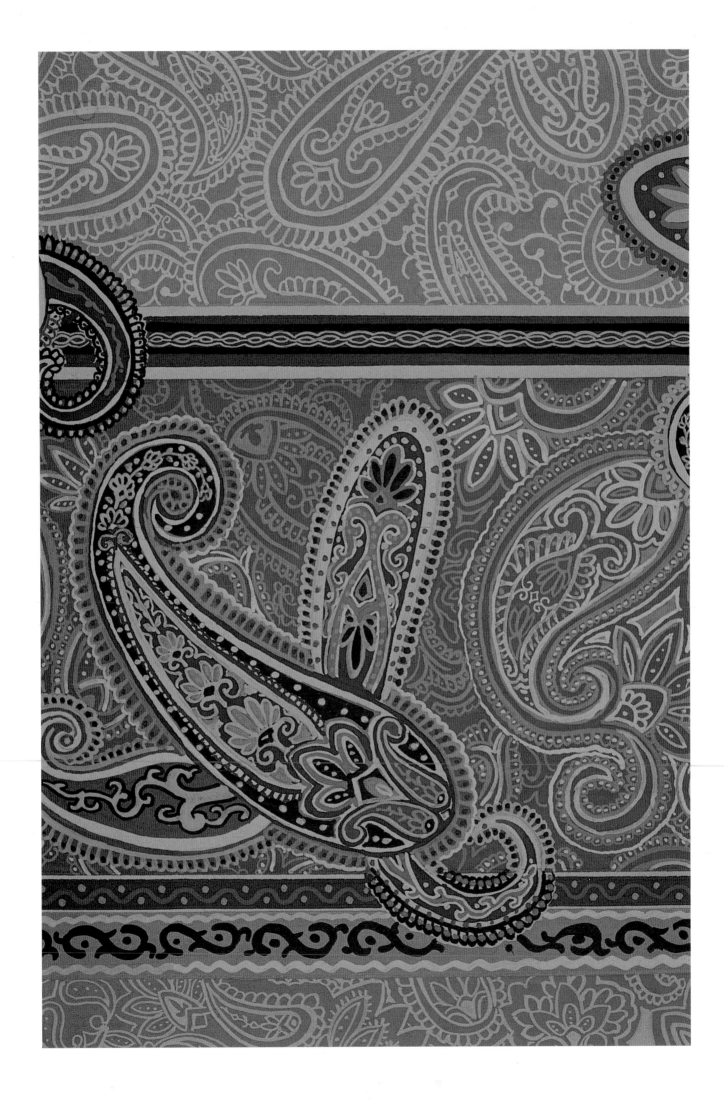

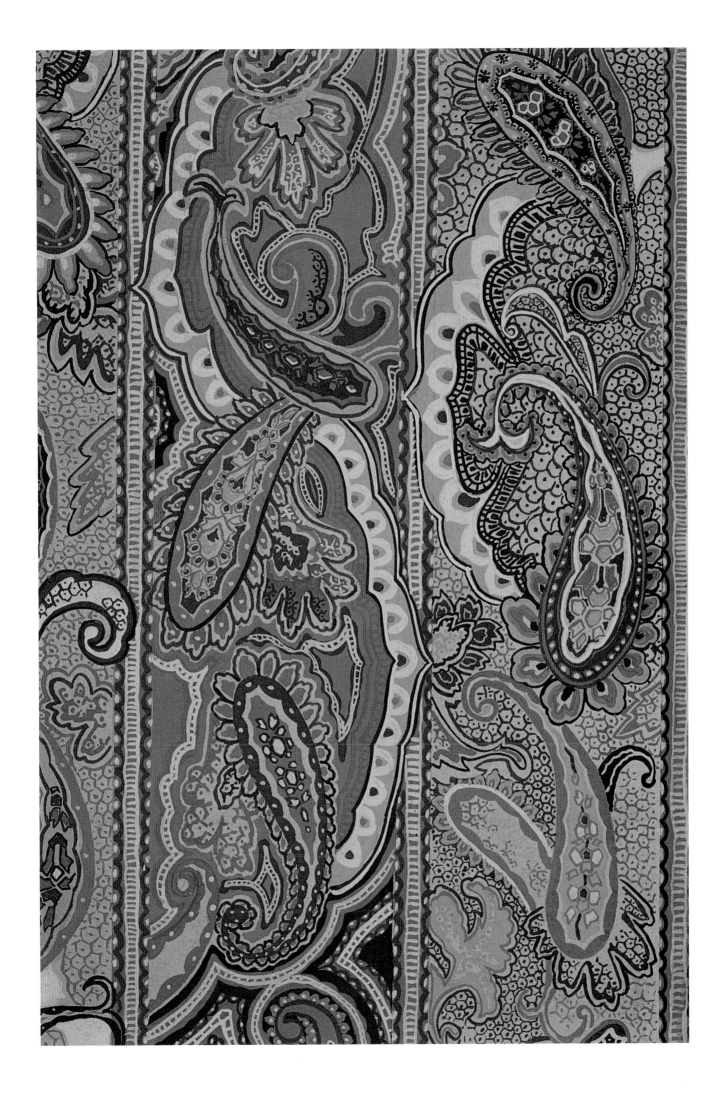

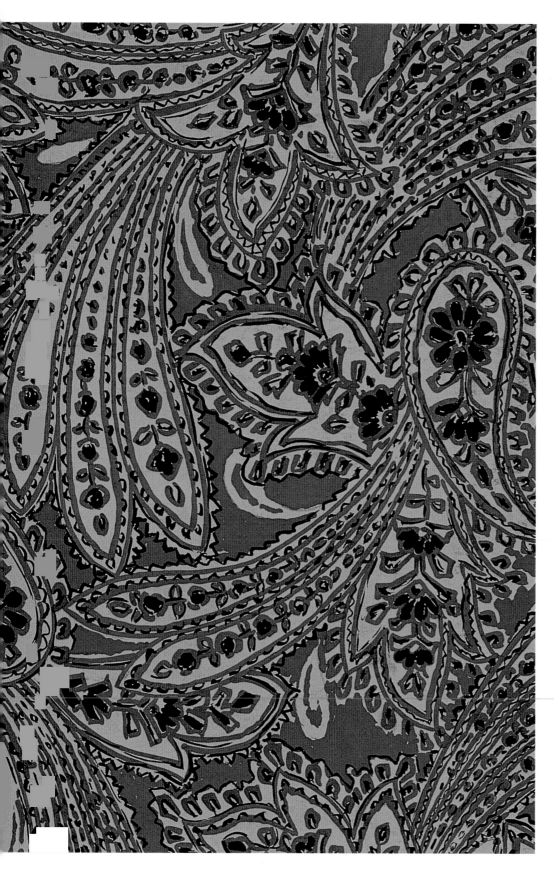
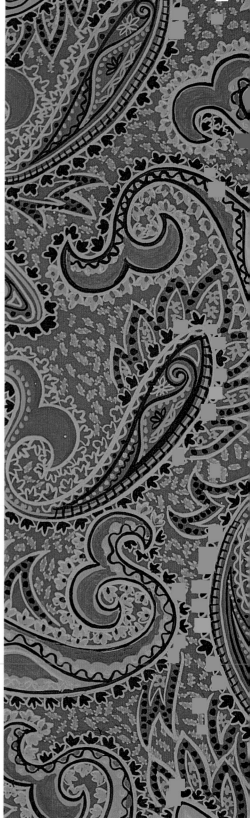

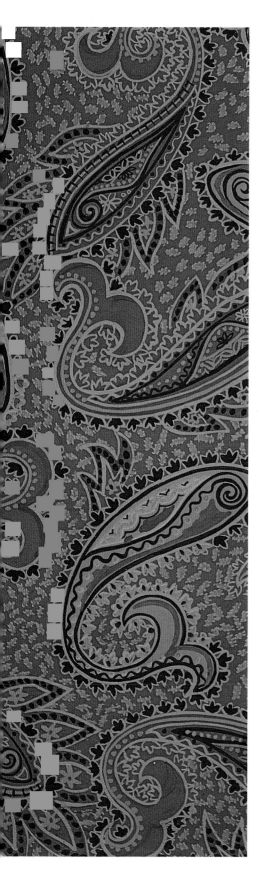
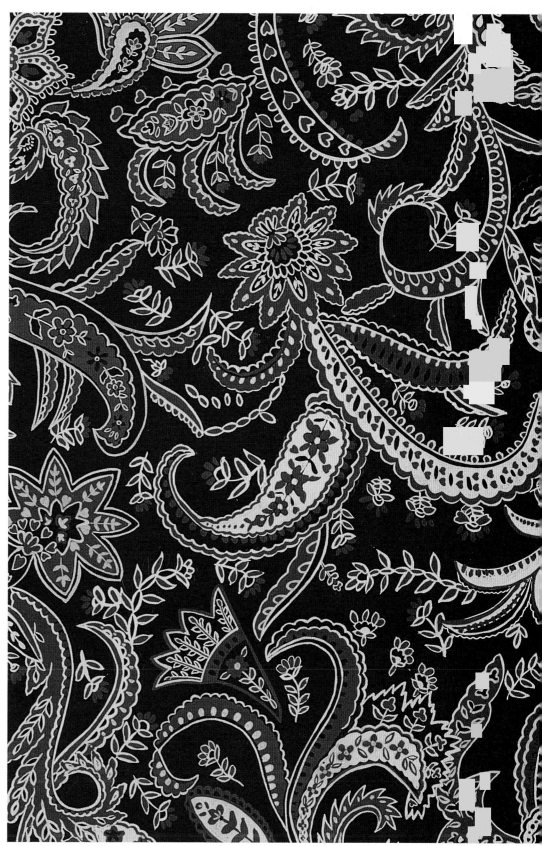

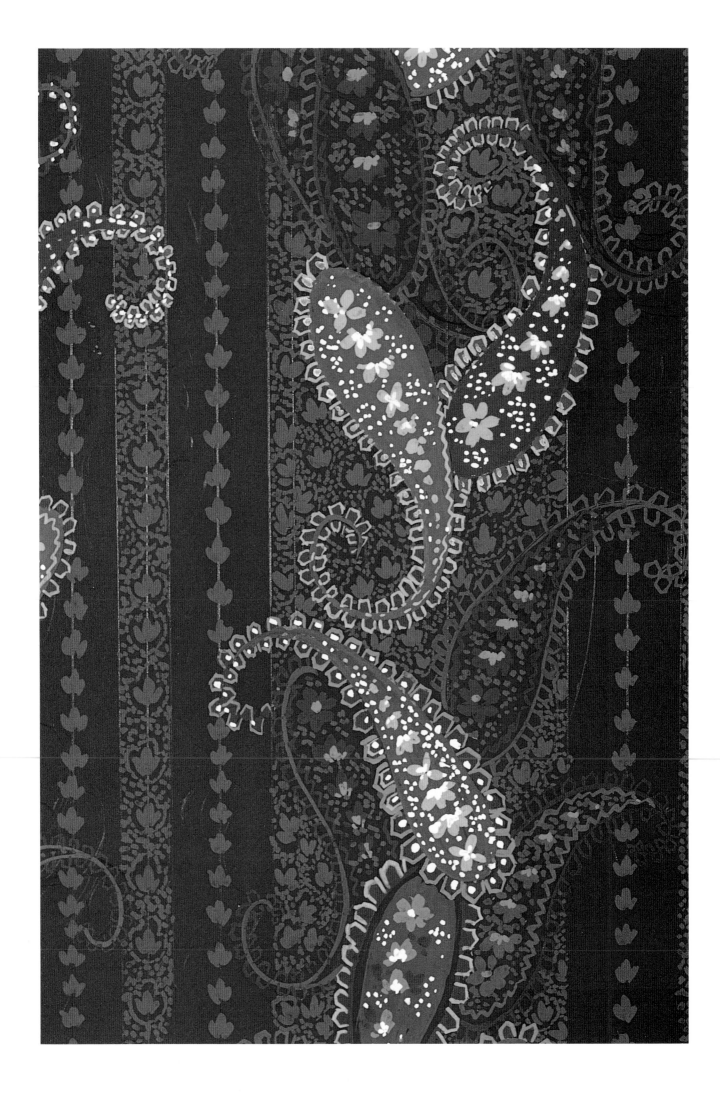

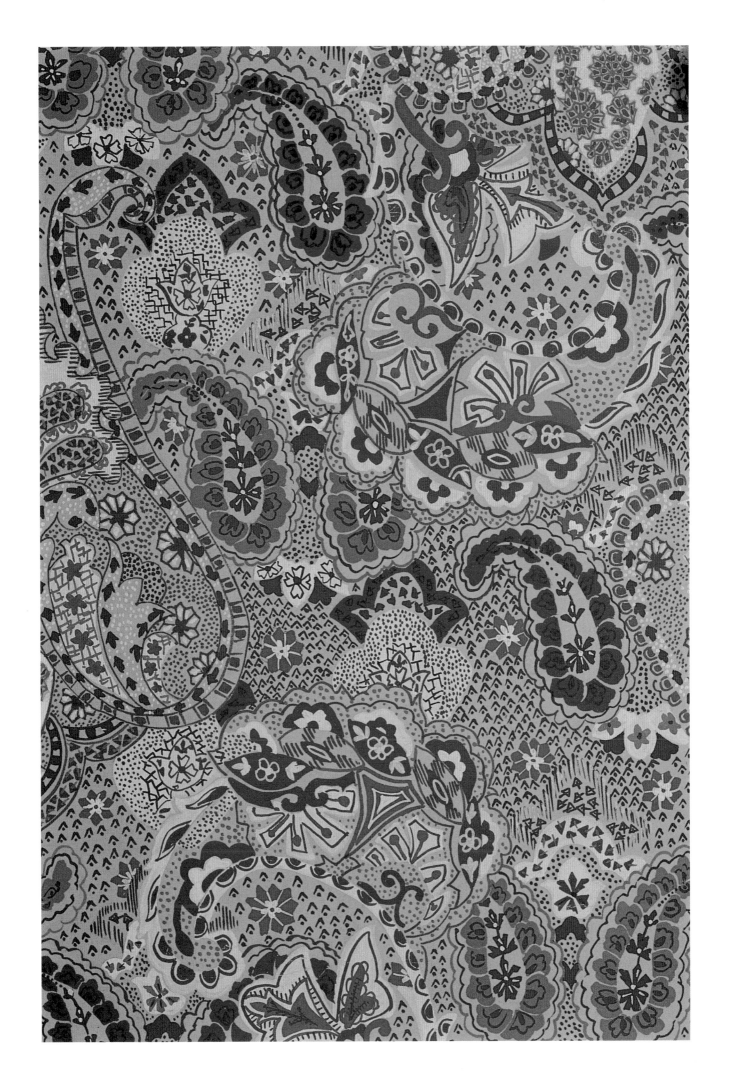

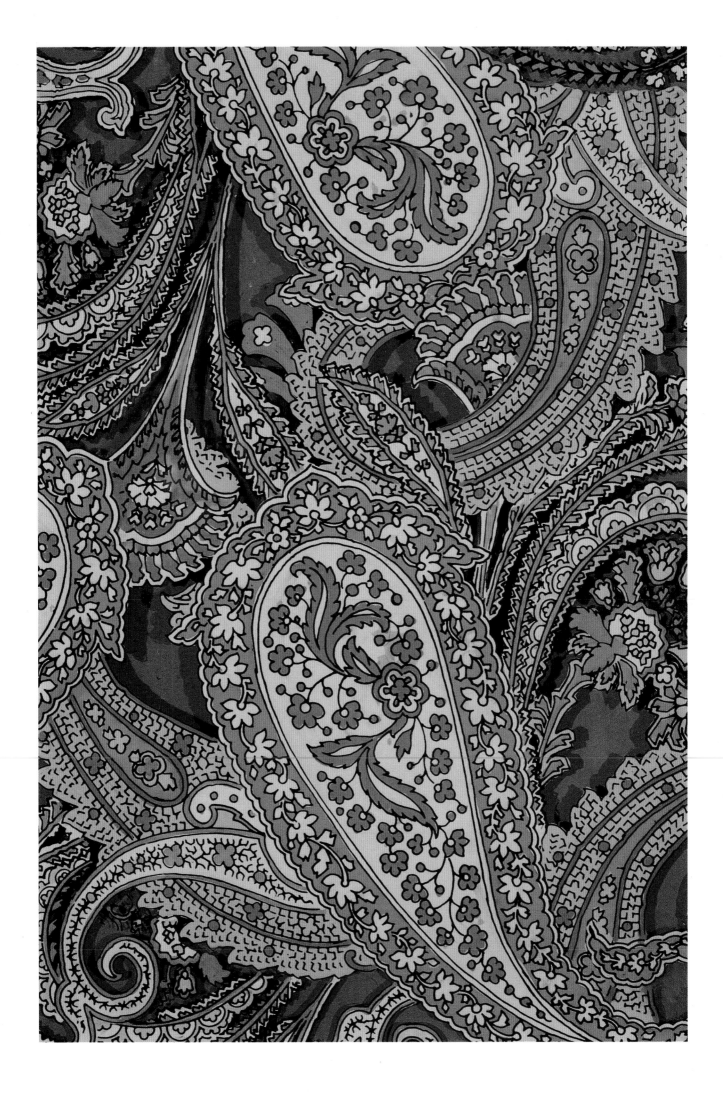

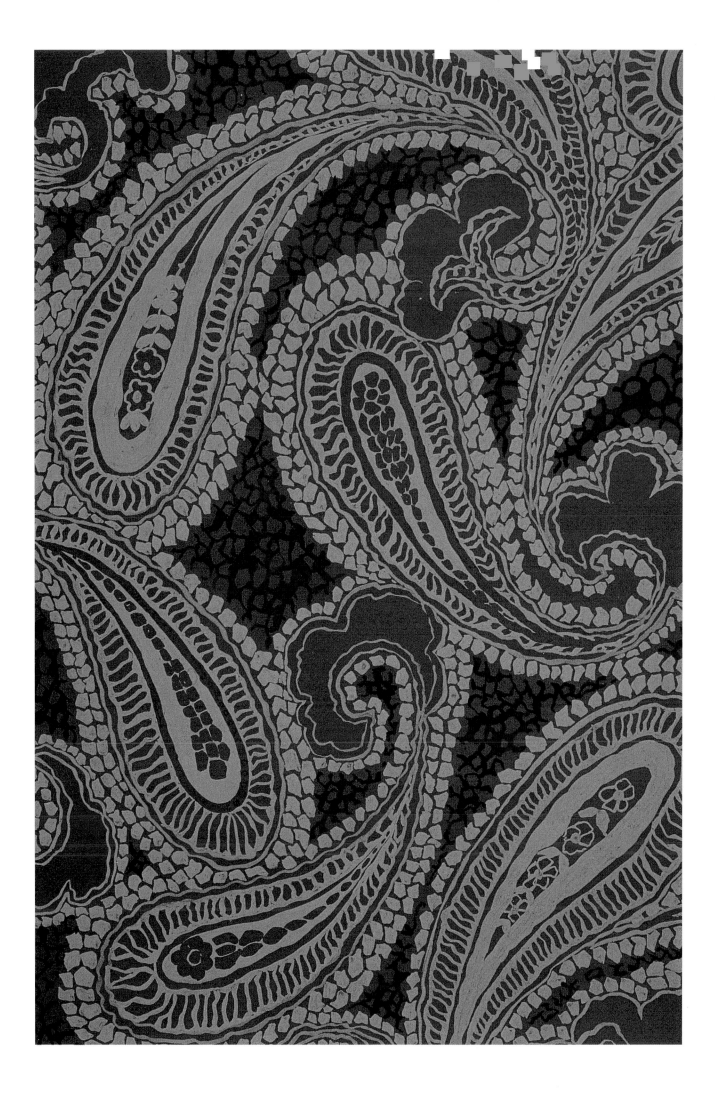

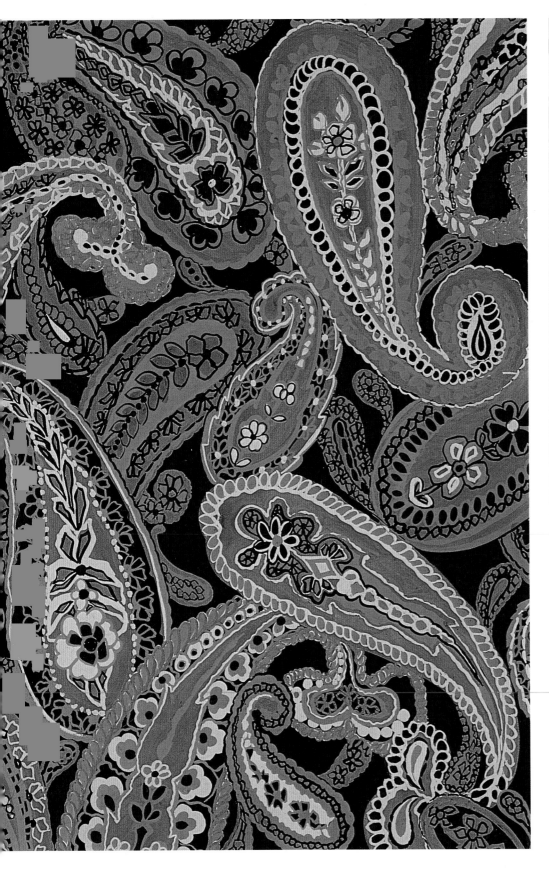
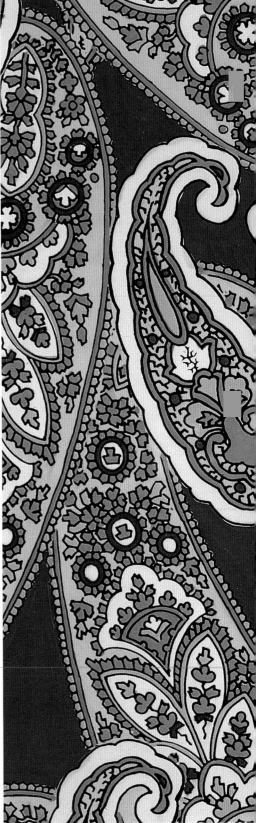

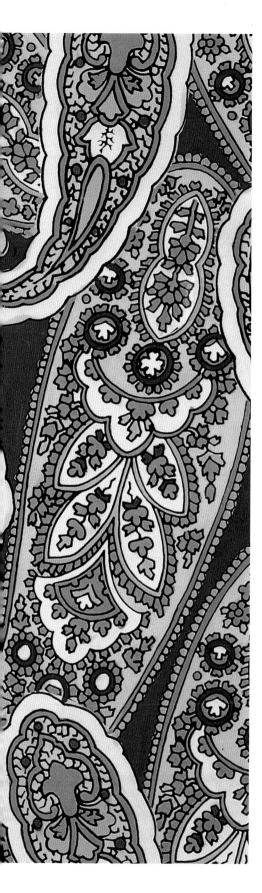
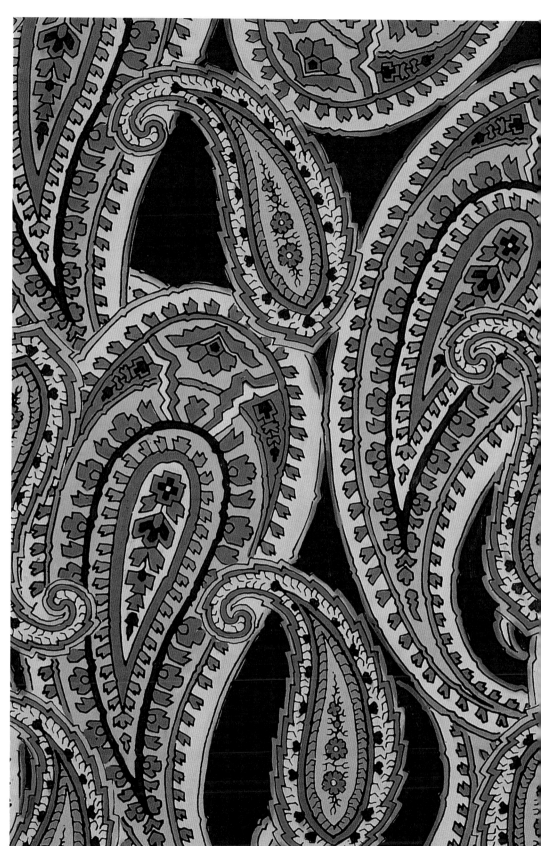

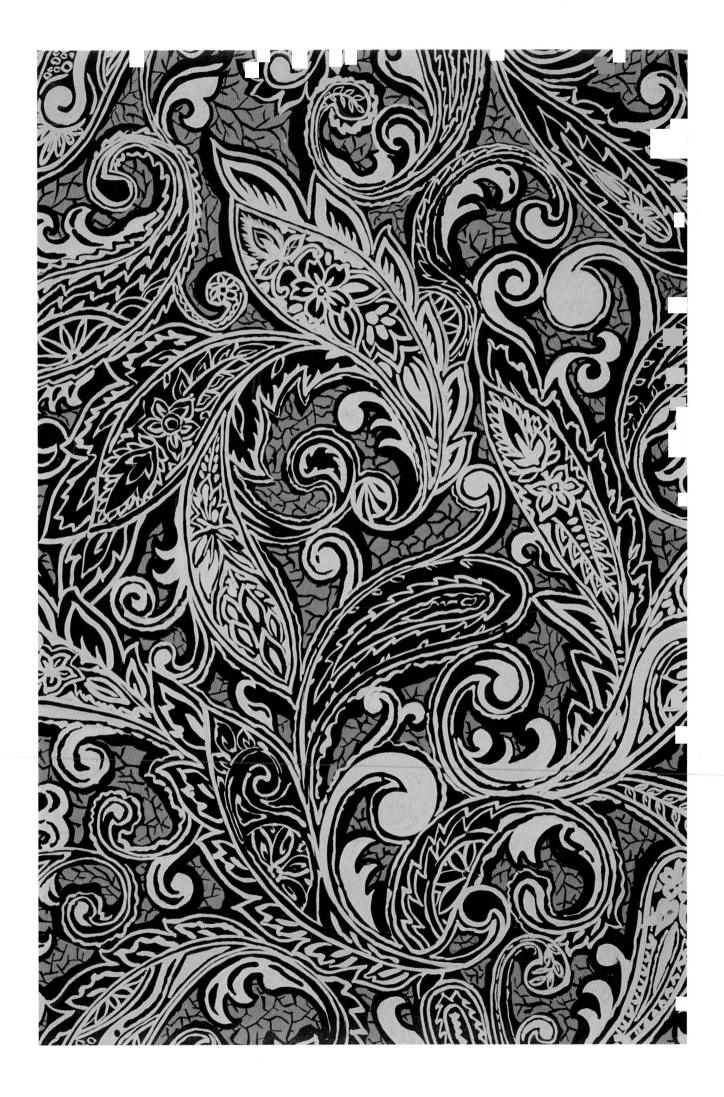

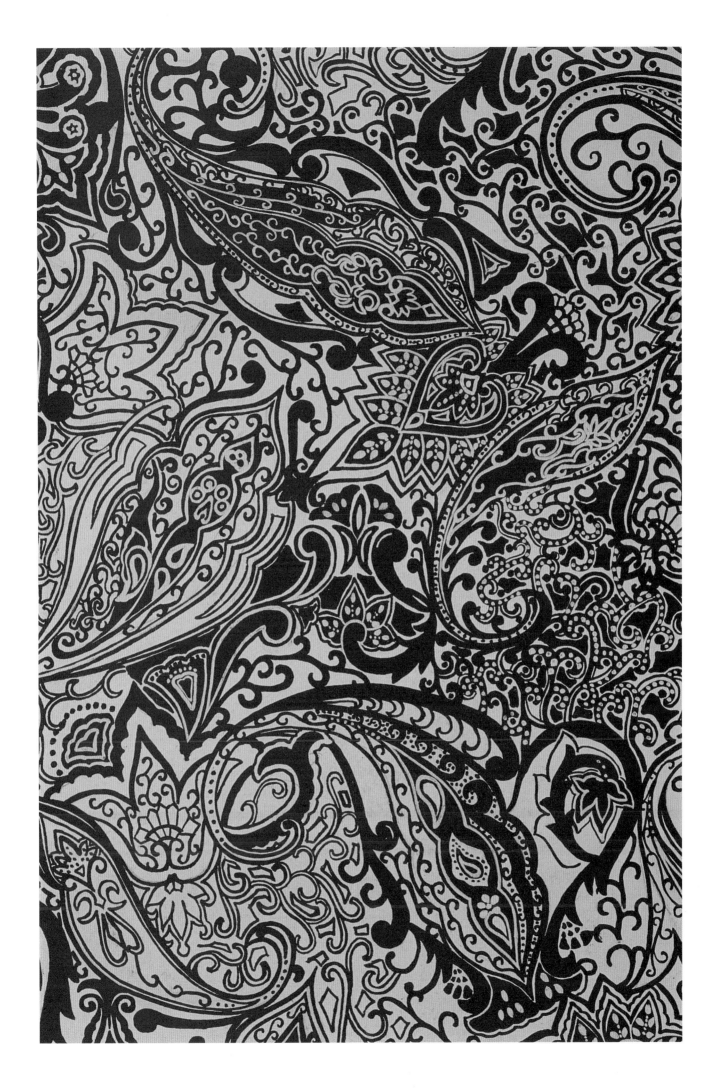

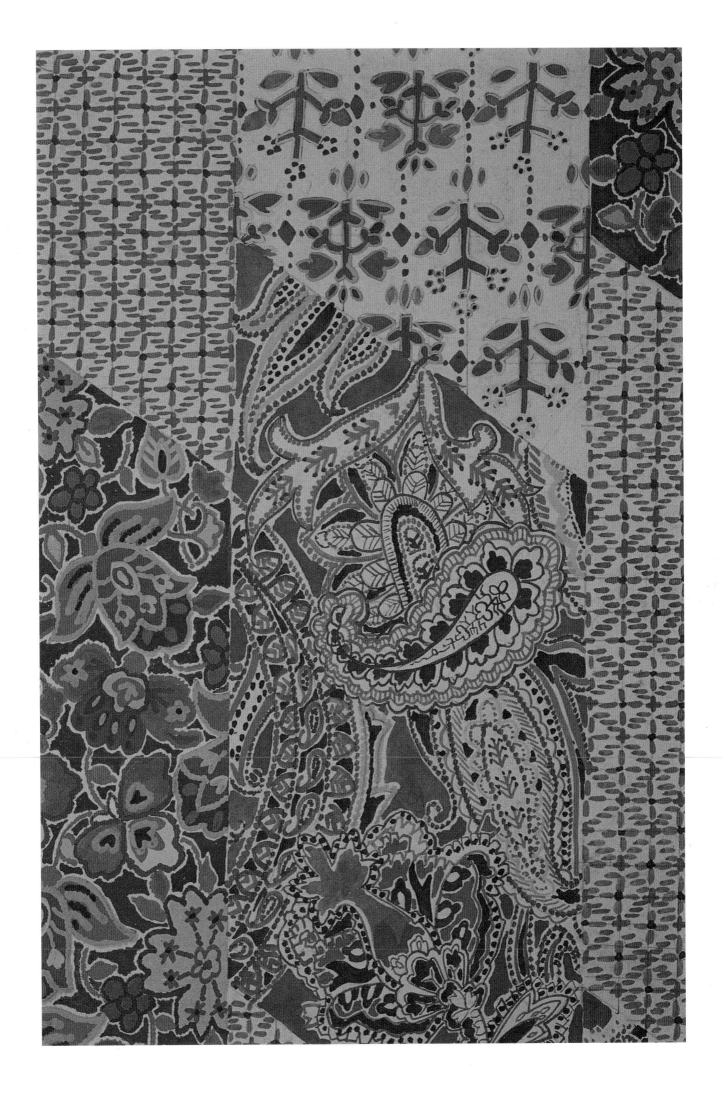

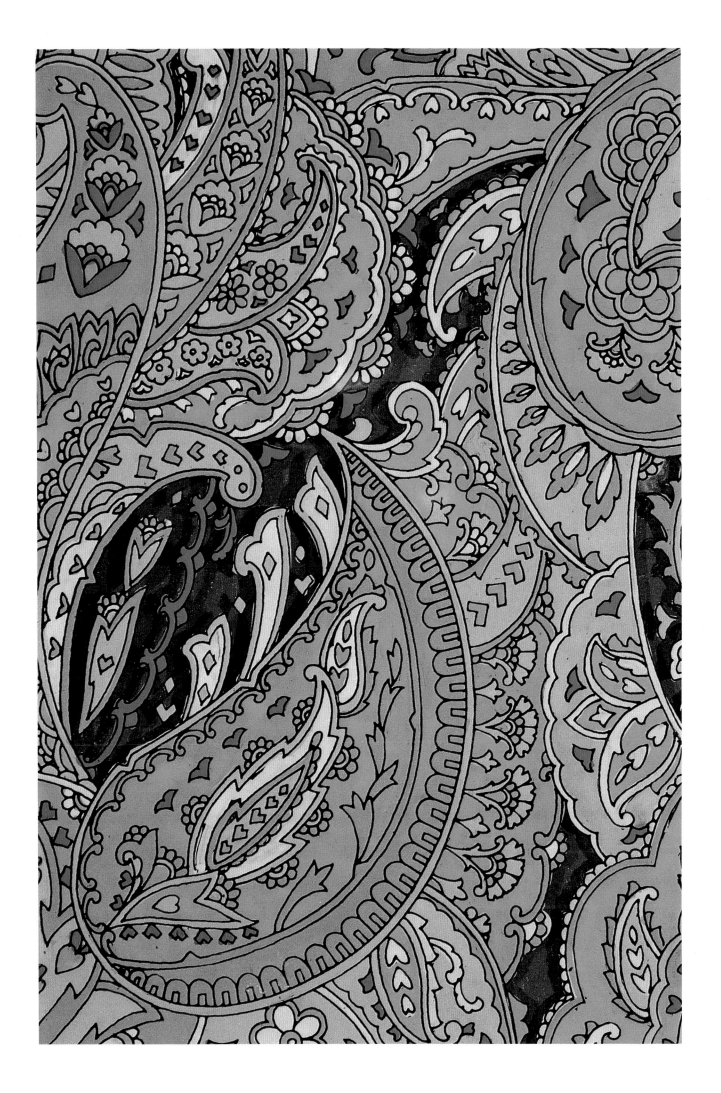

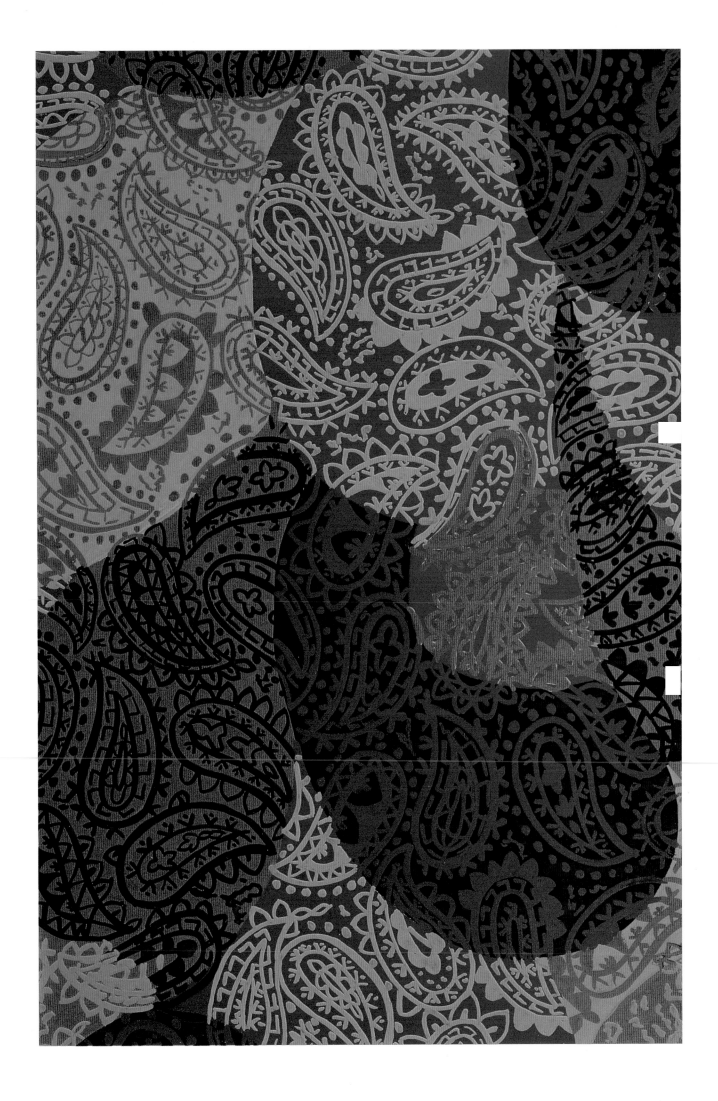

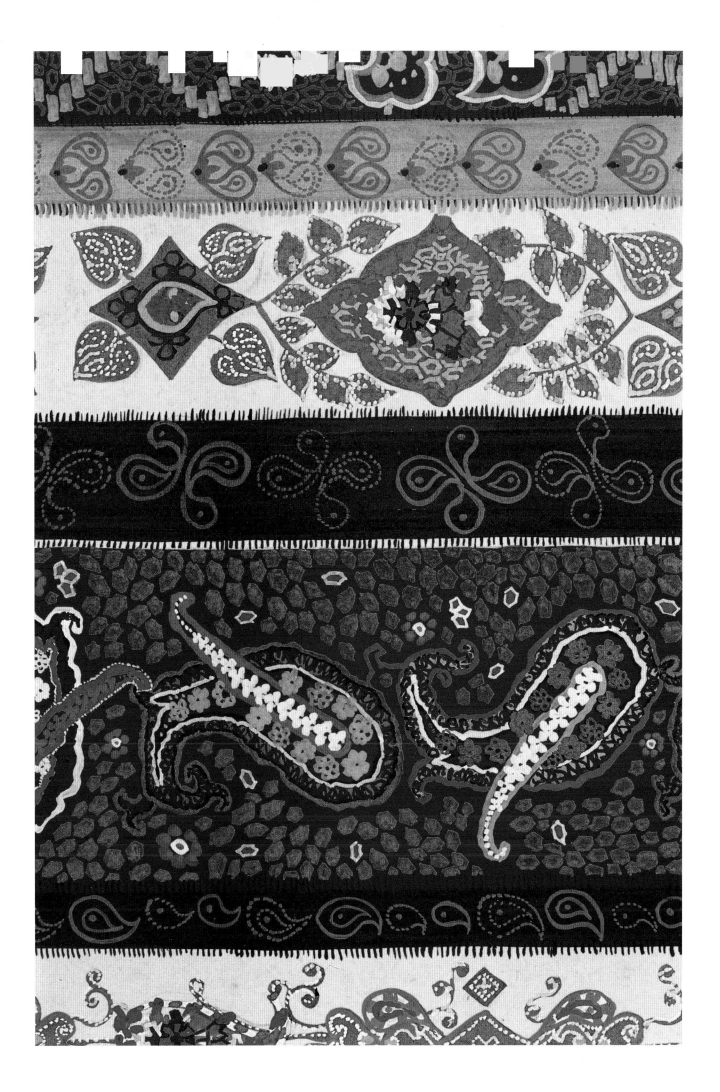

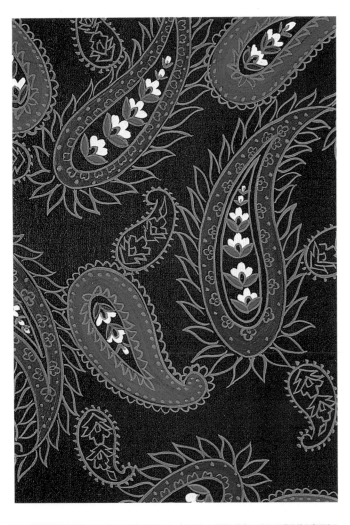
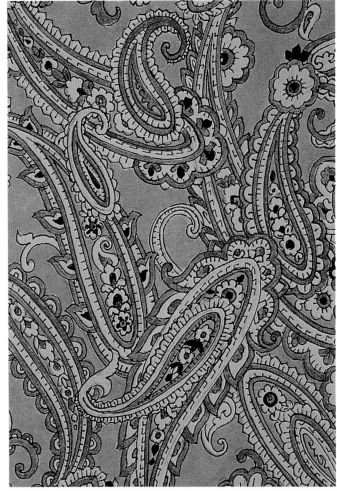
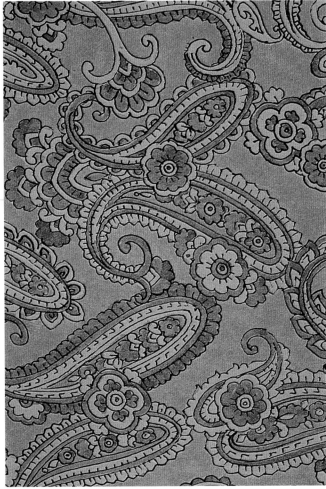
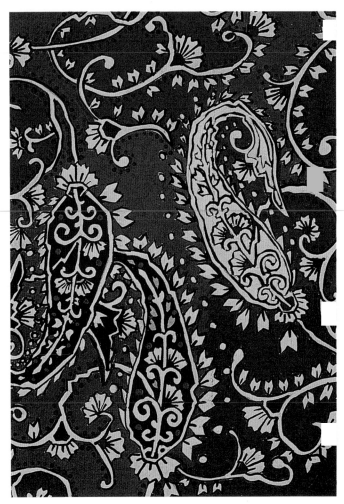

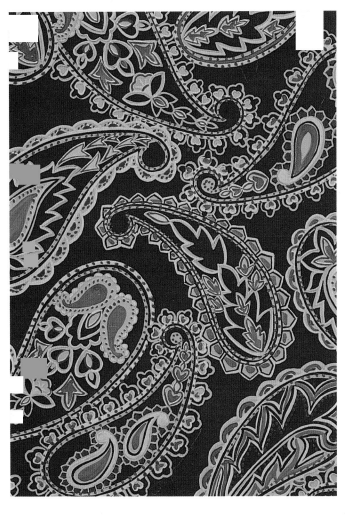
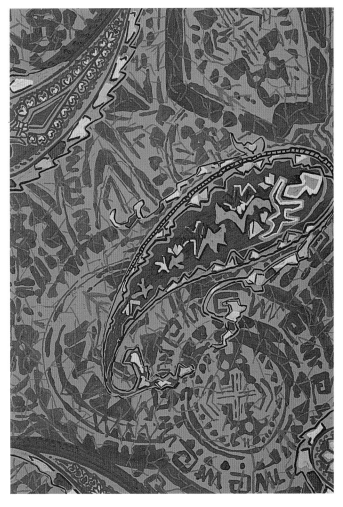
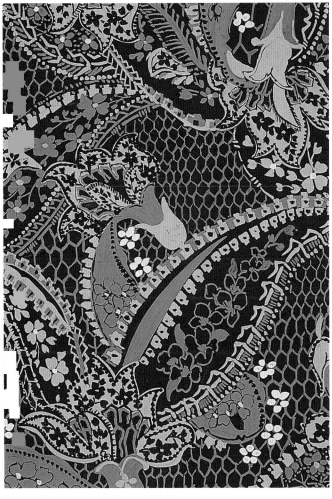
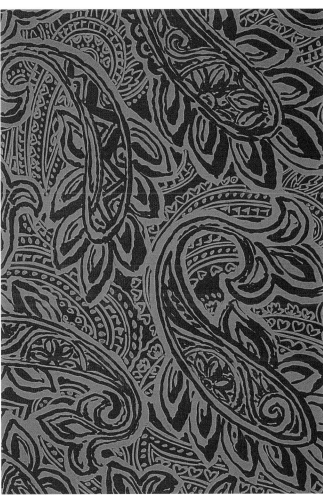

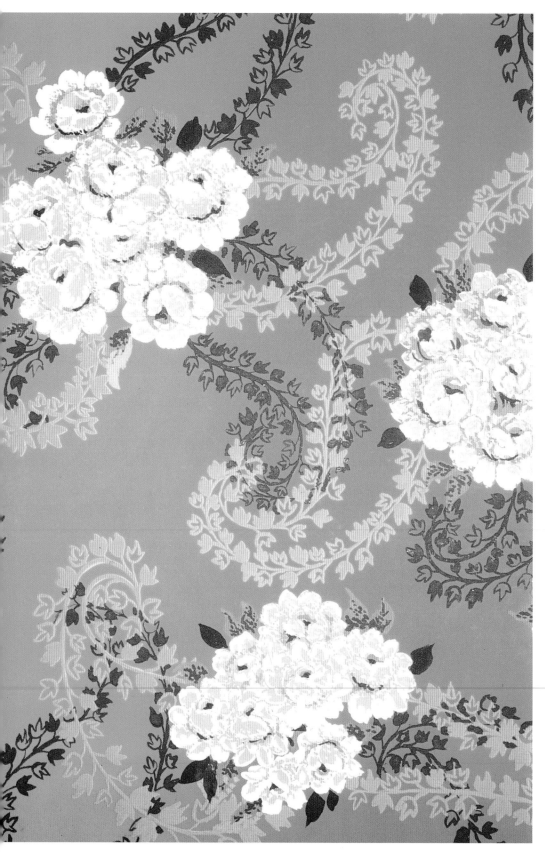
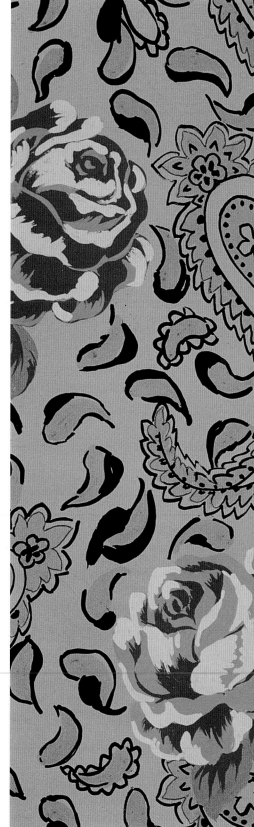

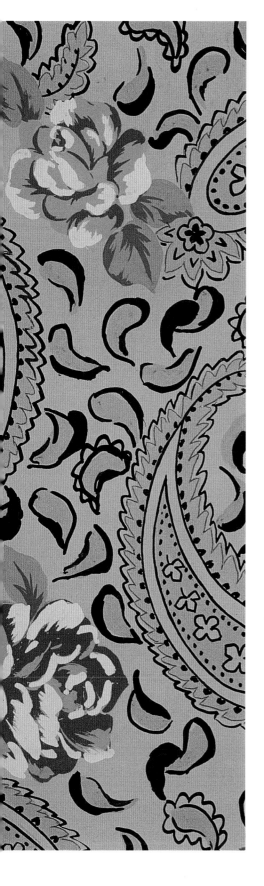
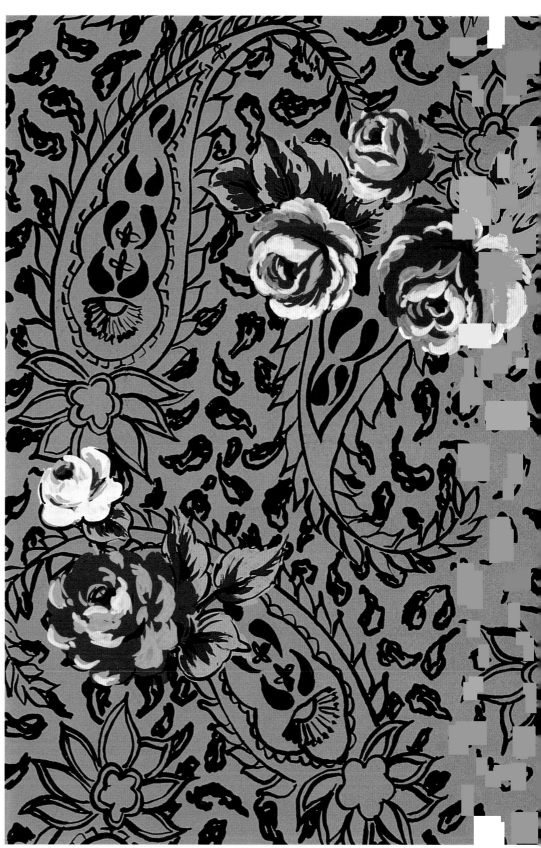

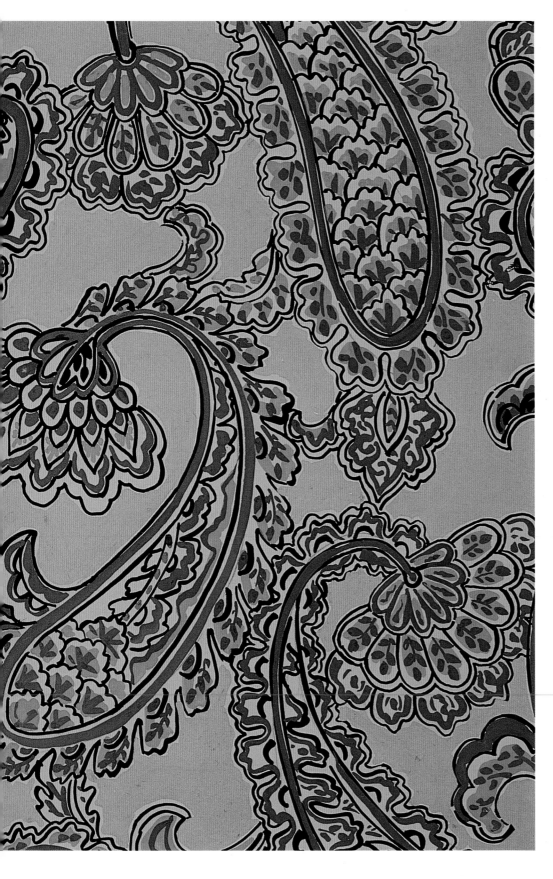
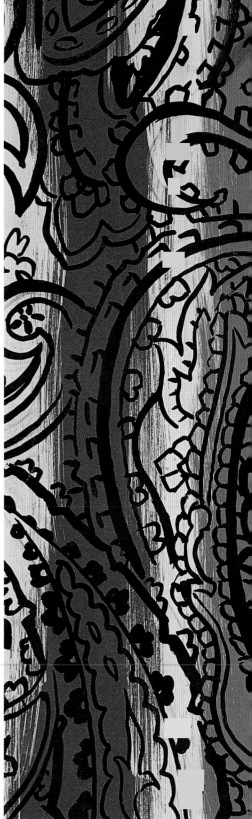

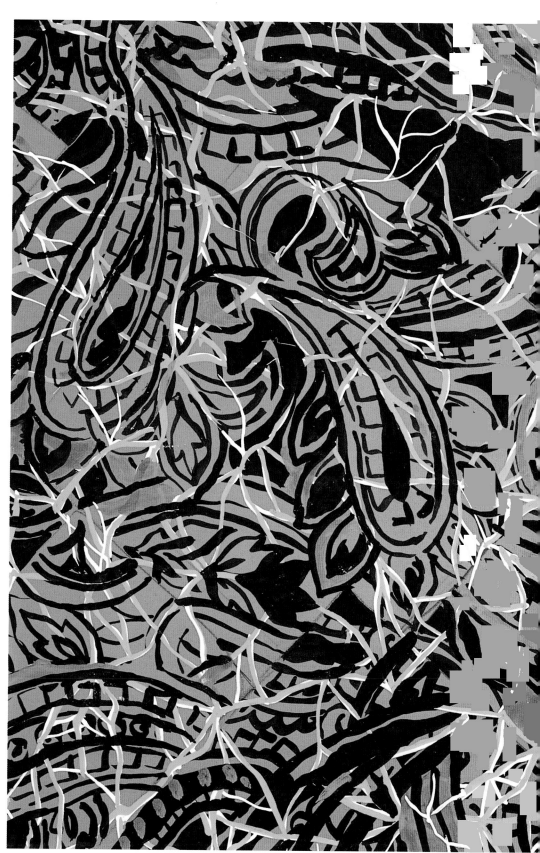

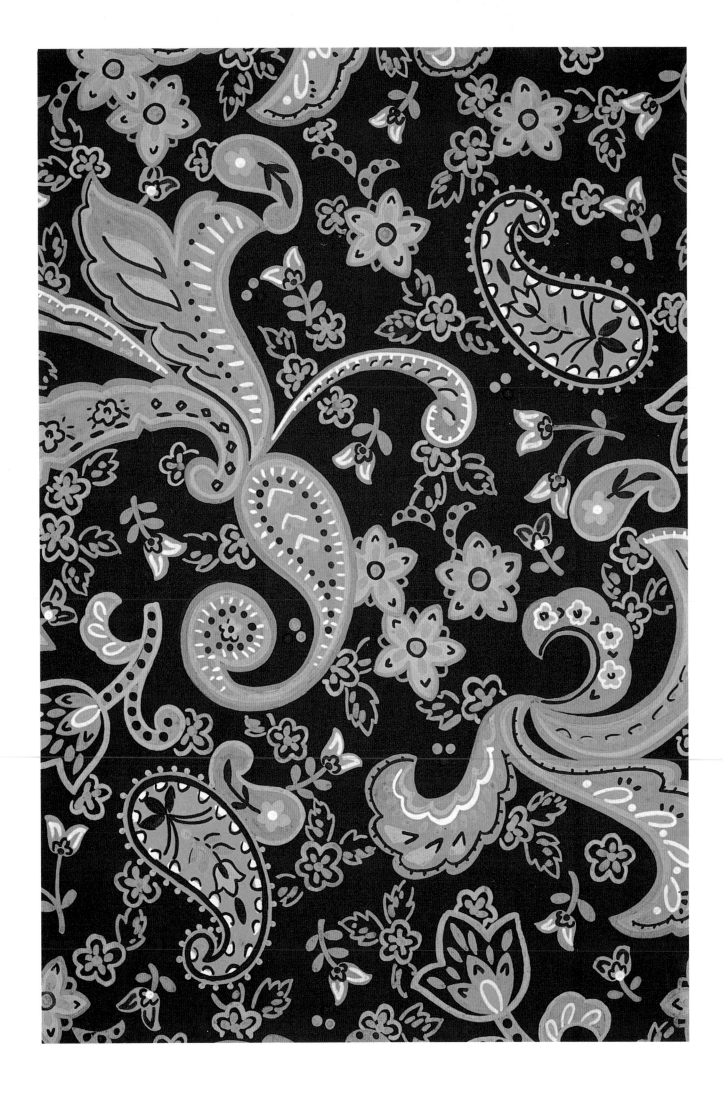

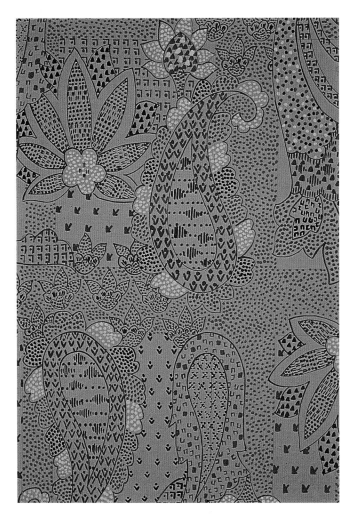
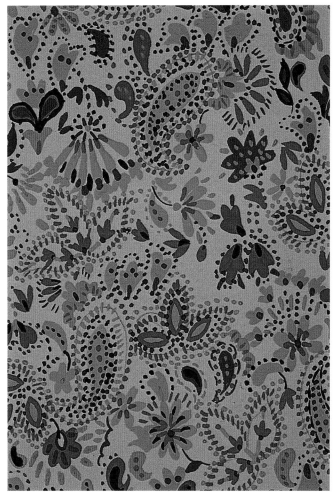
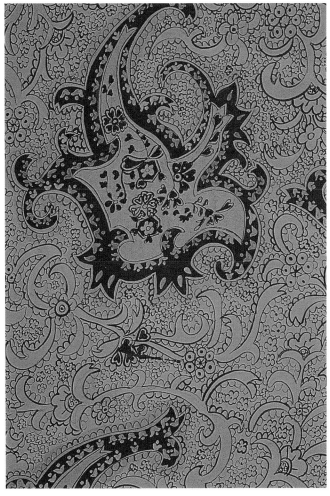
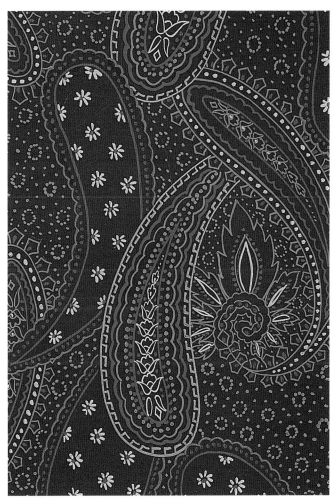

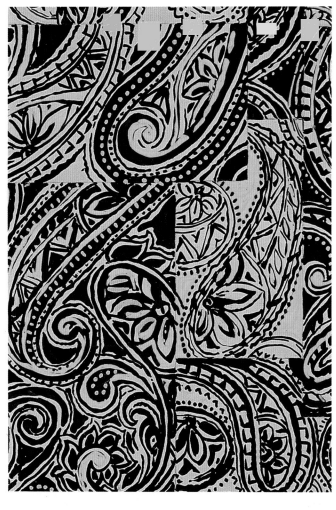
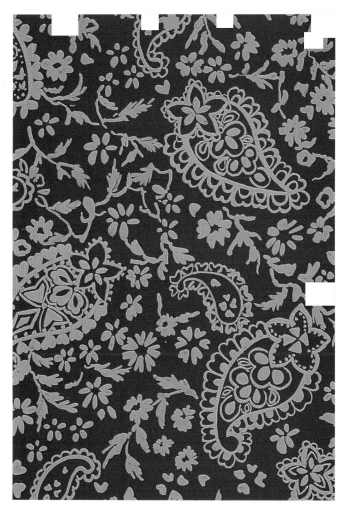
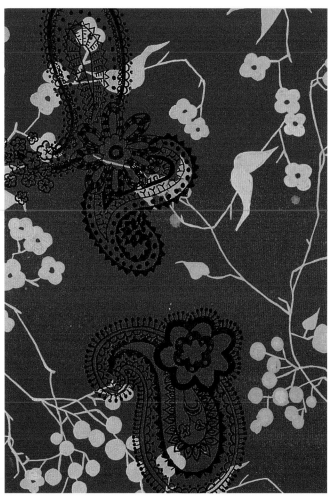
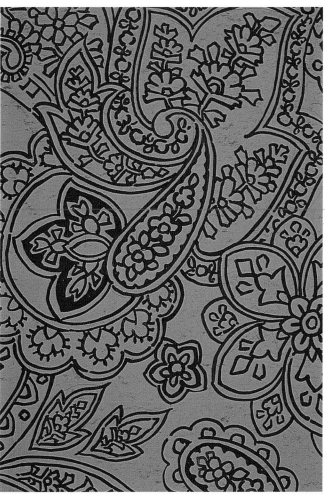

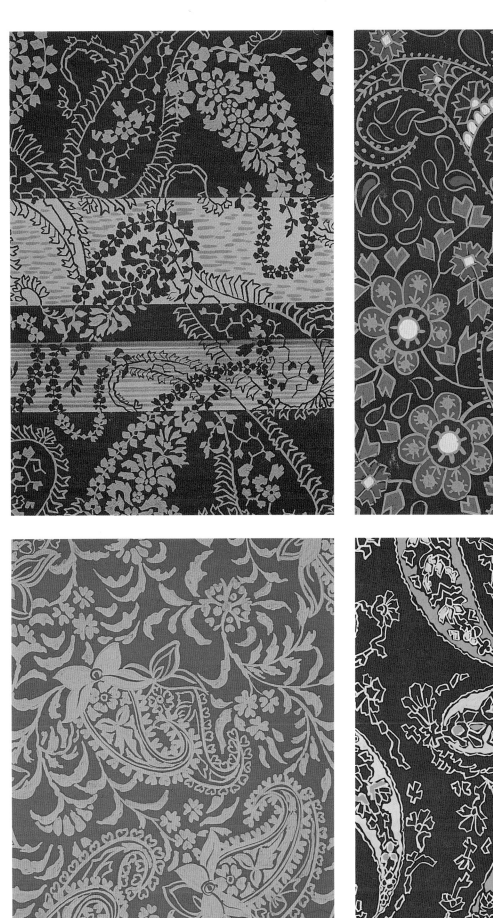
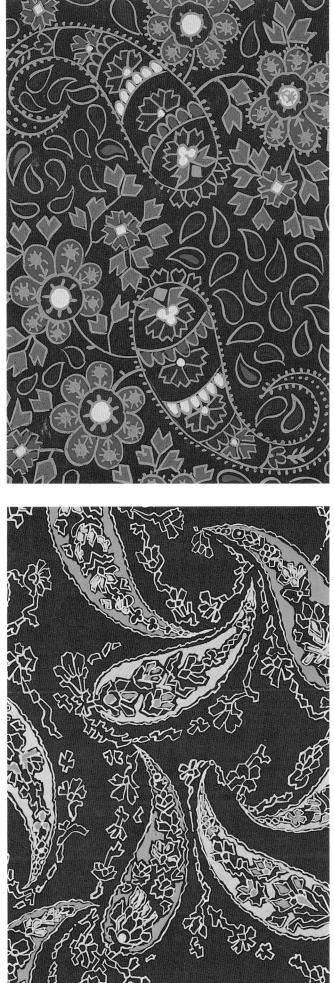

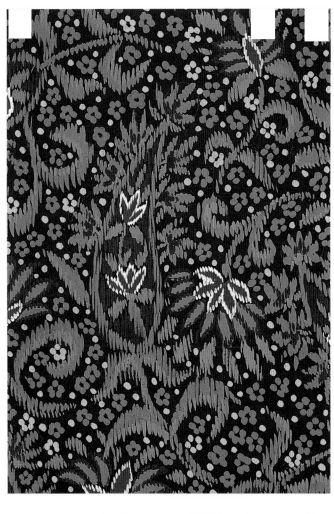
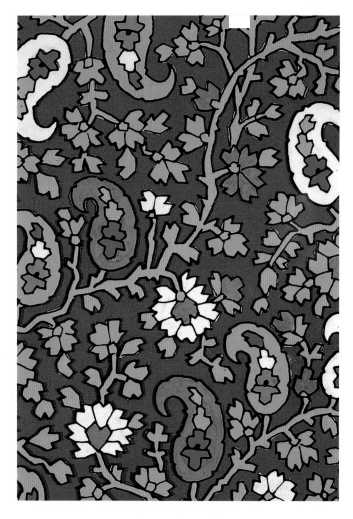
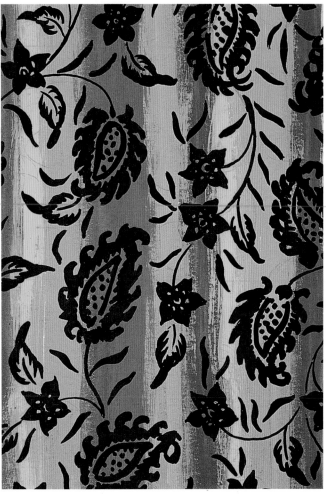
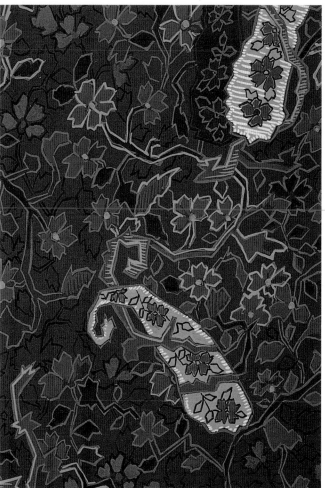

60

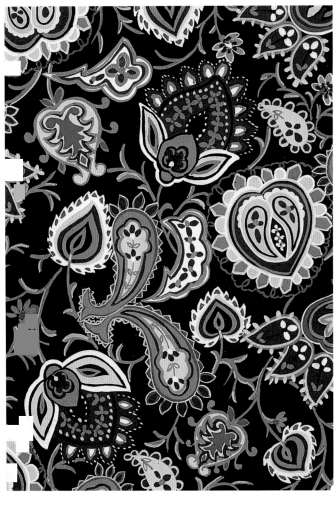
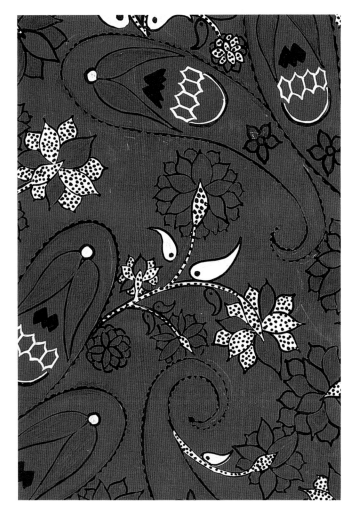
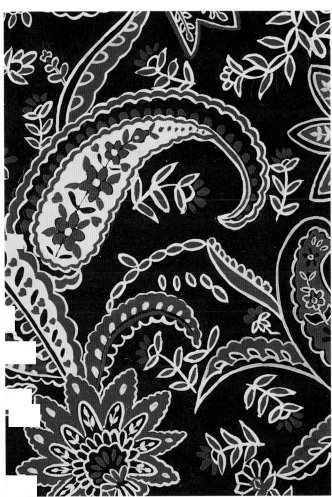
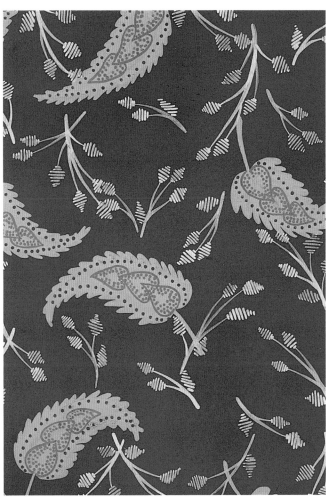

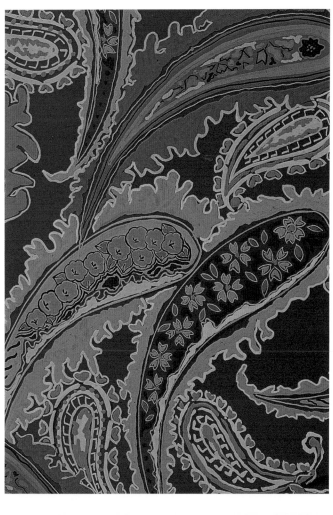
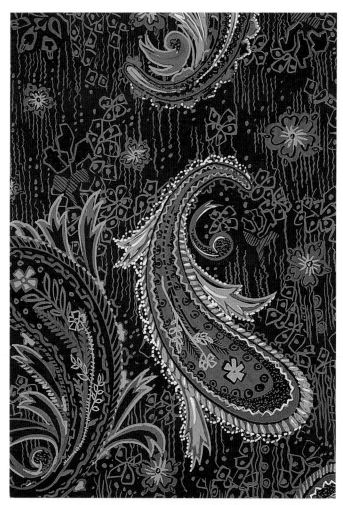
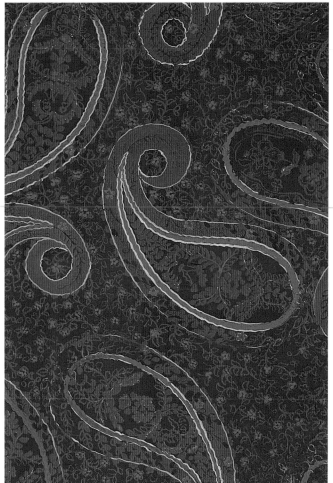
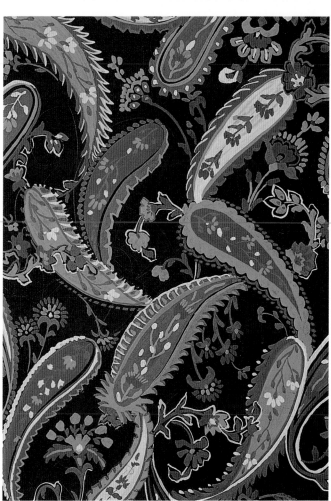

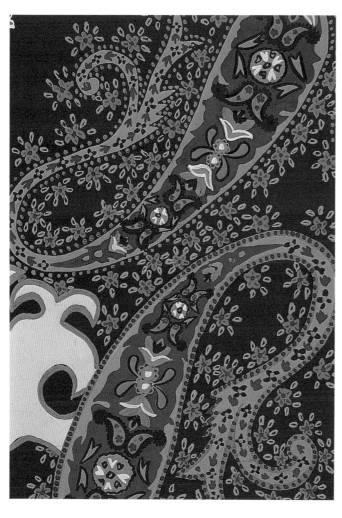
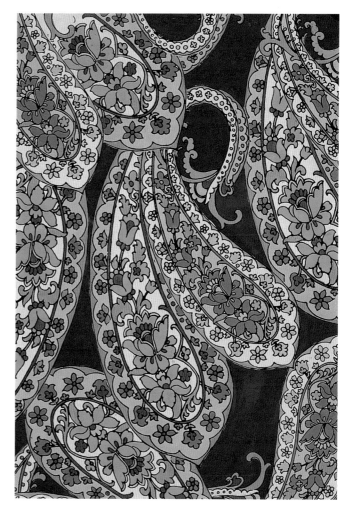
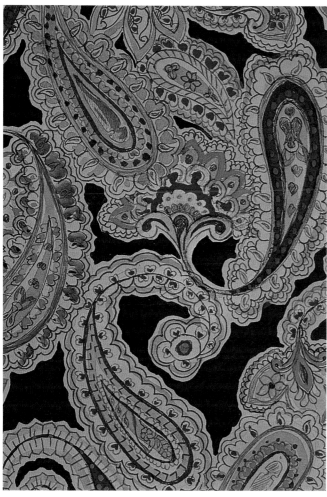
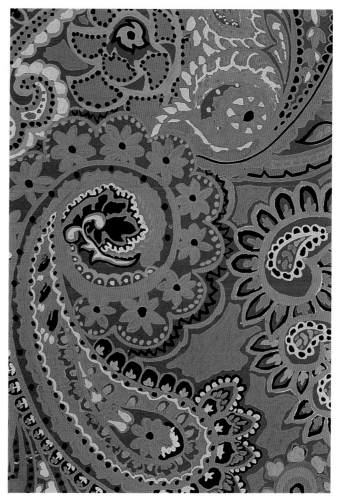

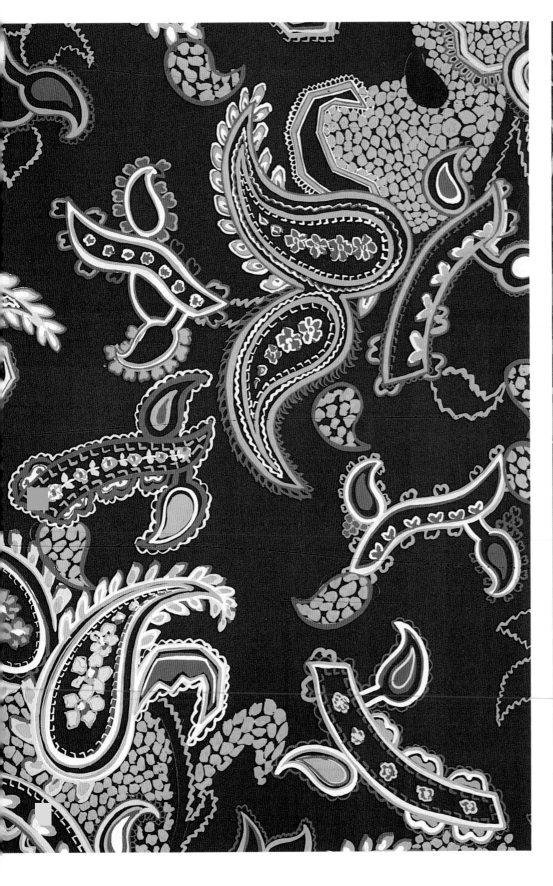
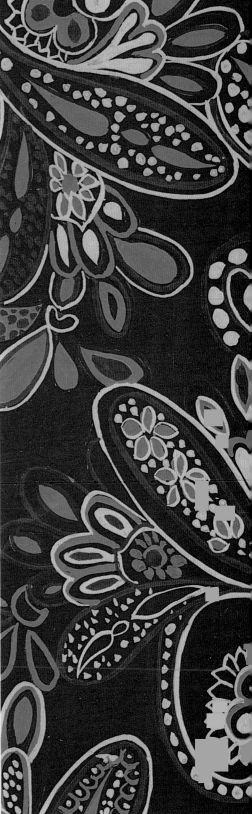

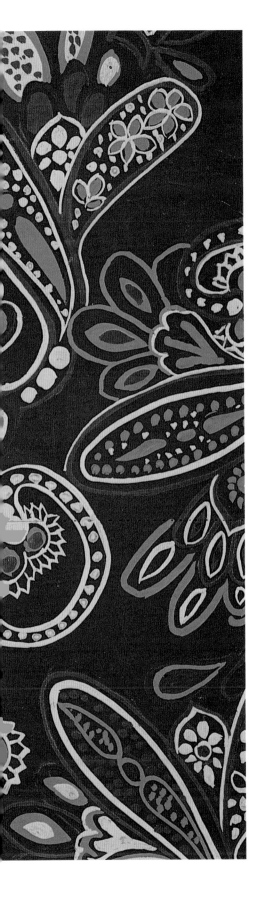
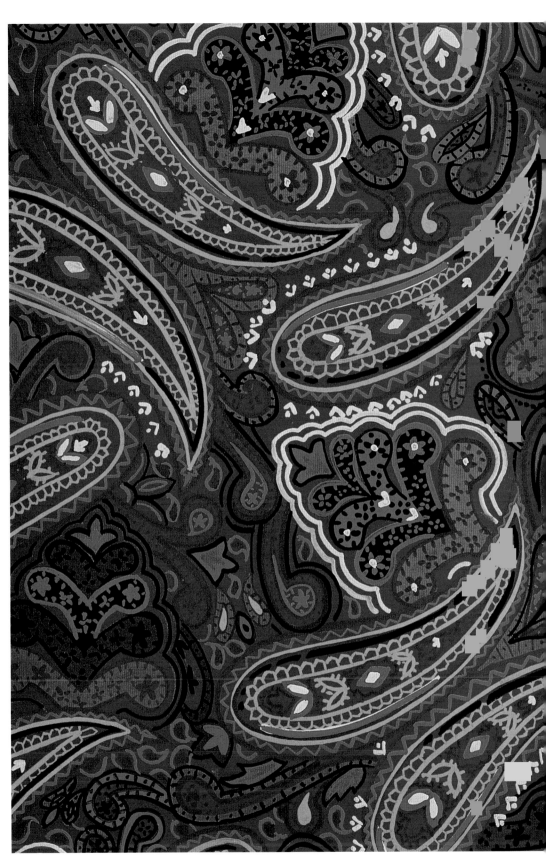

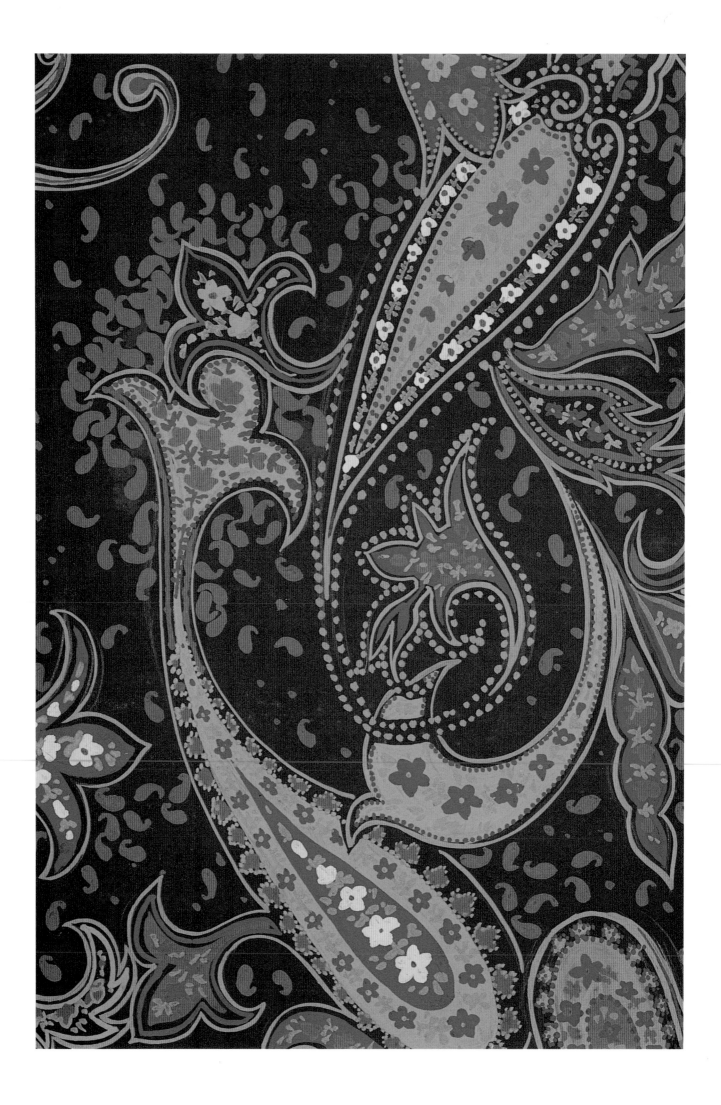

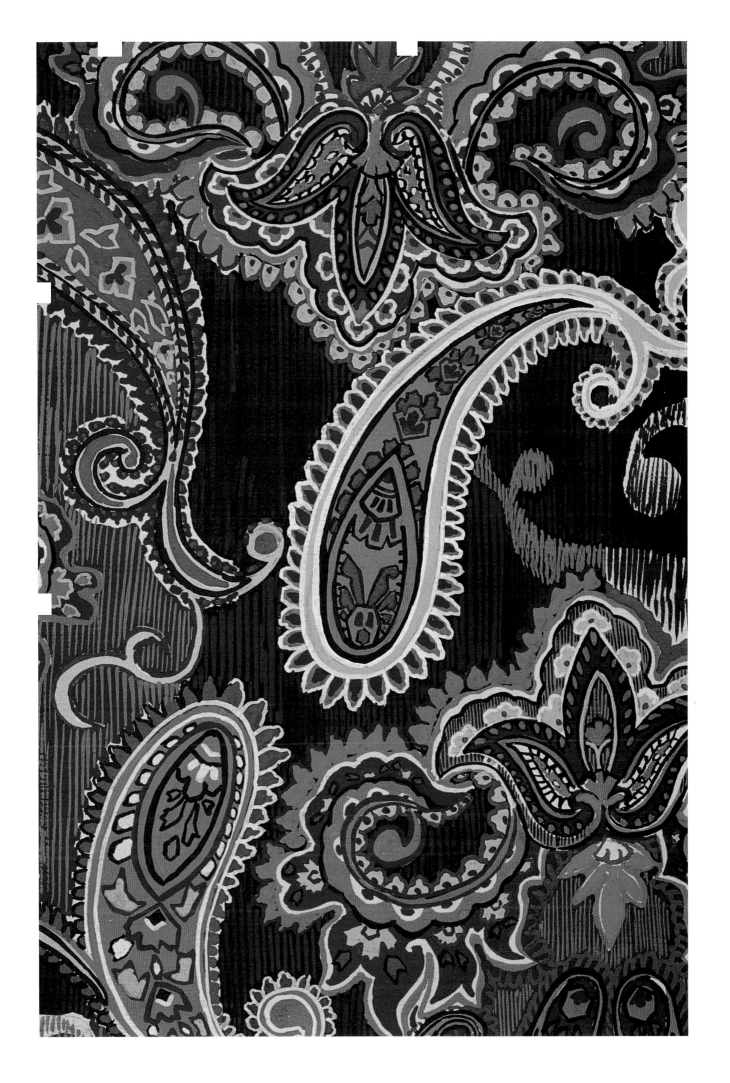

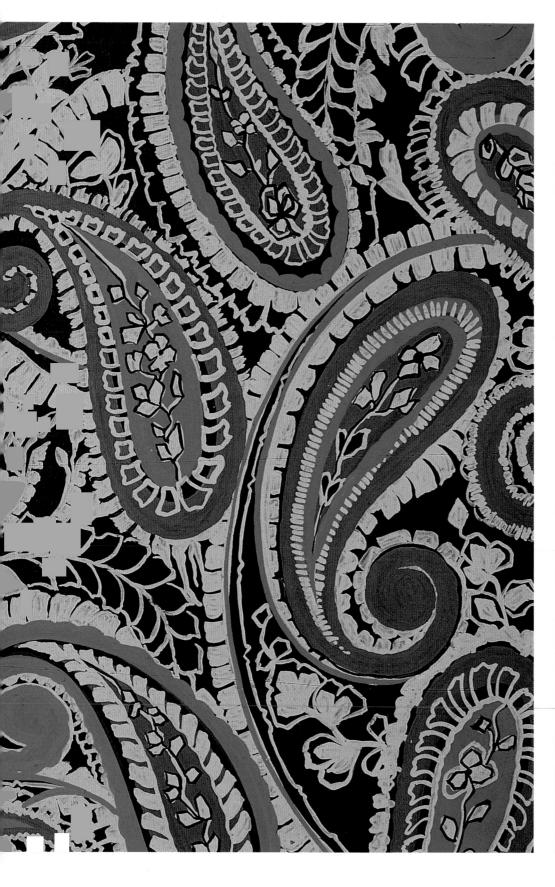
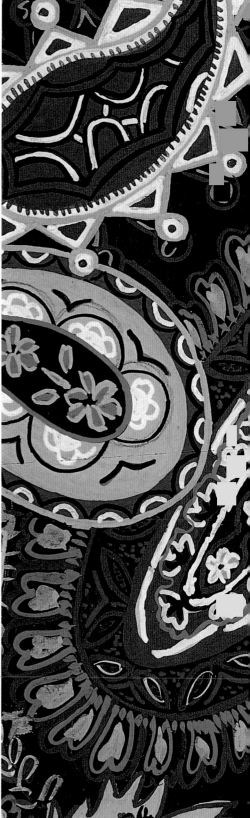

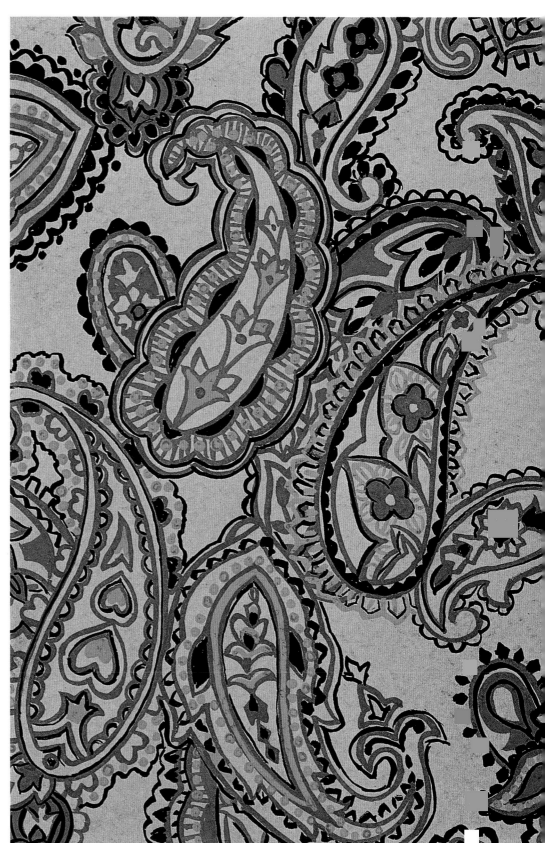

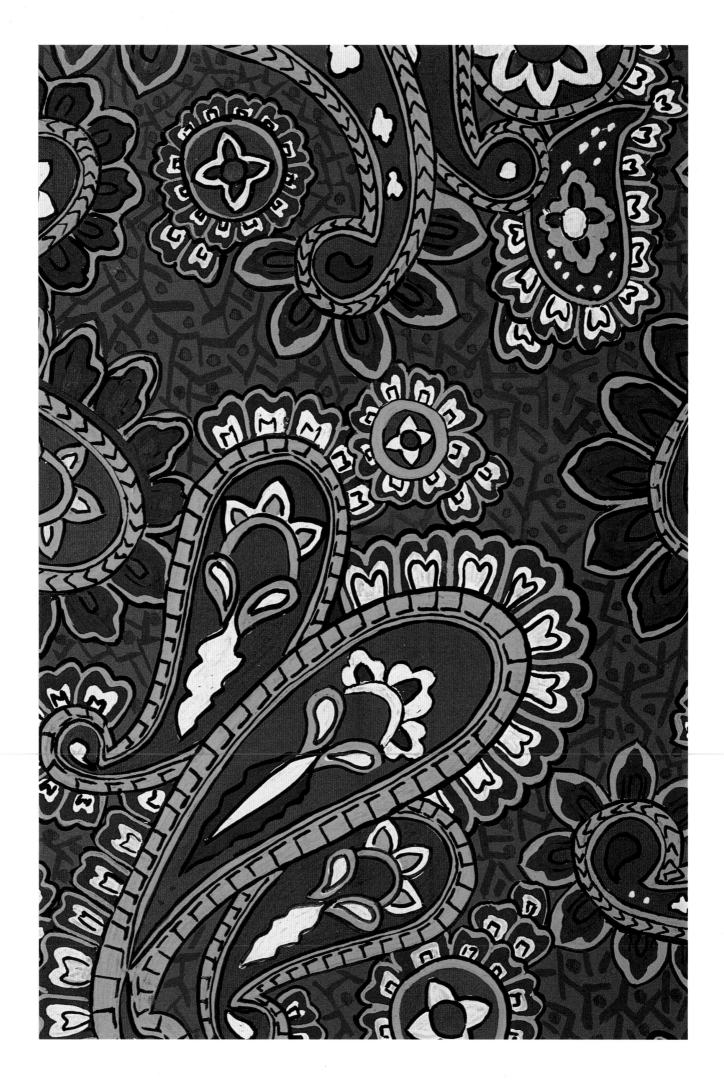

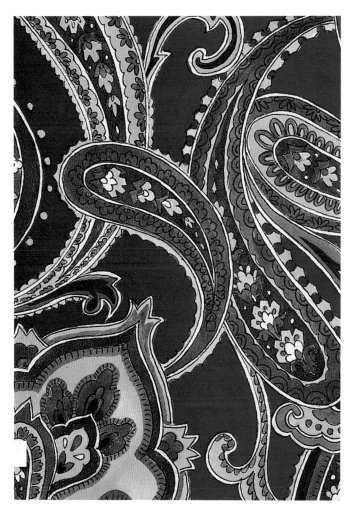
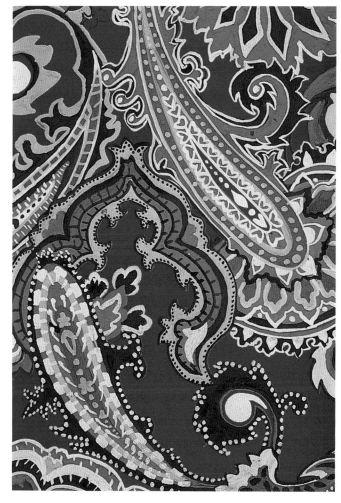
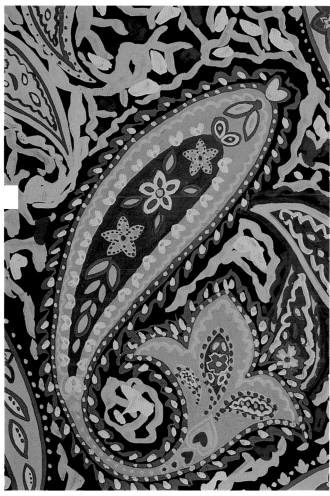
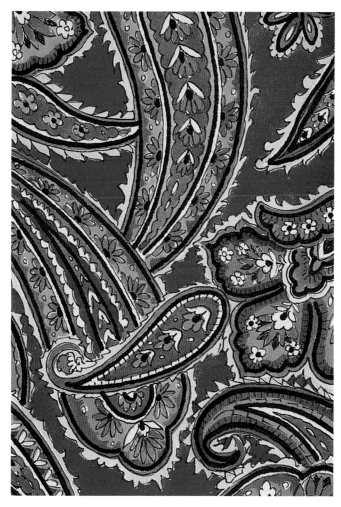

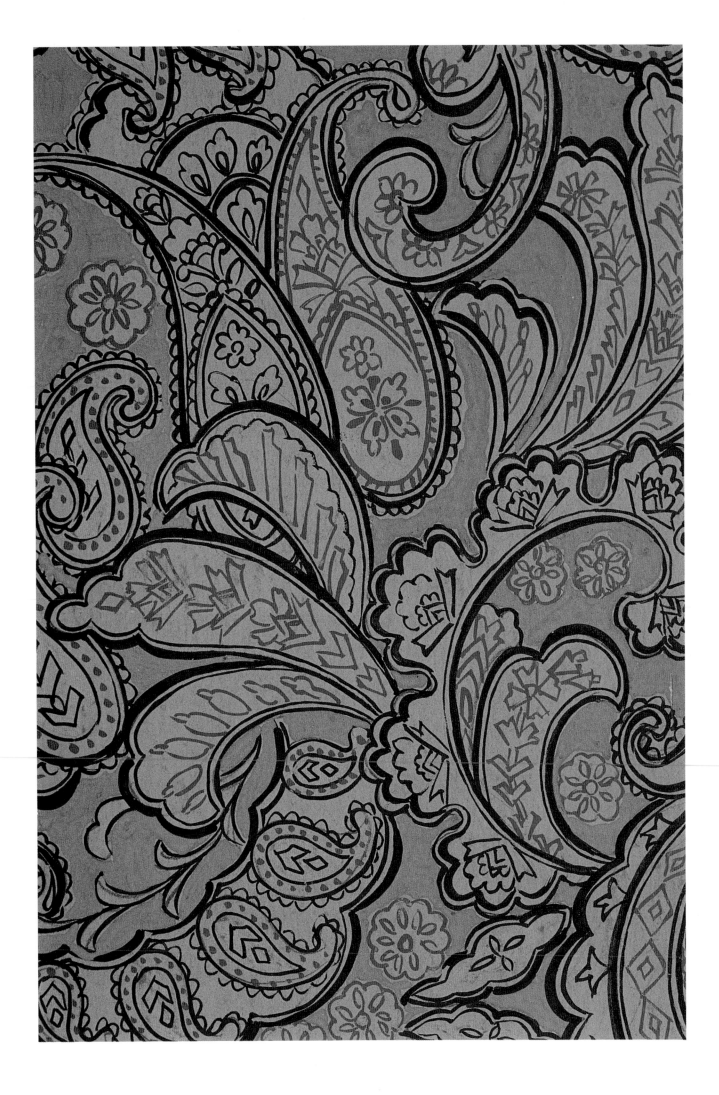

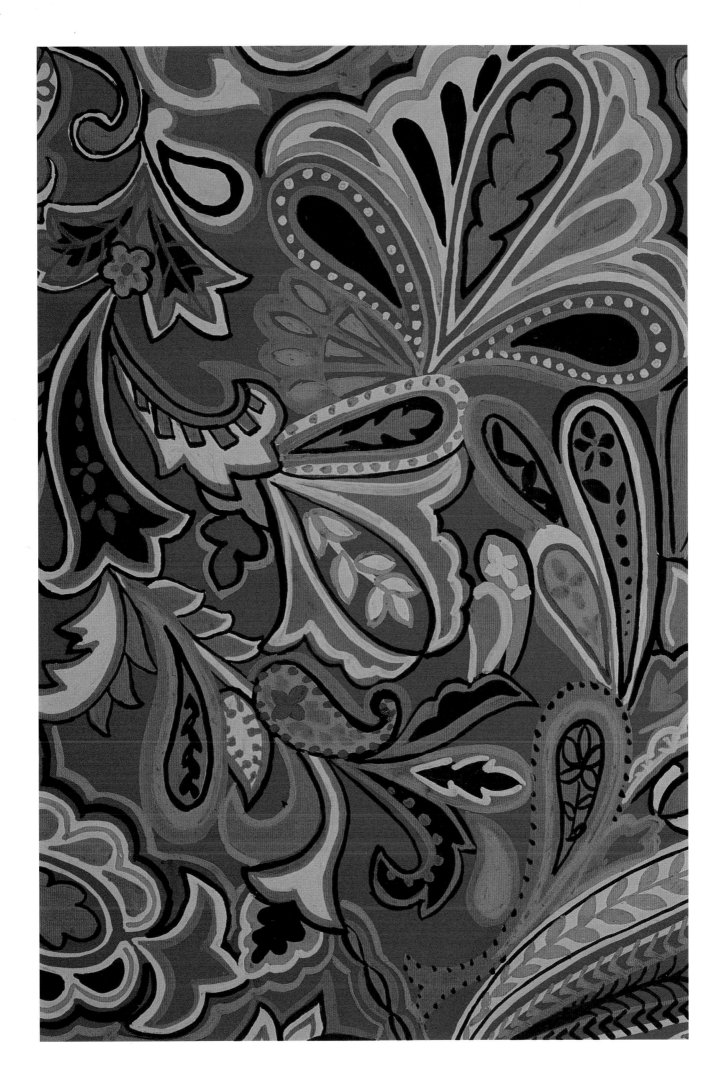

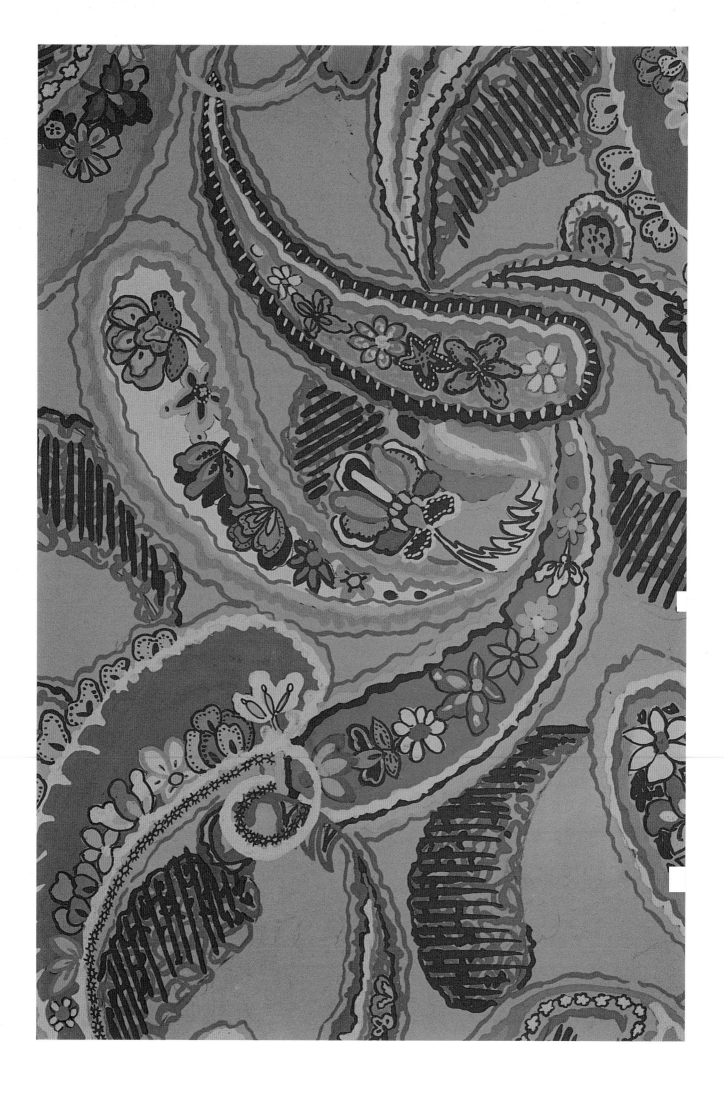

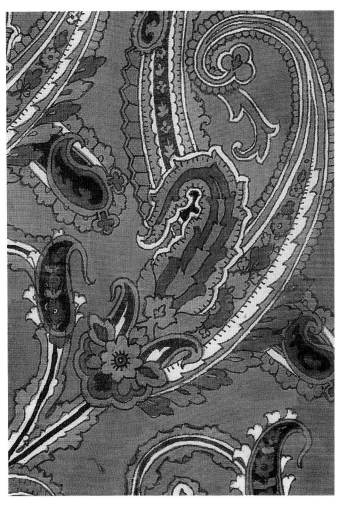
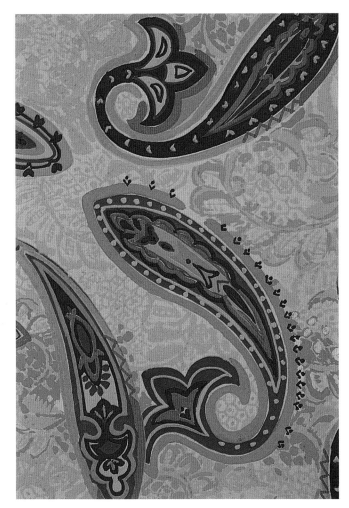
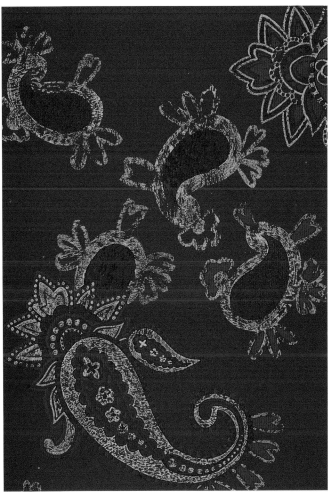
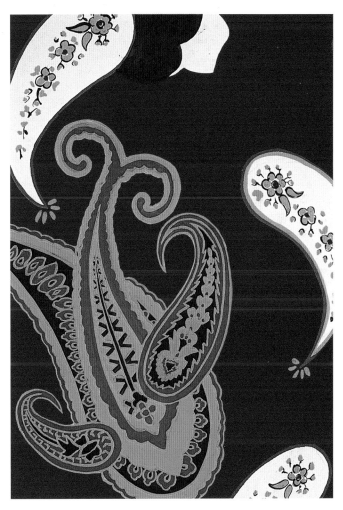

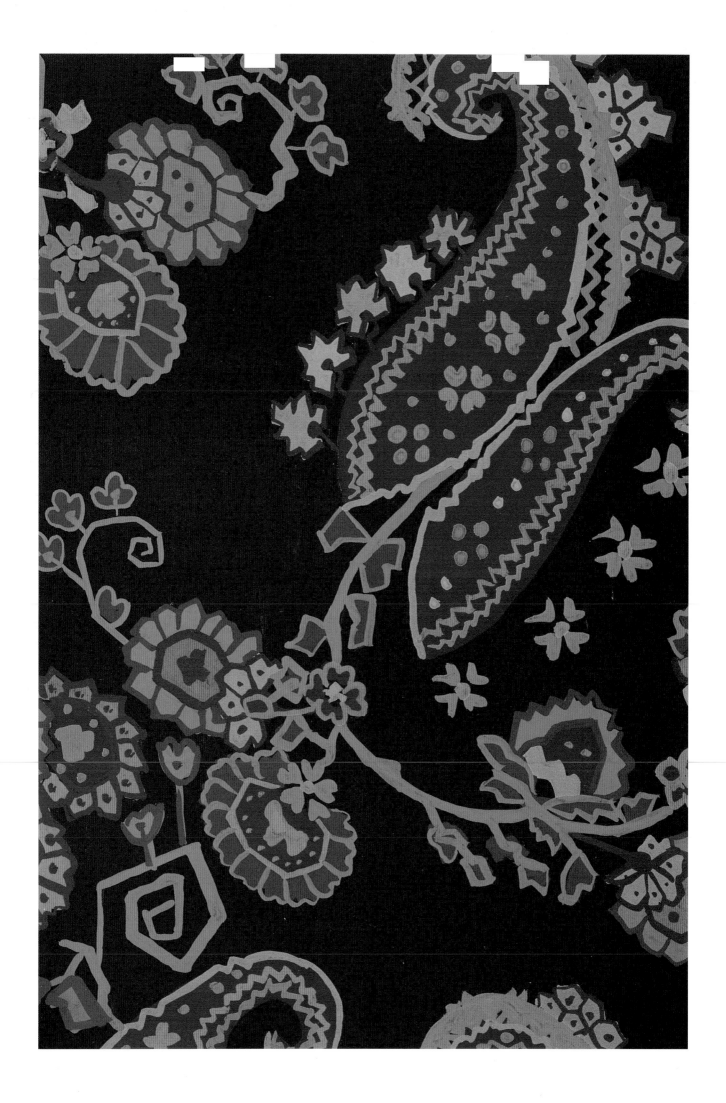

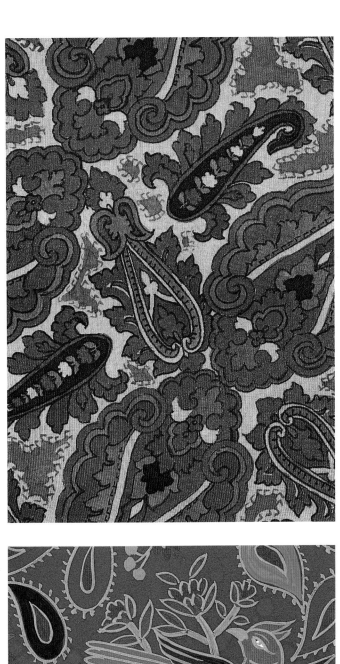
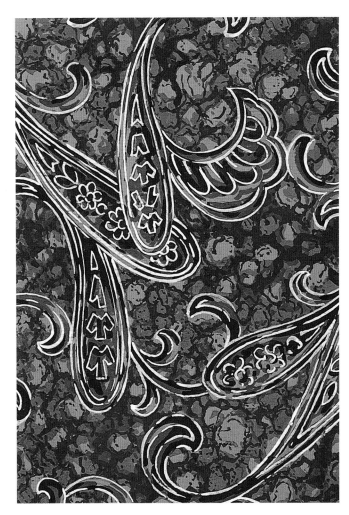
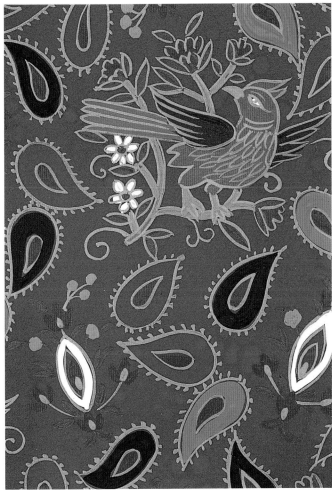
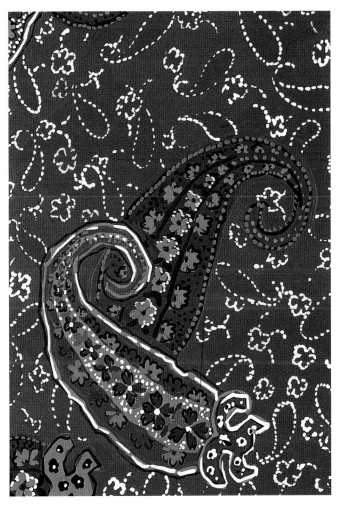

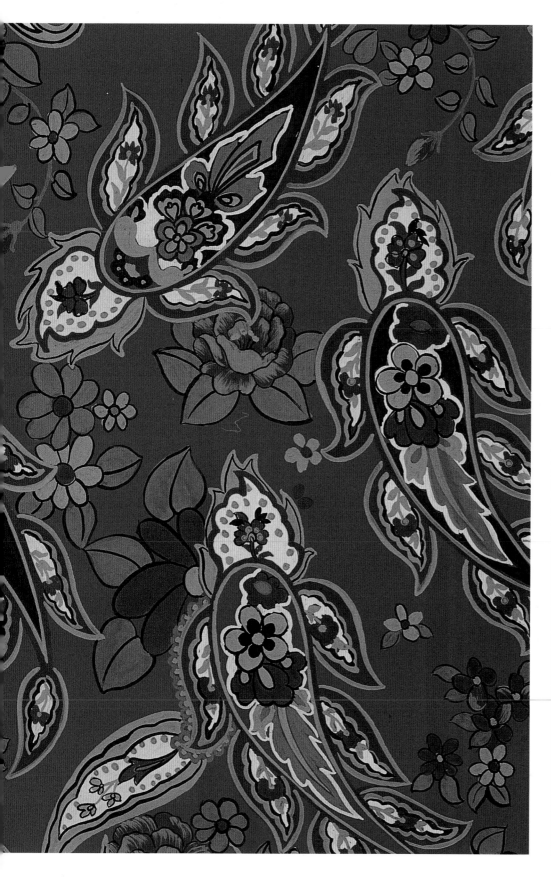
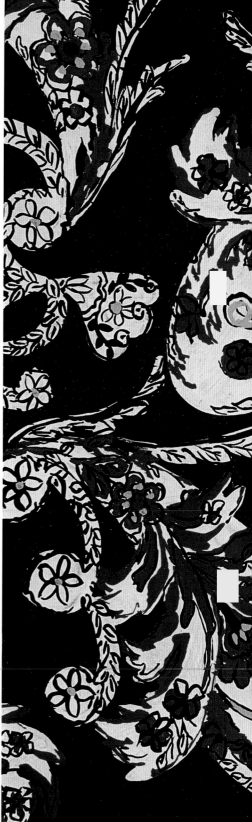

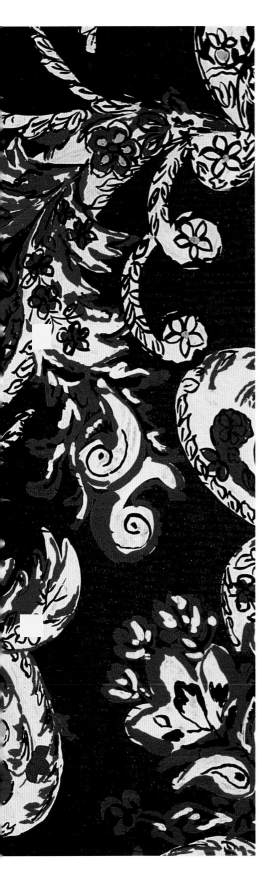
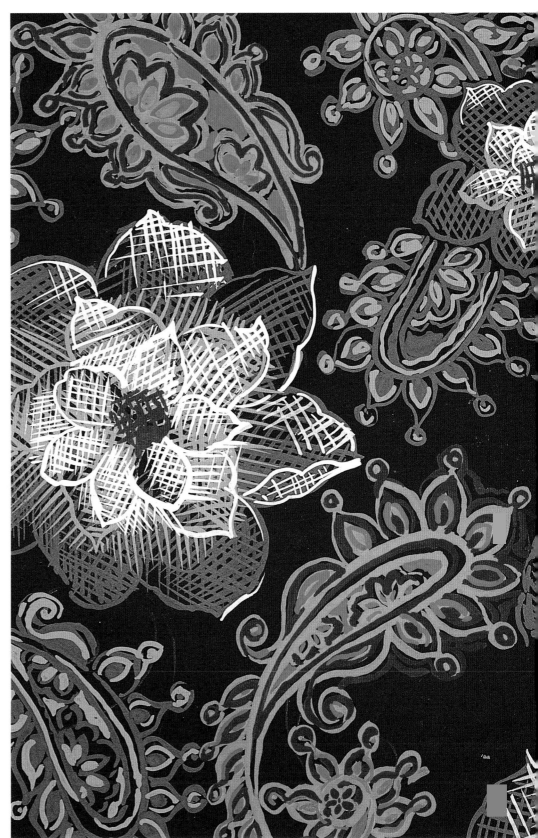

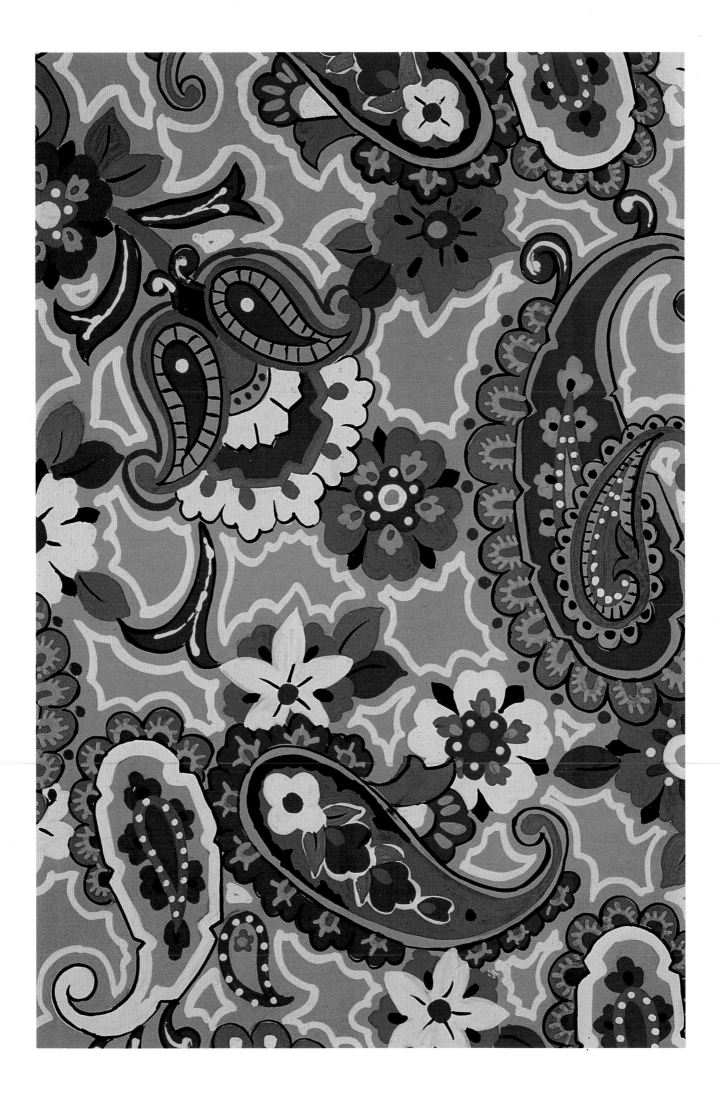

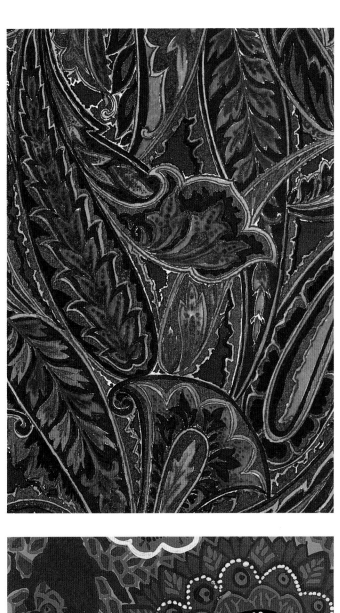
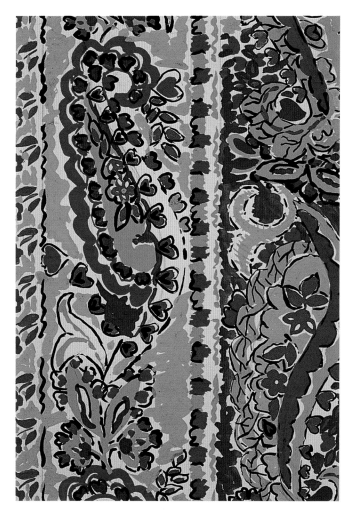
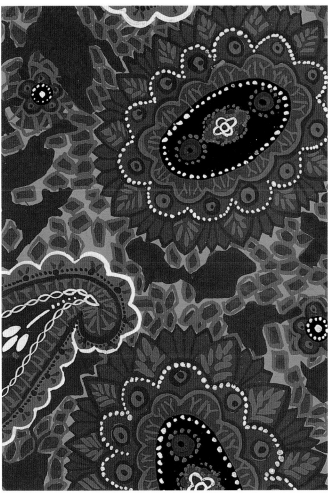
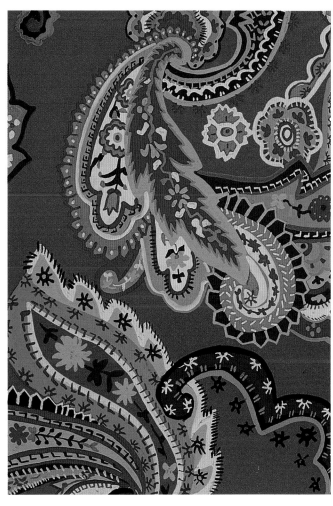

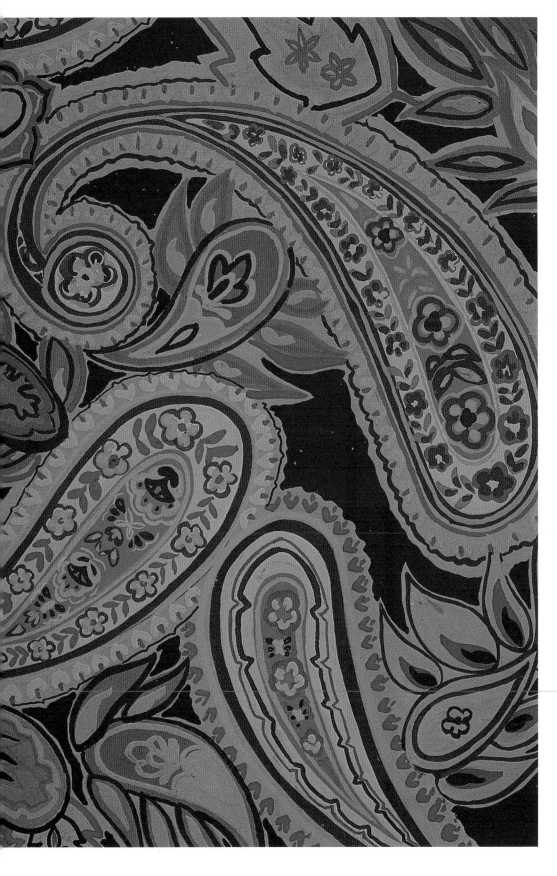
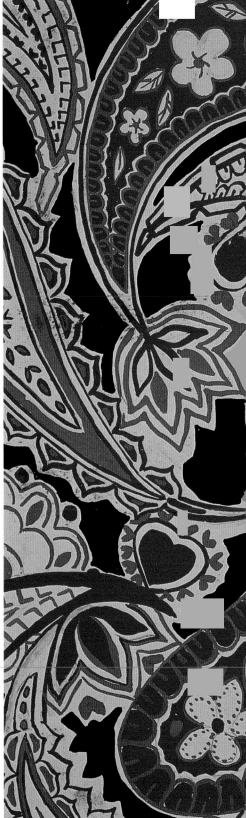

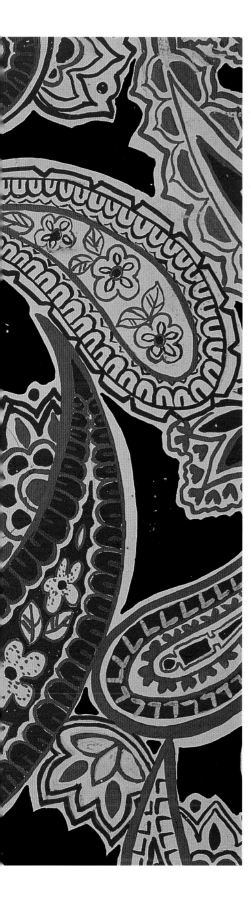
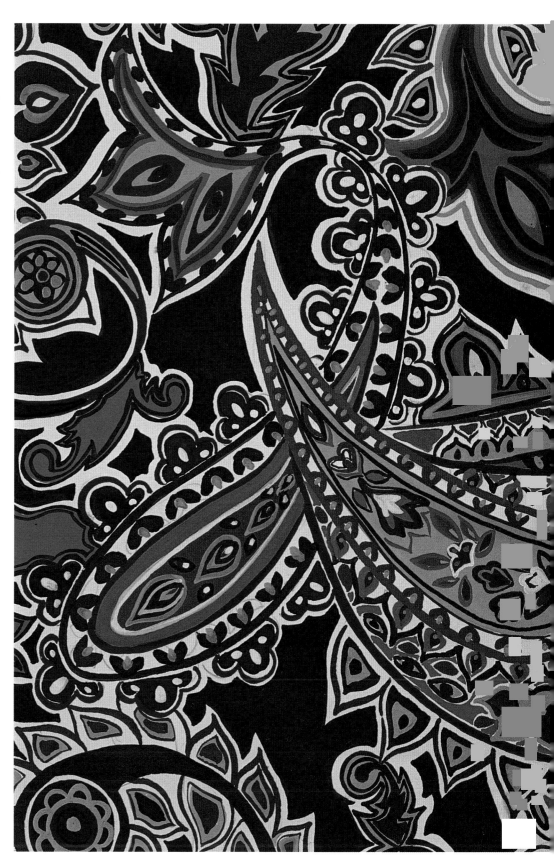

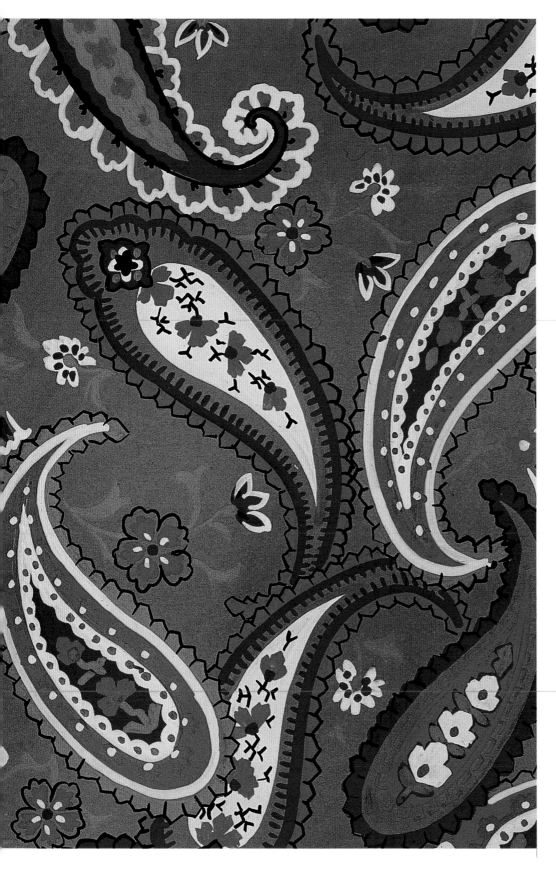
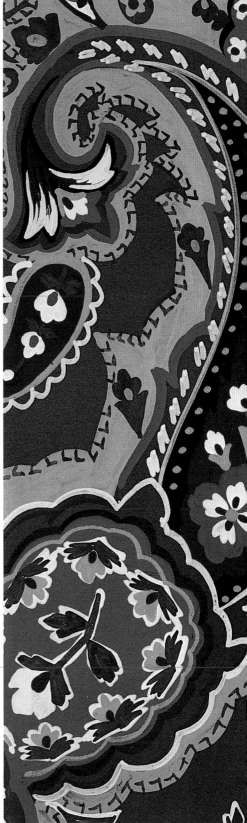

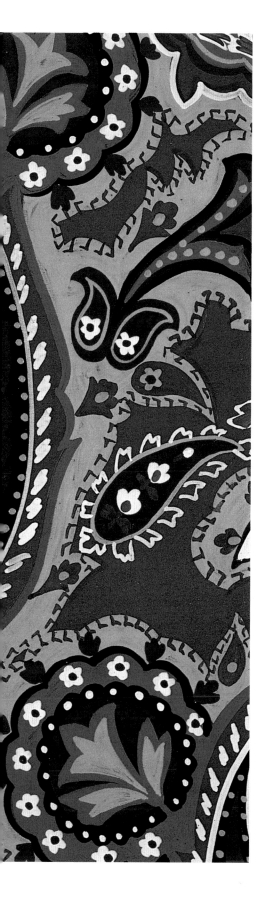
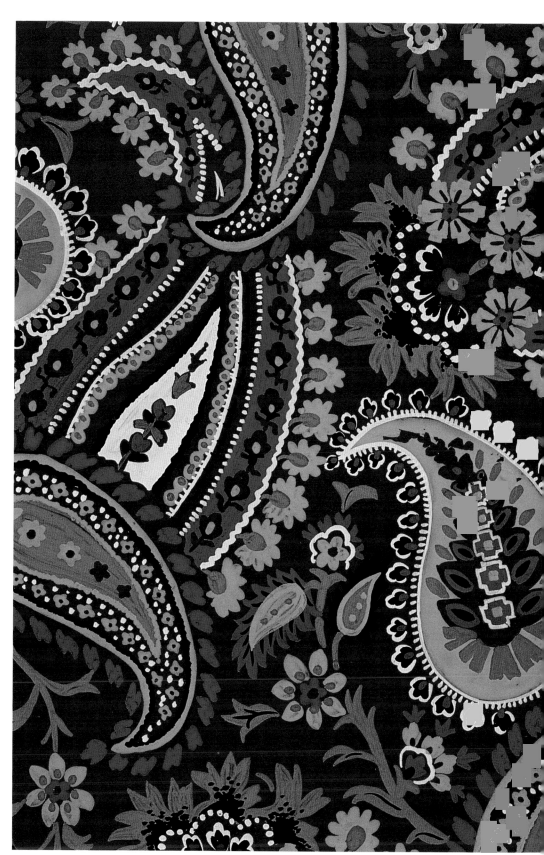

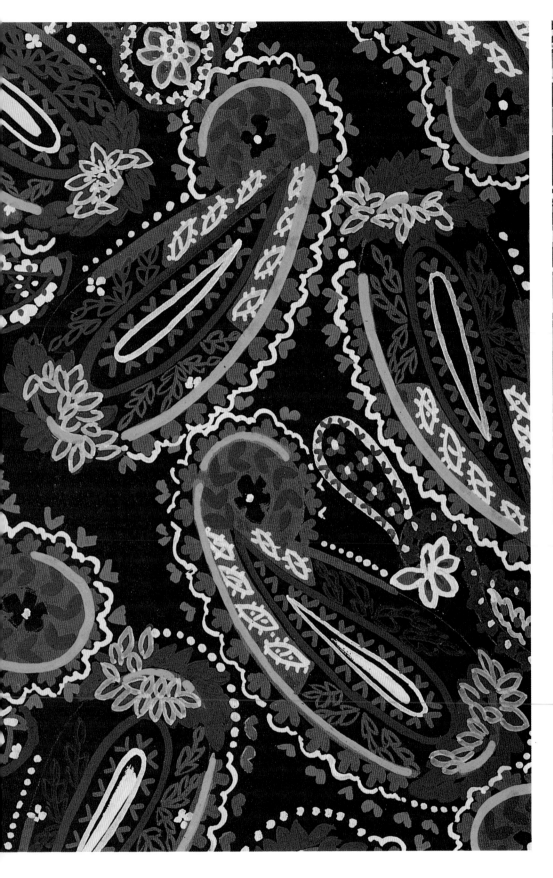

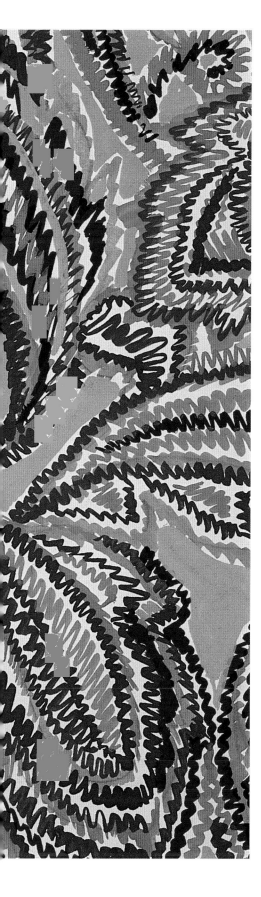
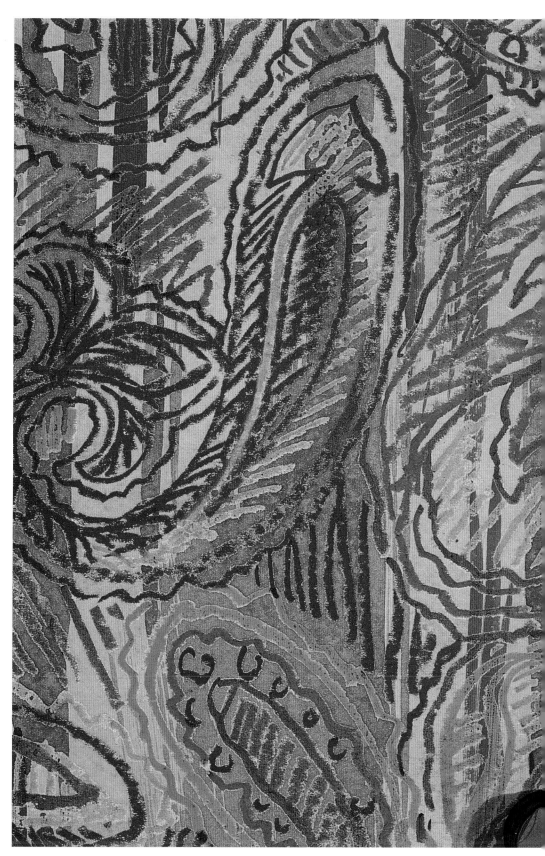

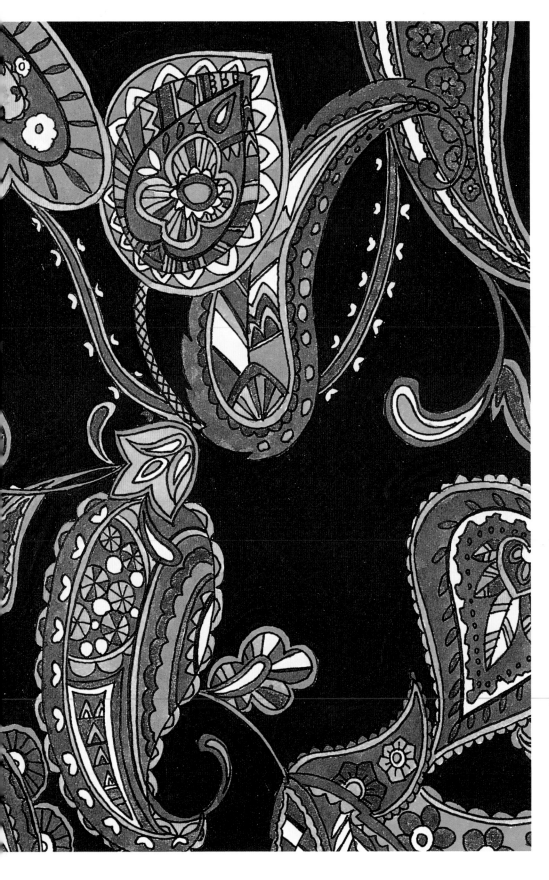
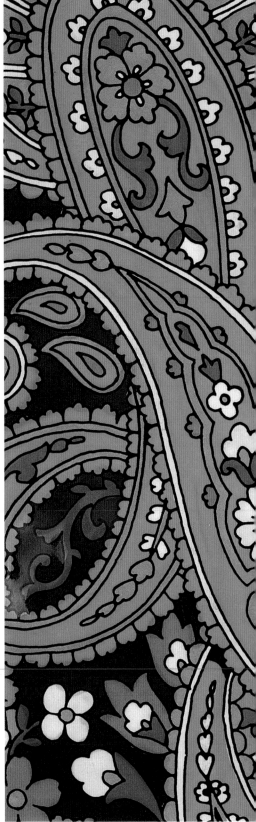

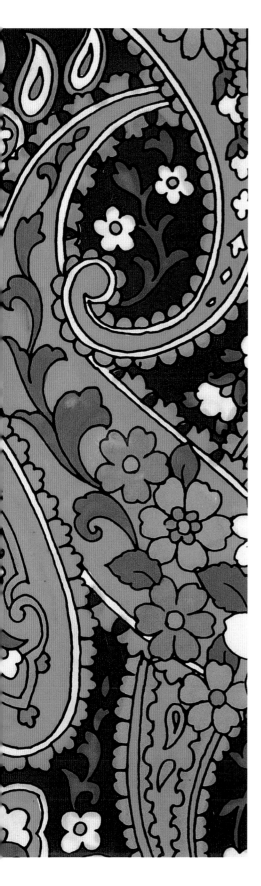
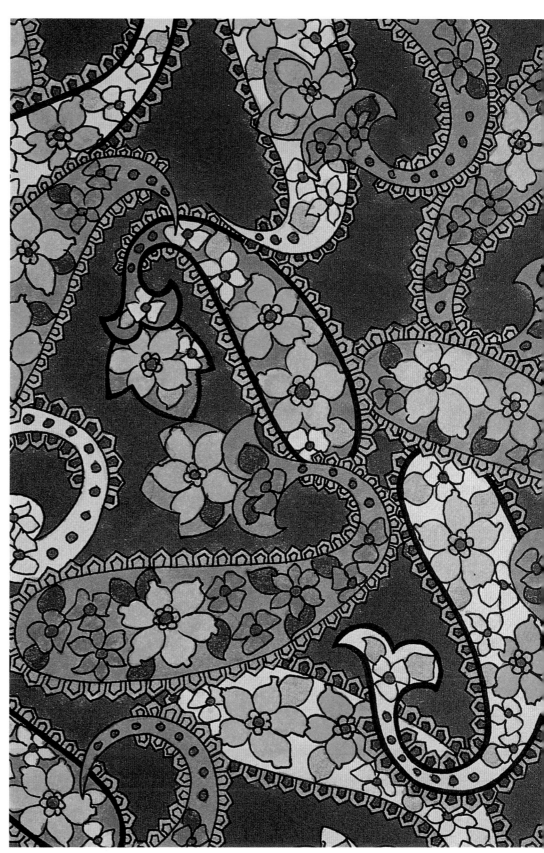

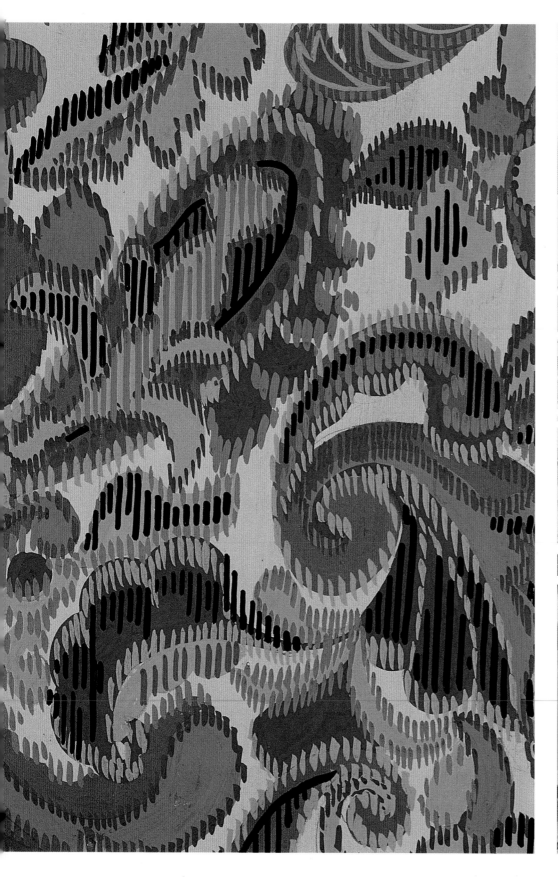

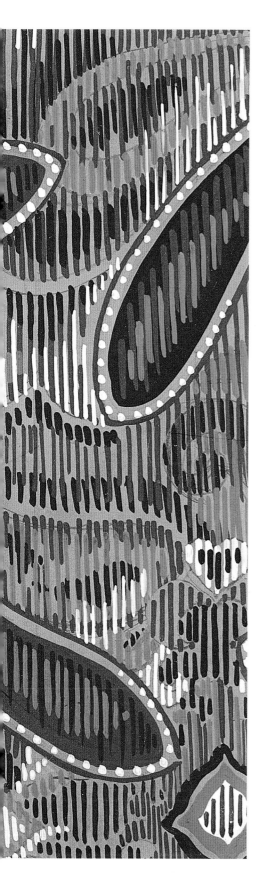
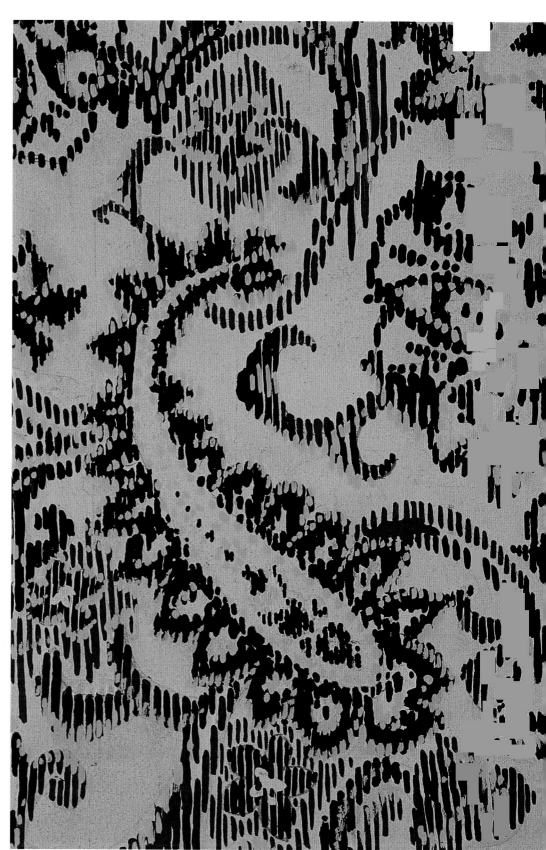

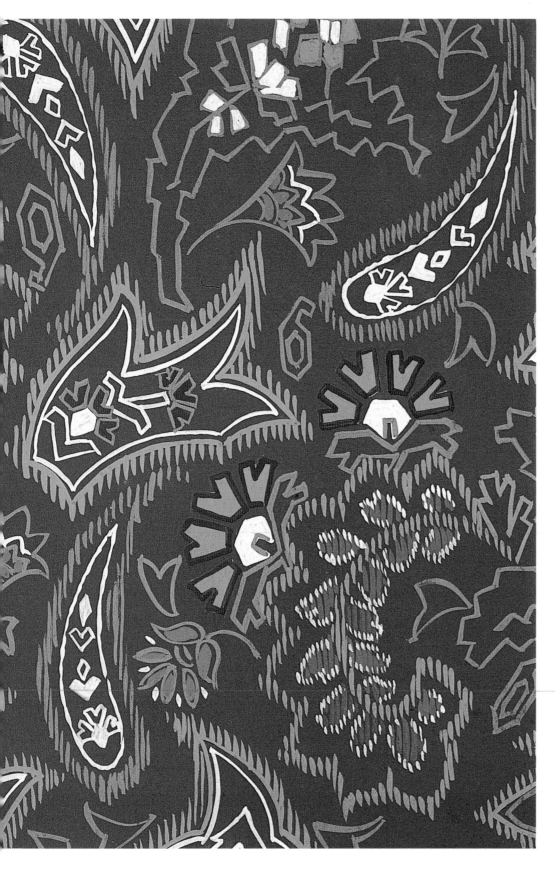
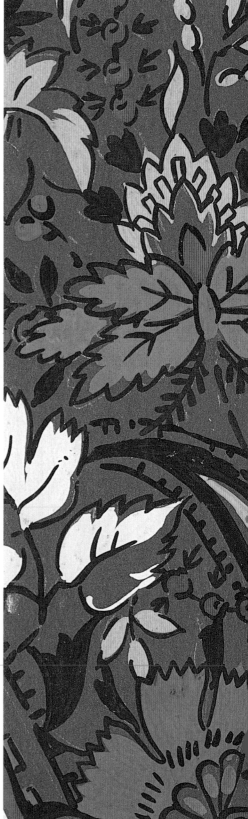

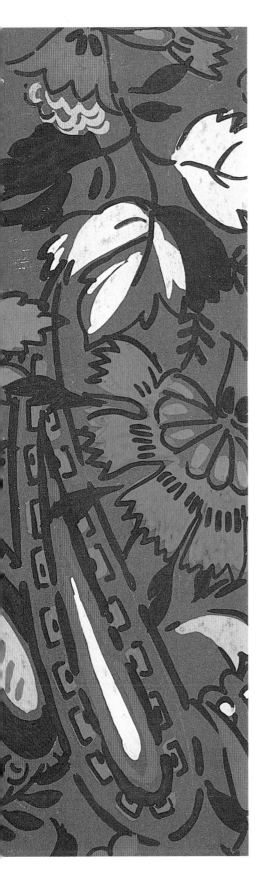

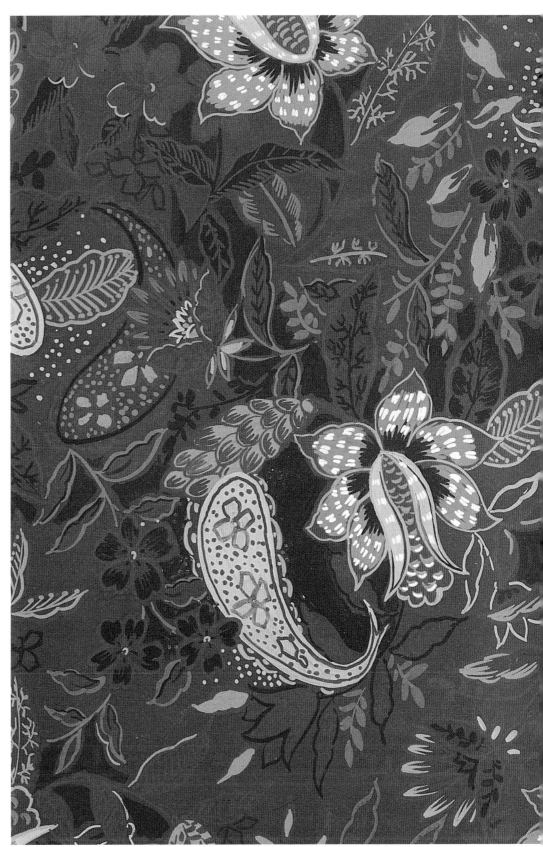

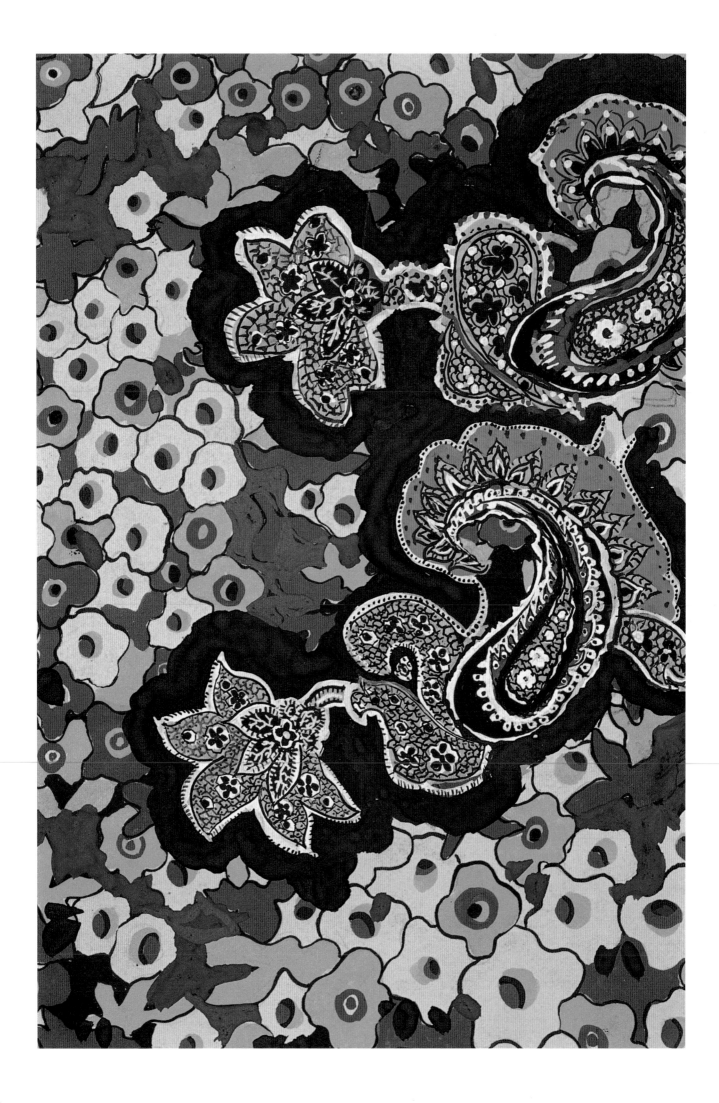

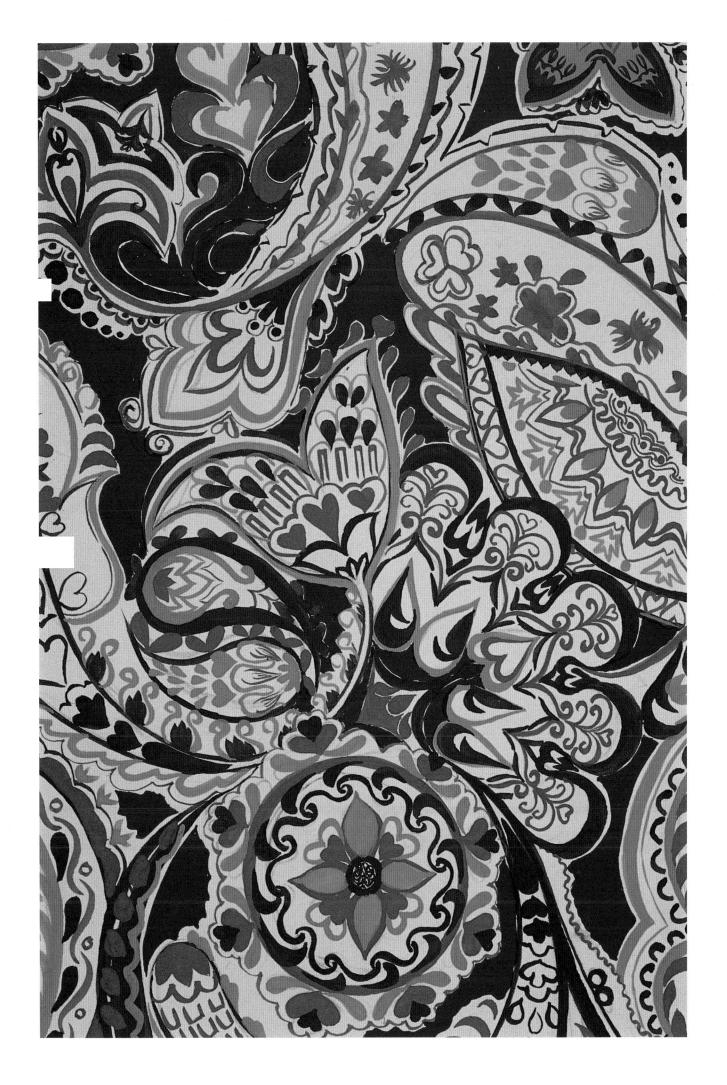

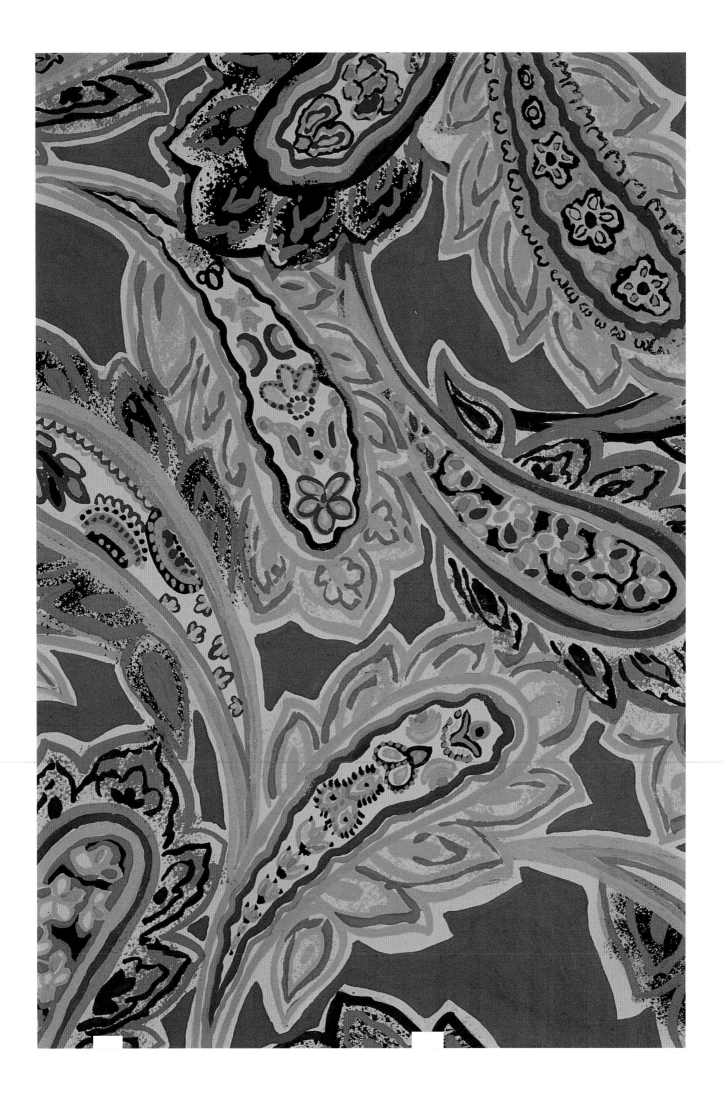

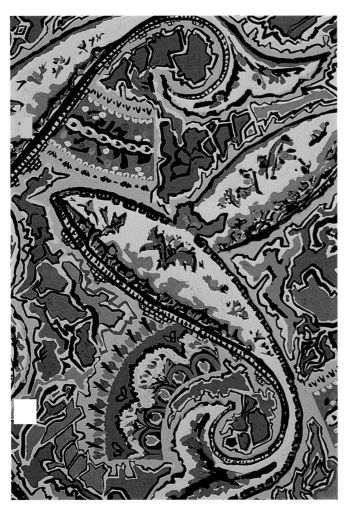
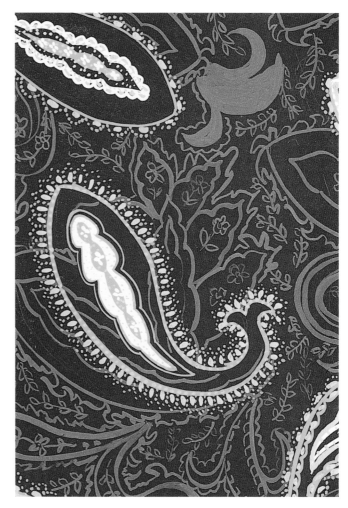
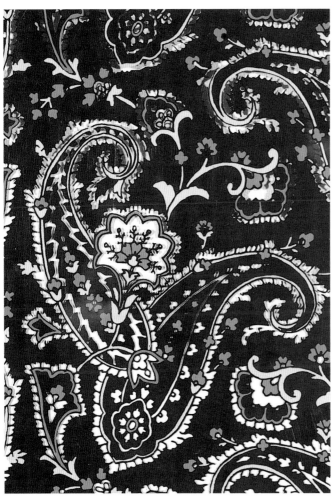
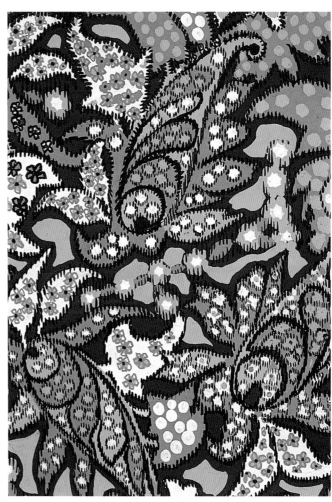

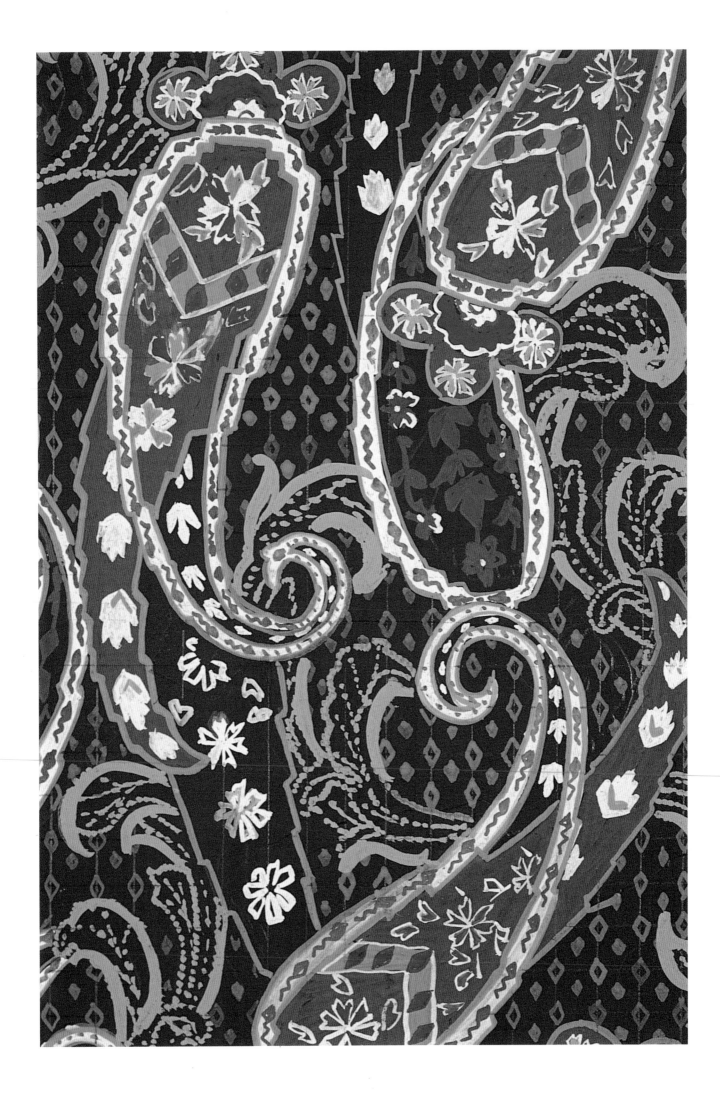

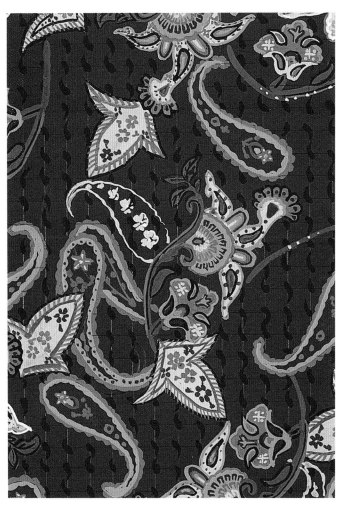
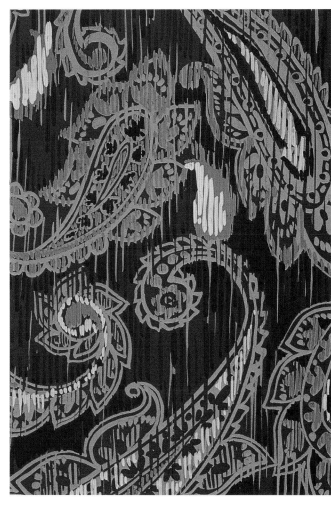
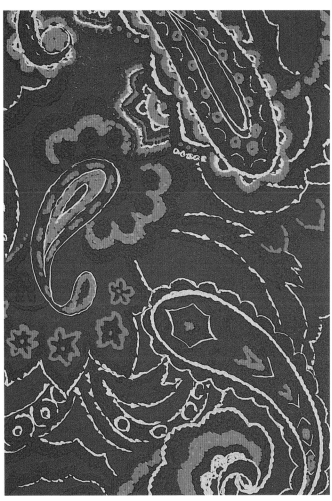
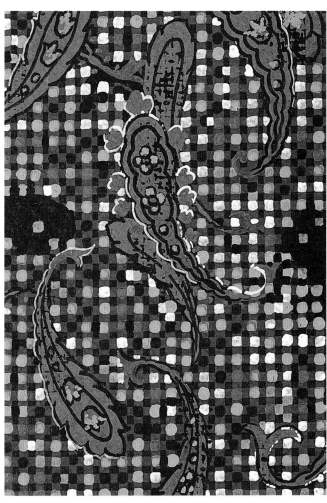

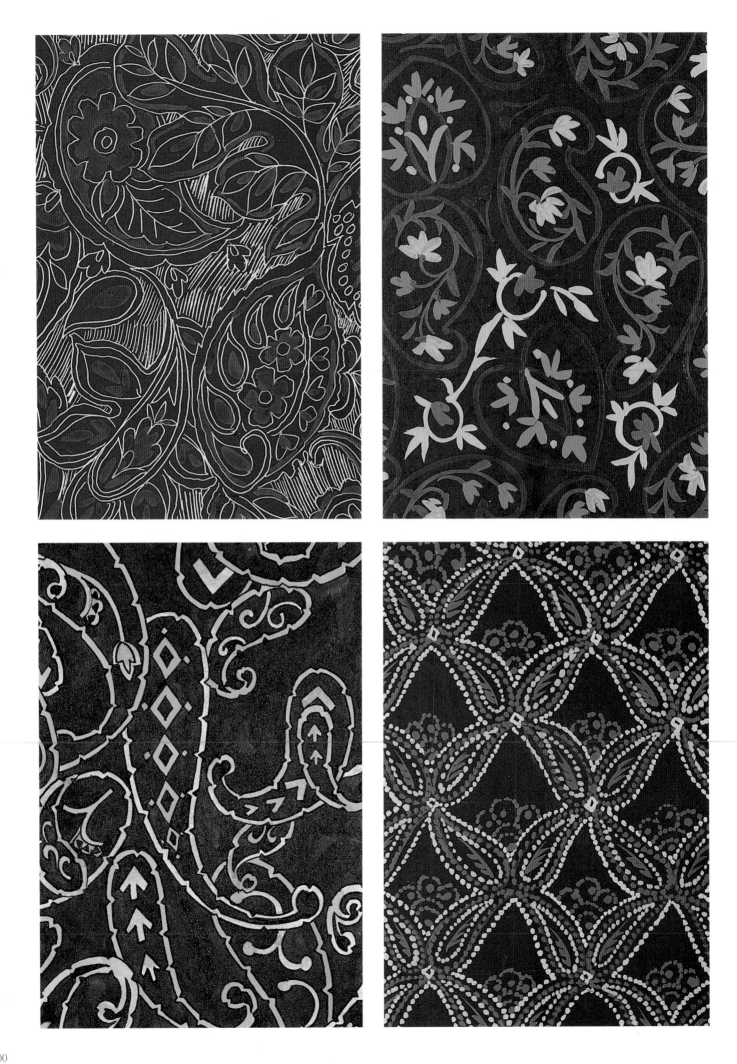

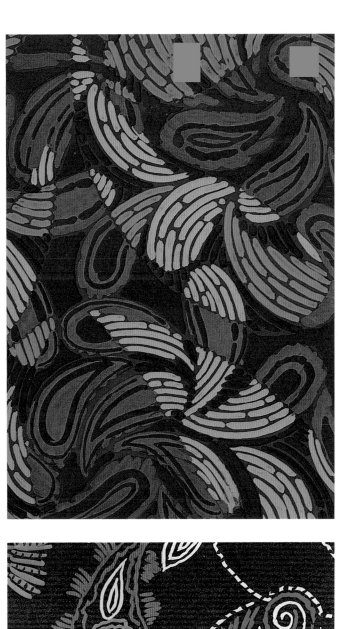
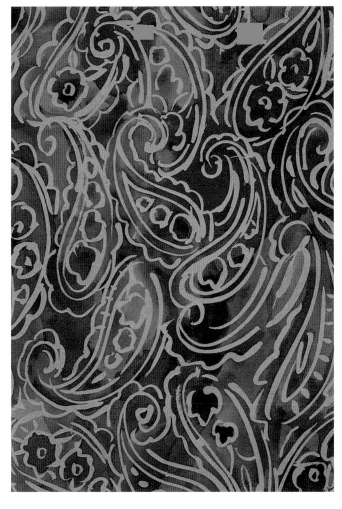
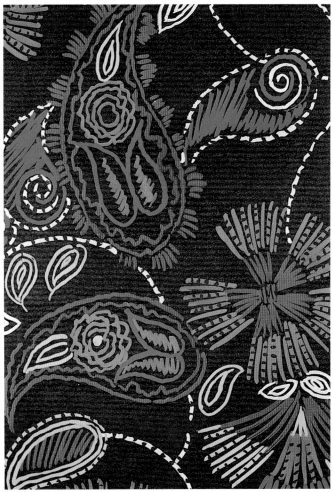
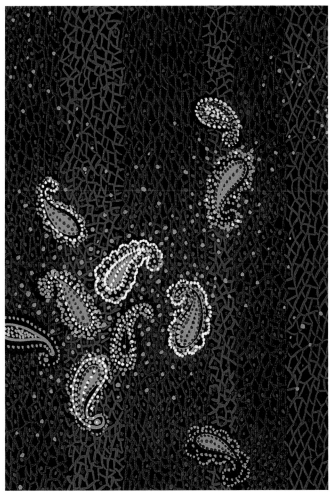

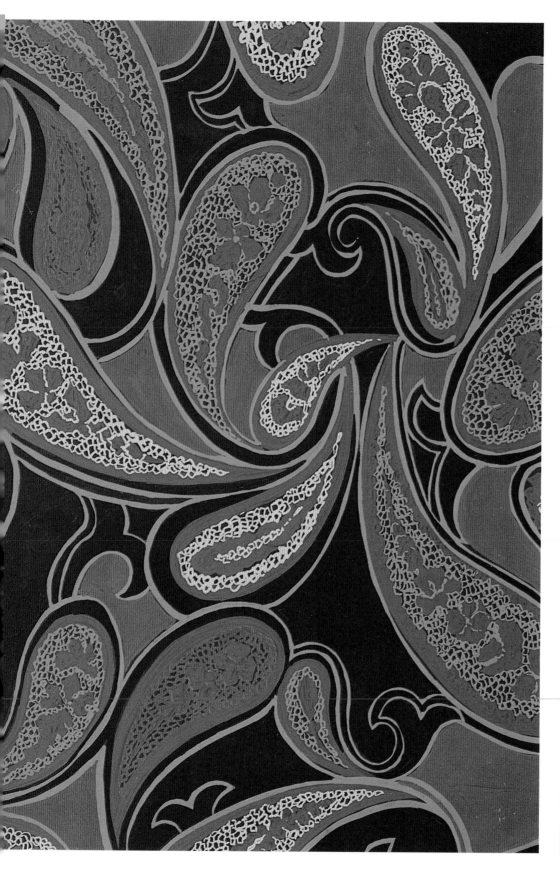
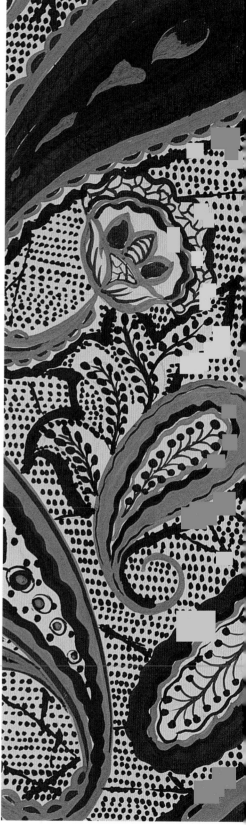

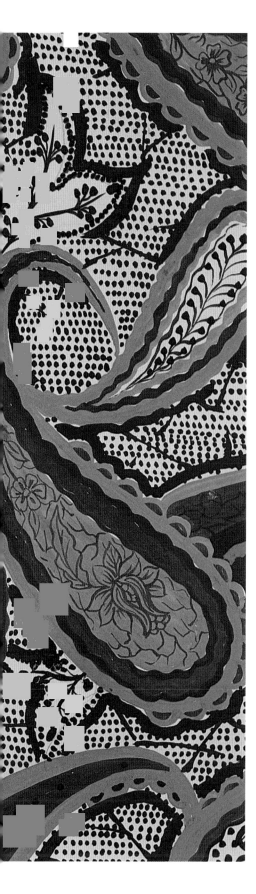
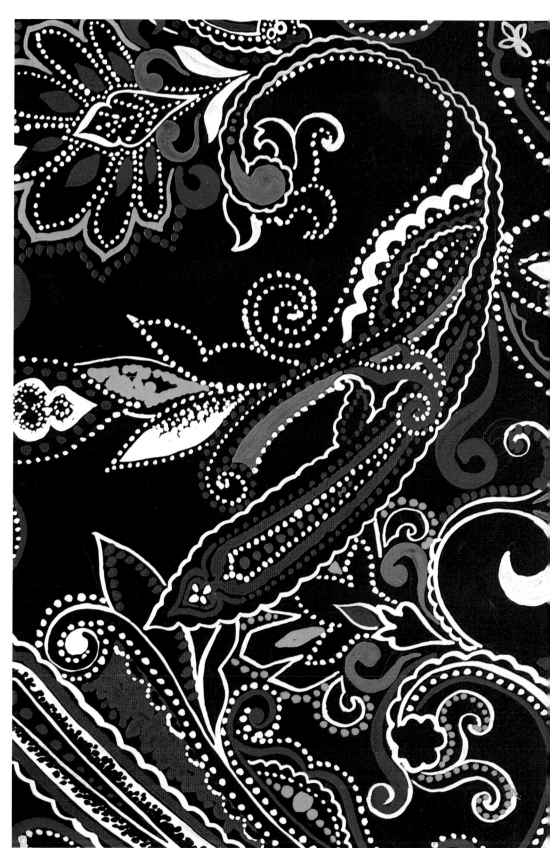

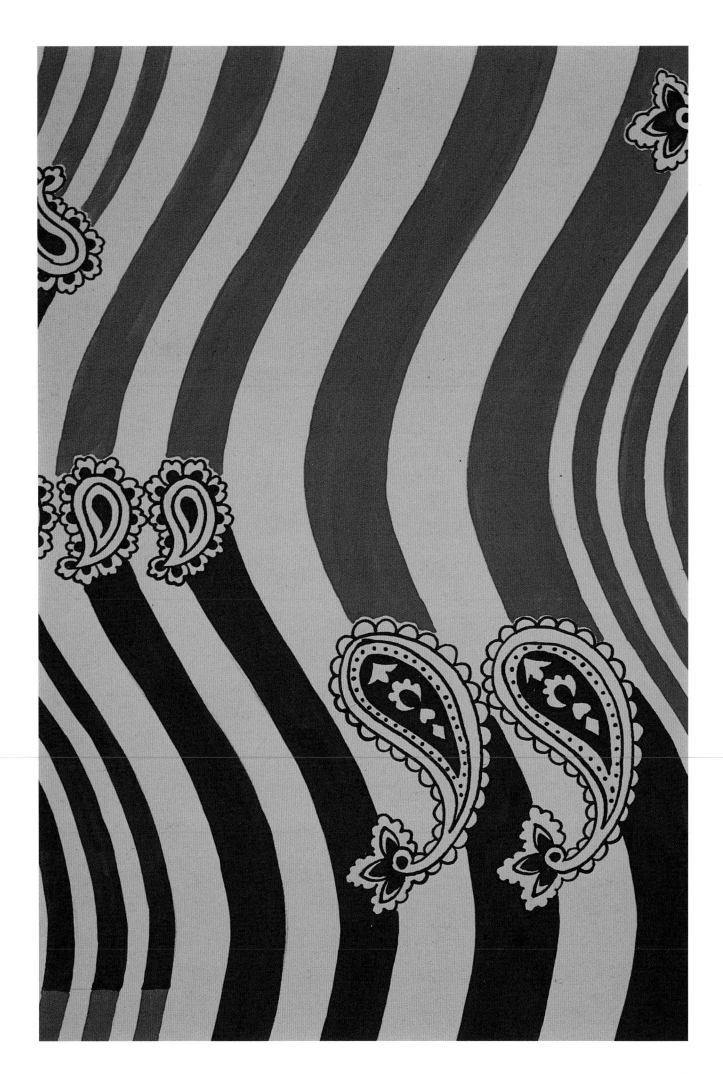

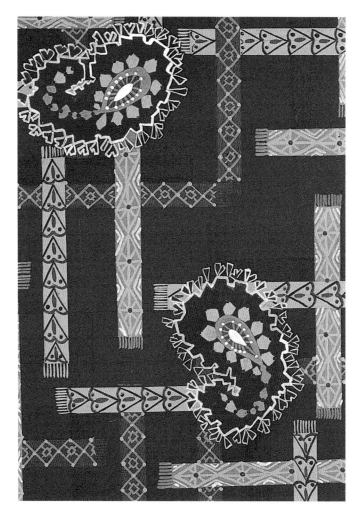
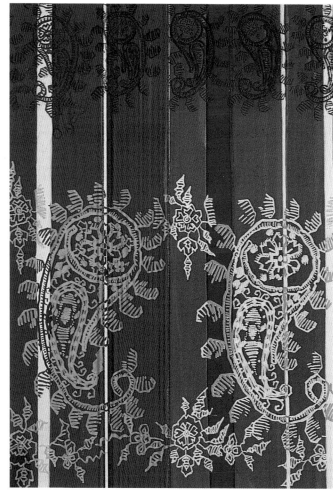
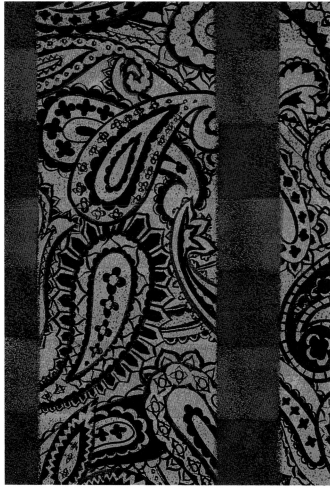
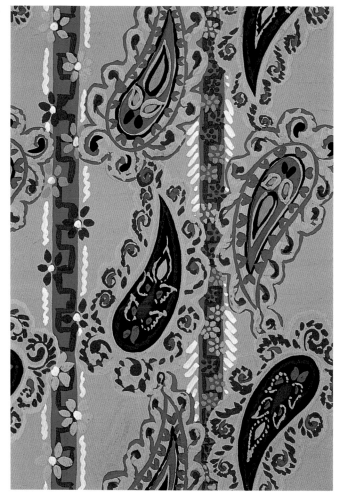

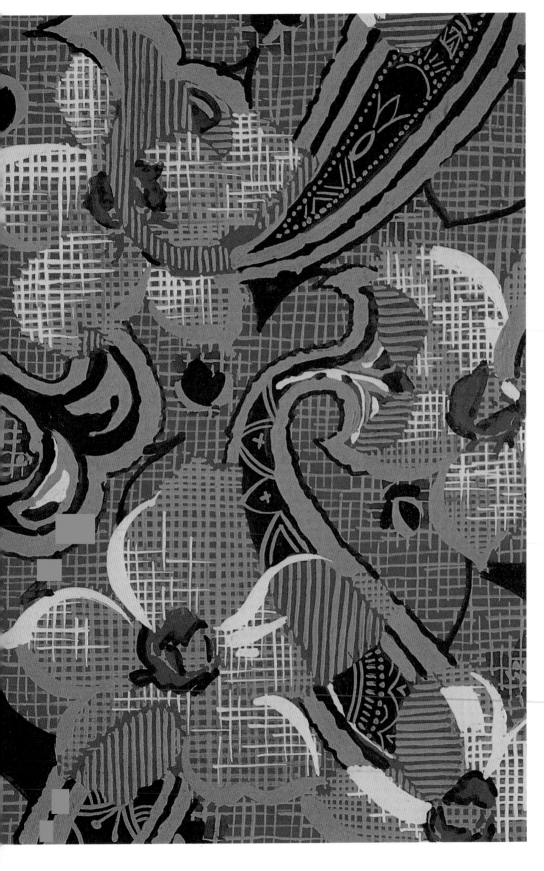
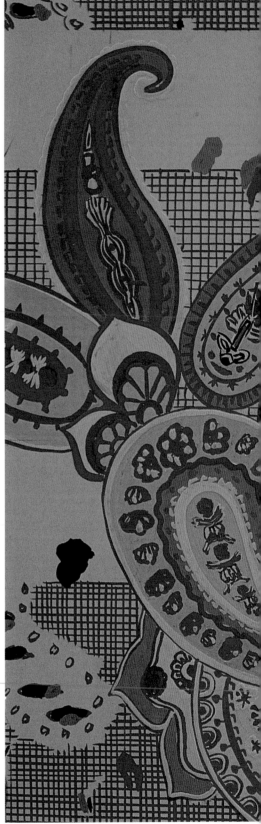

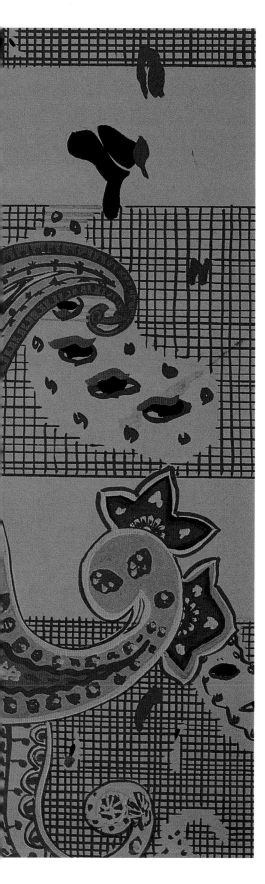
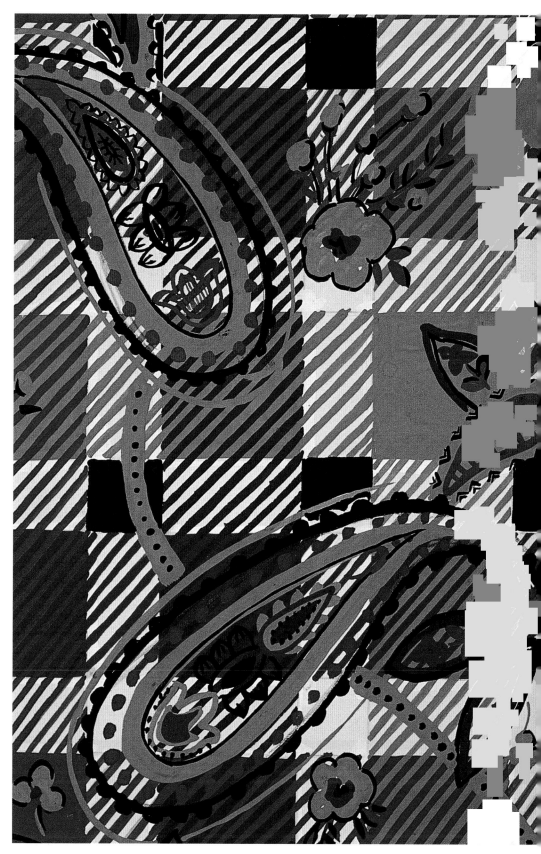

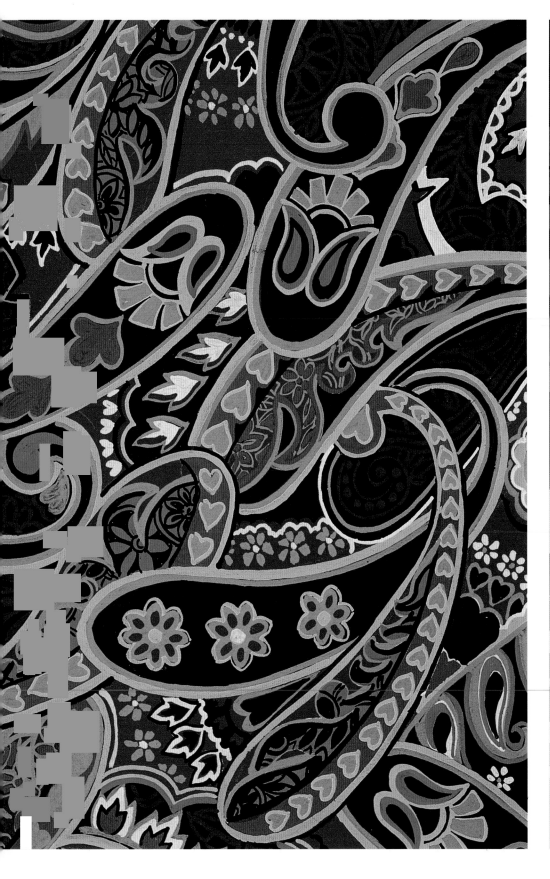
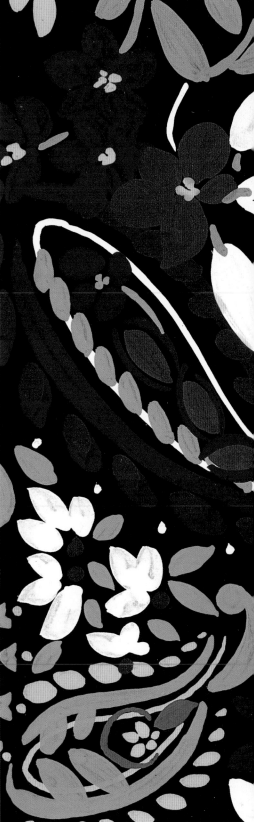

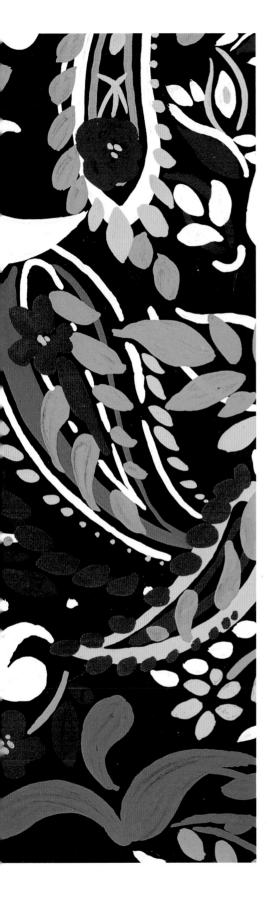
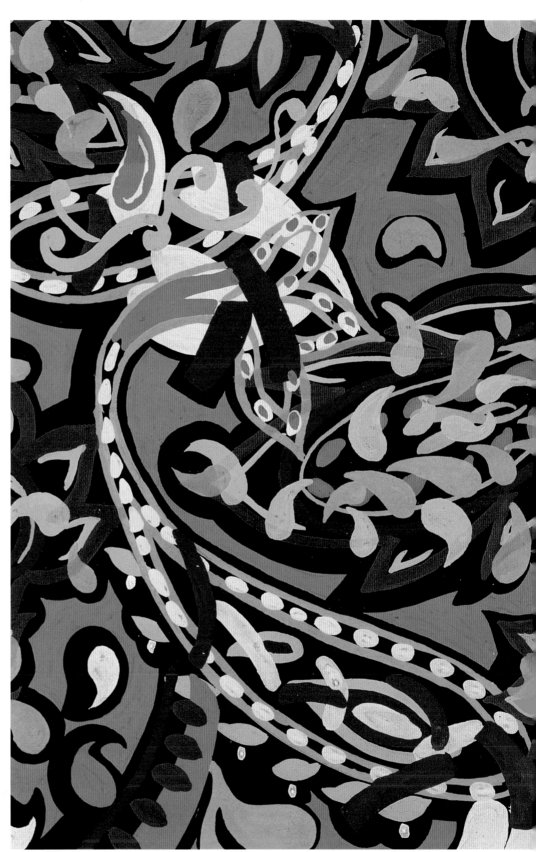

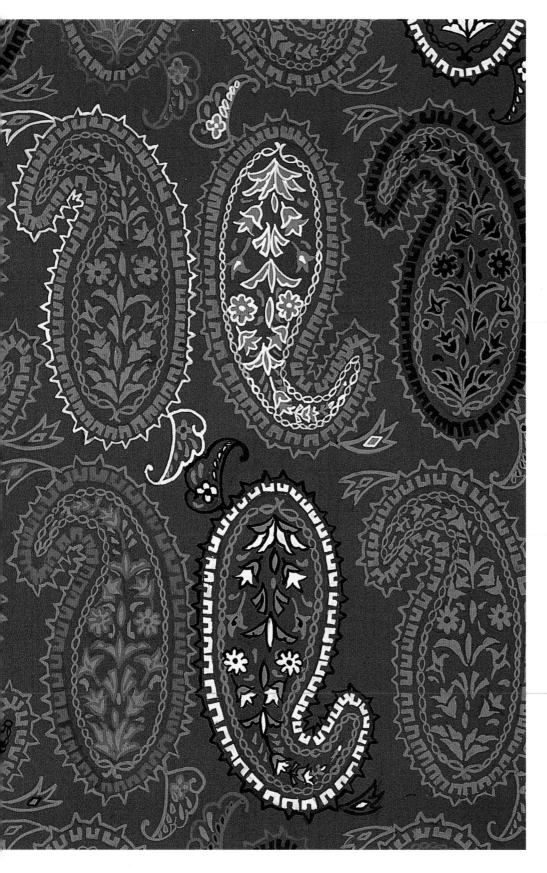

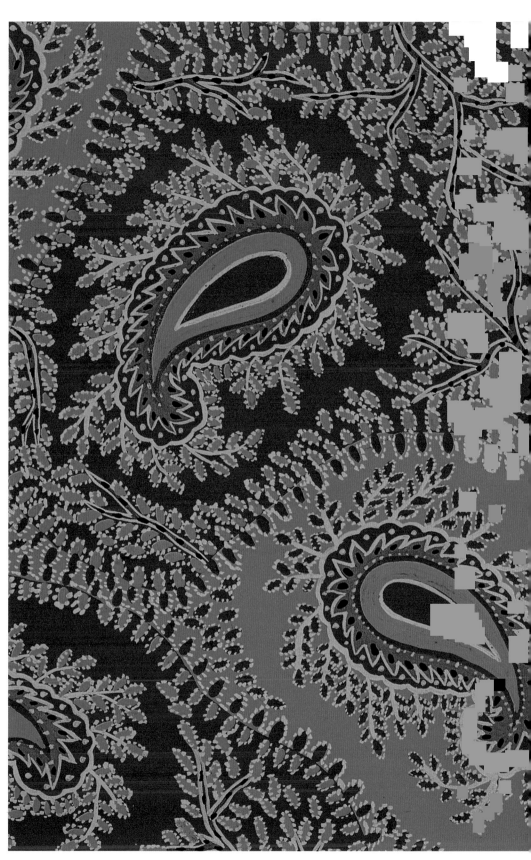

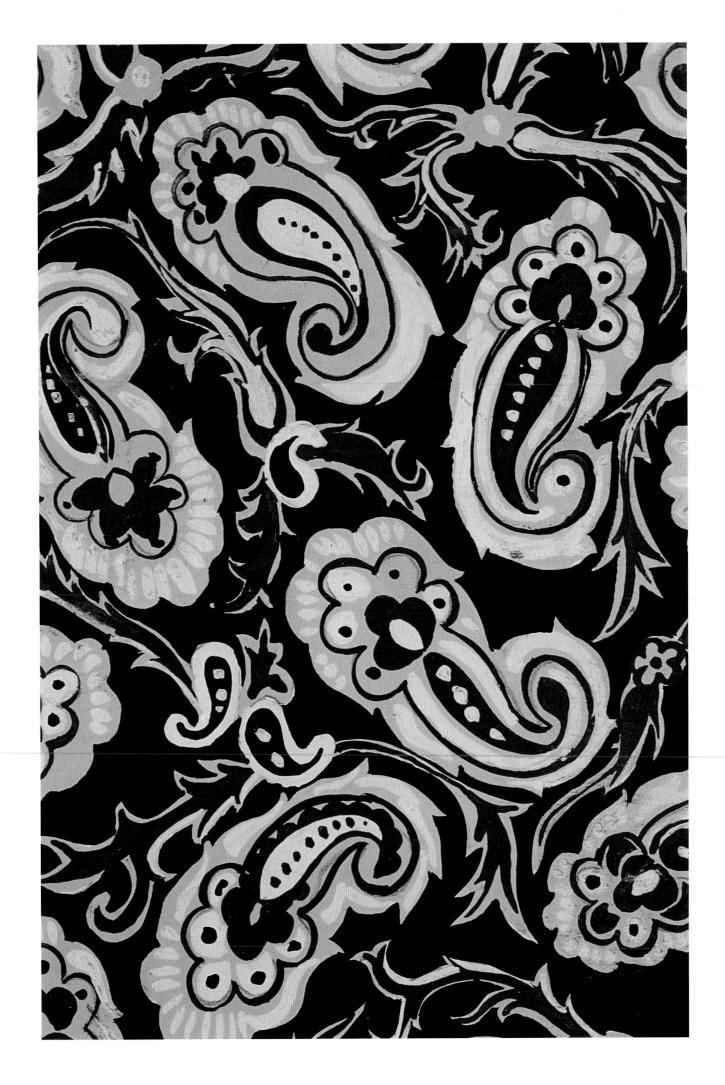

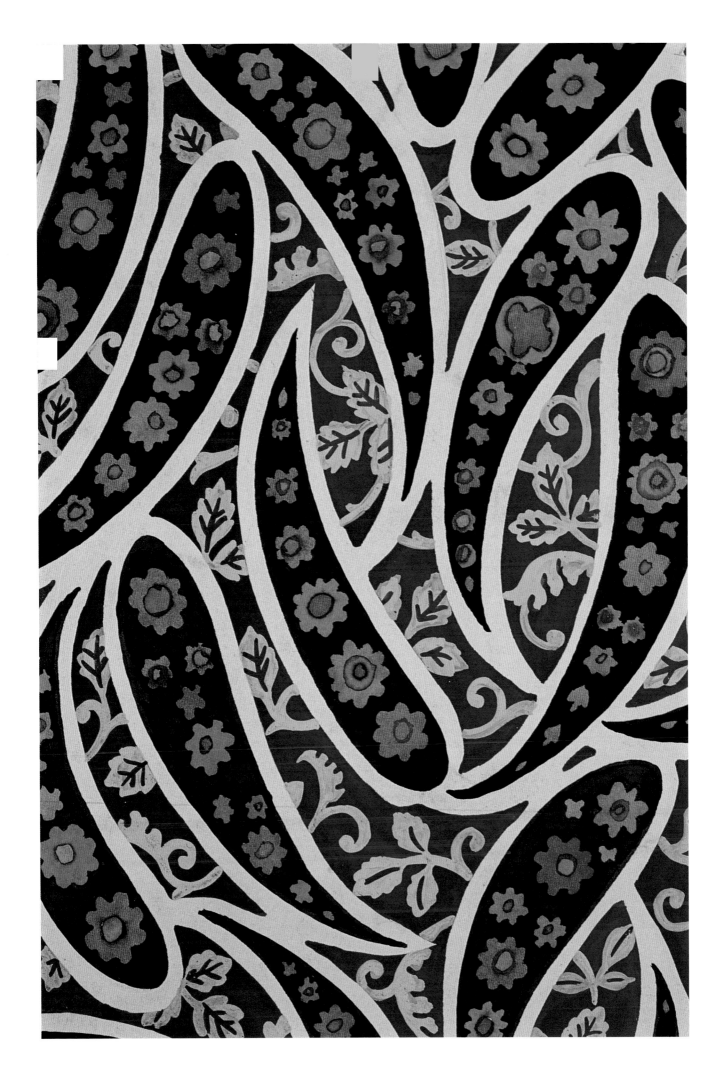

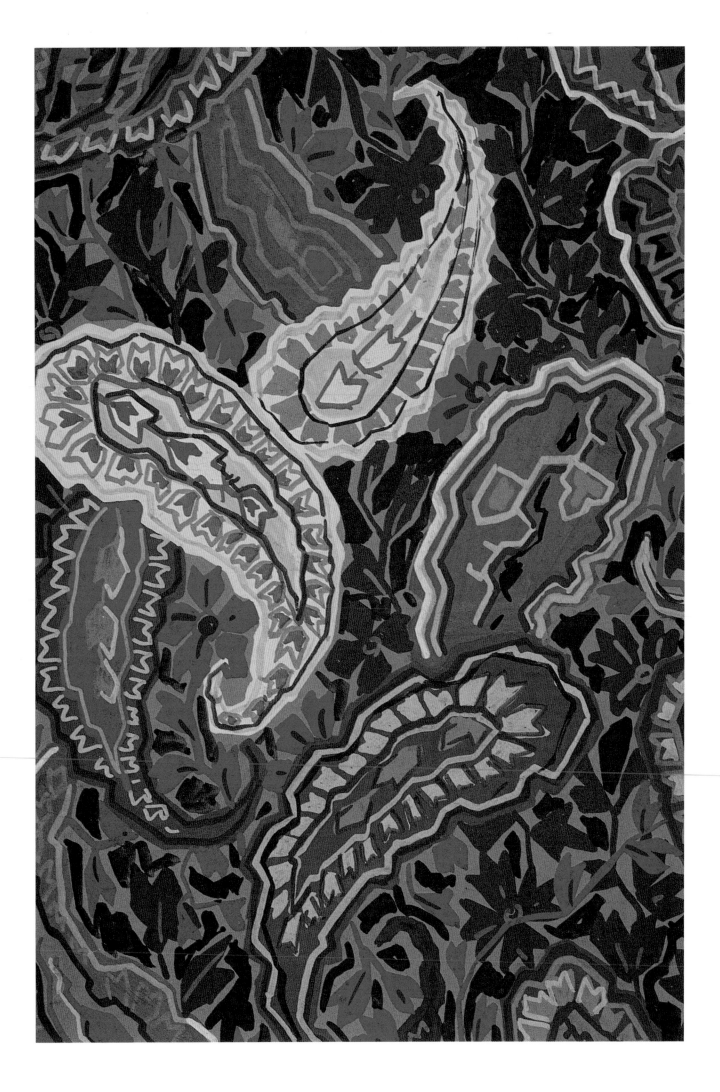

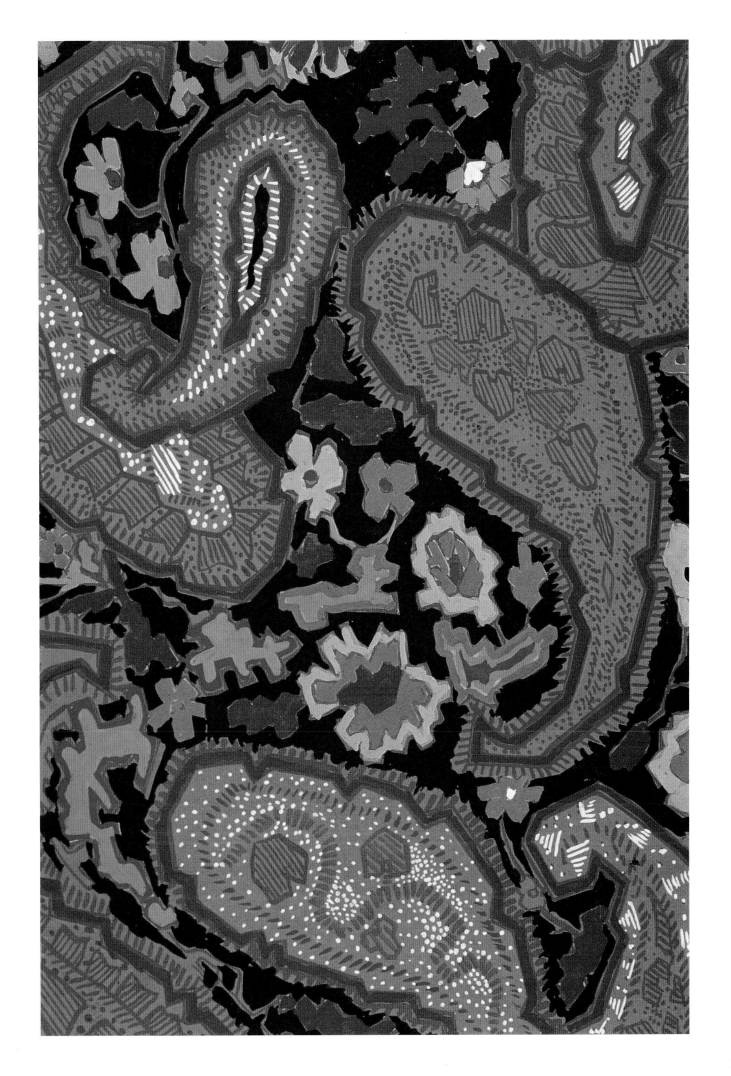

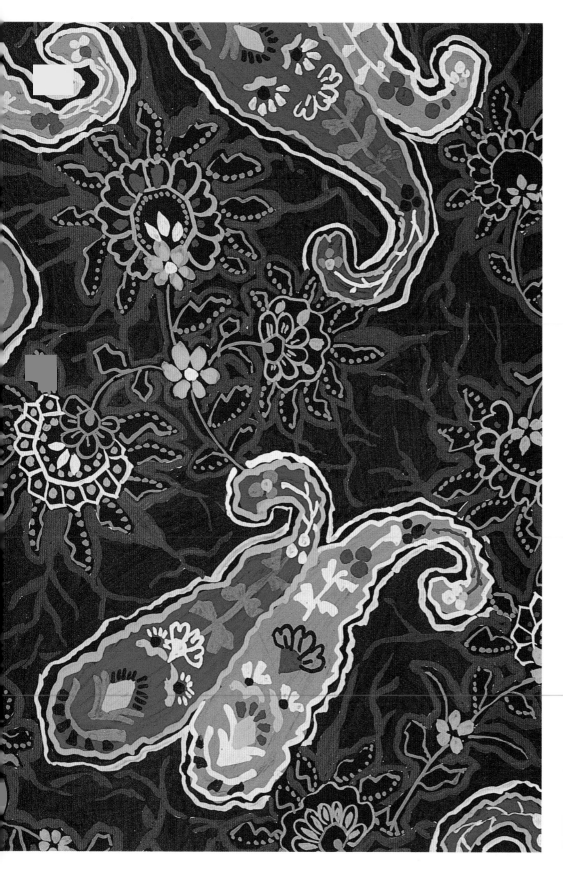
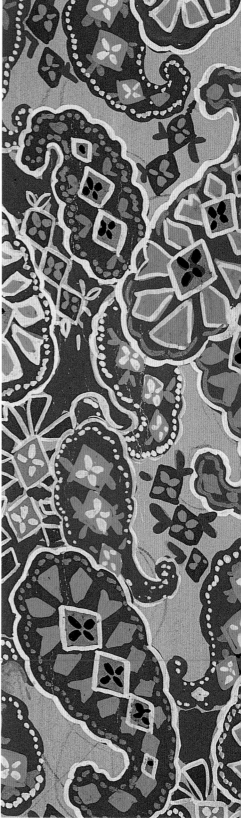

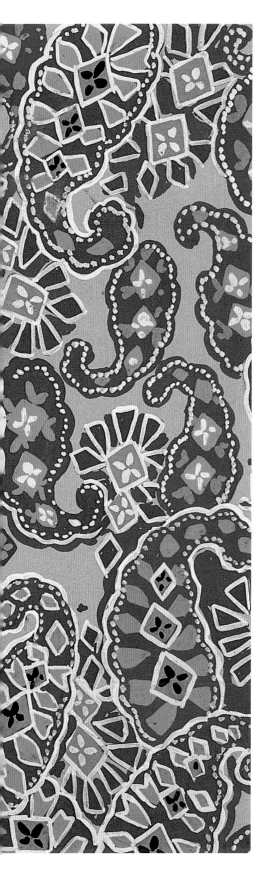
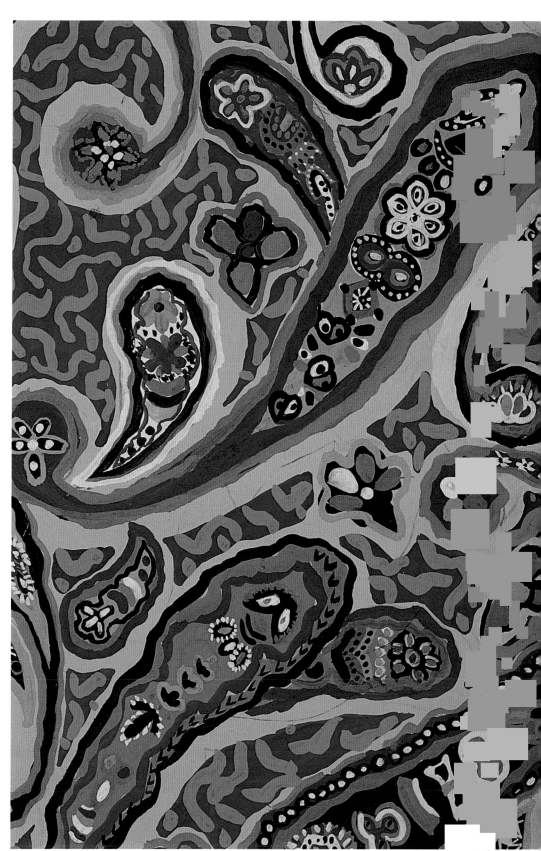

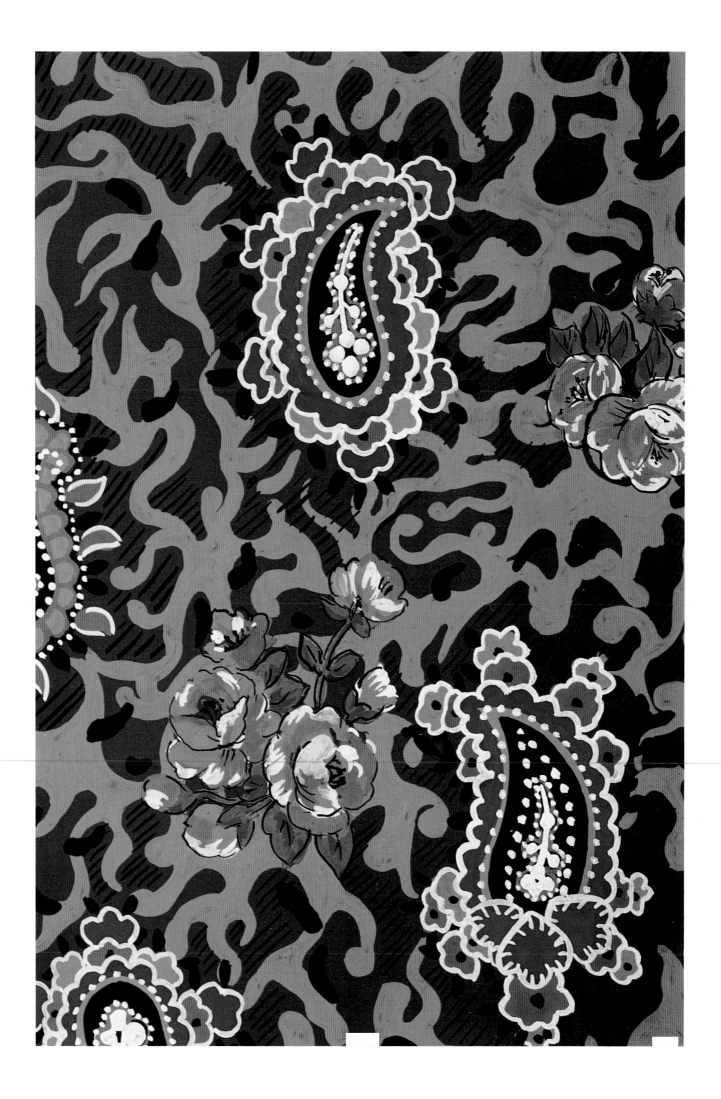

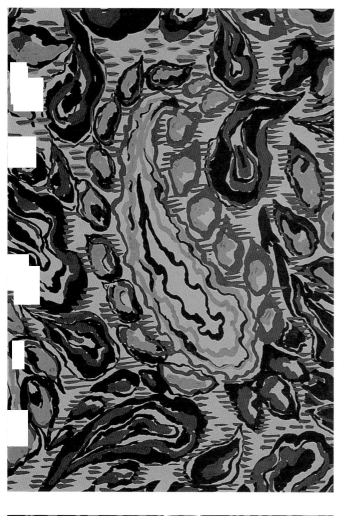
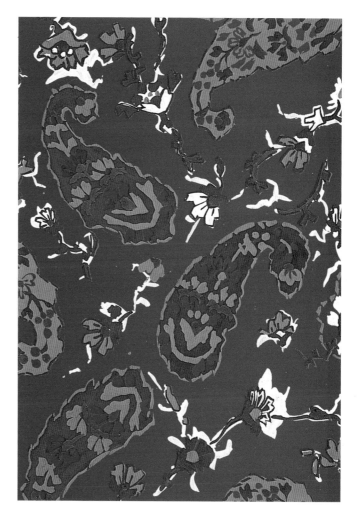
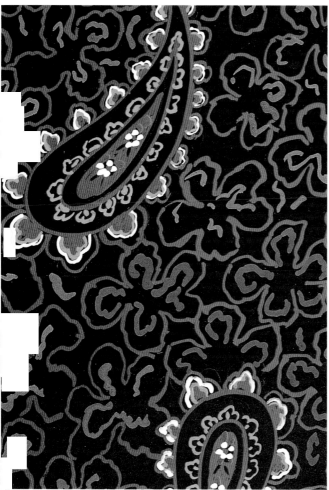
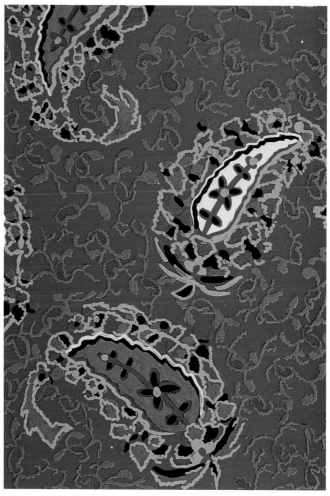

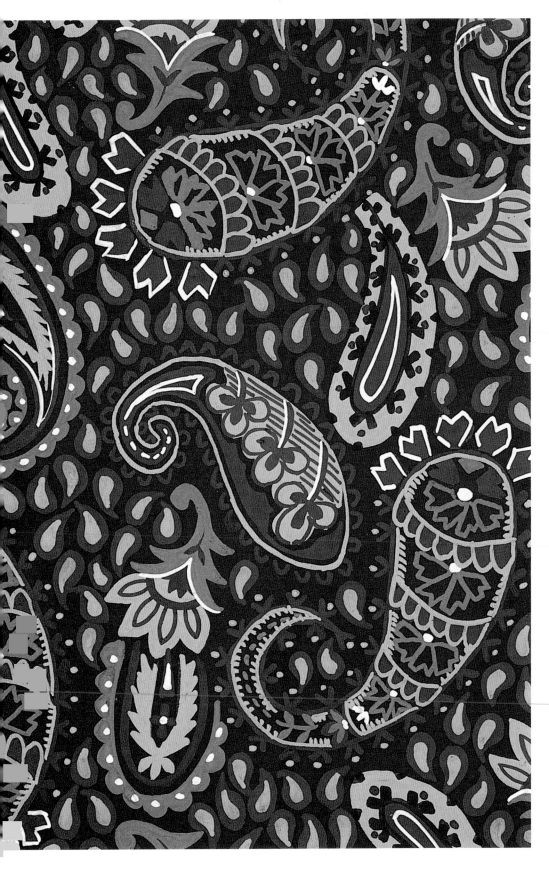
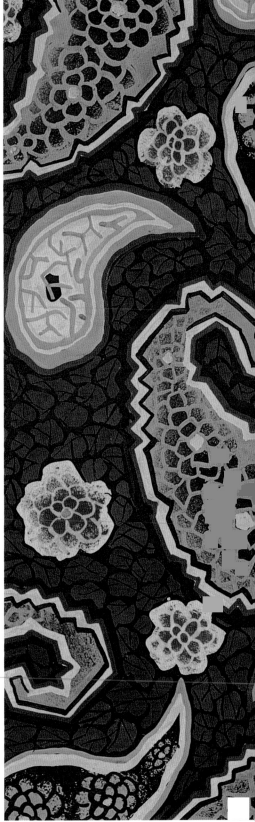

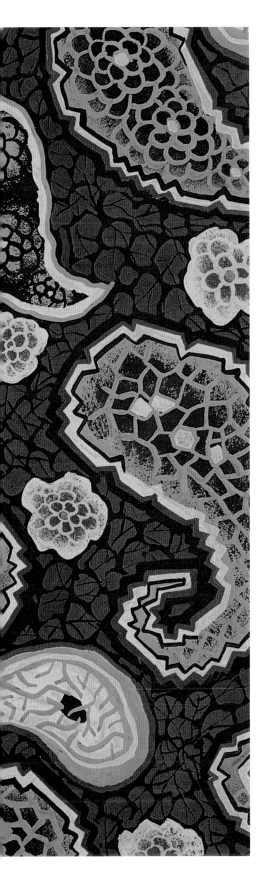

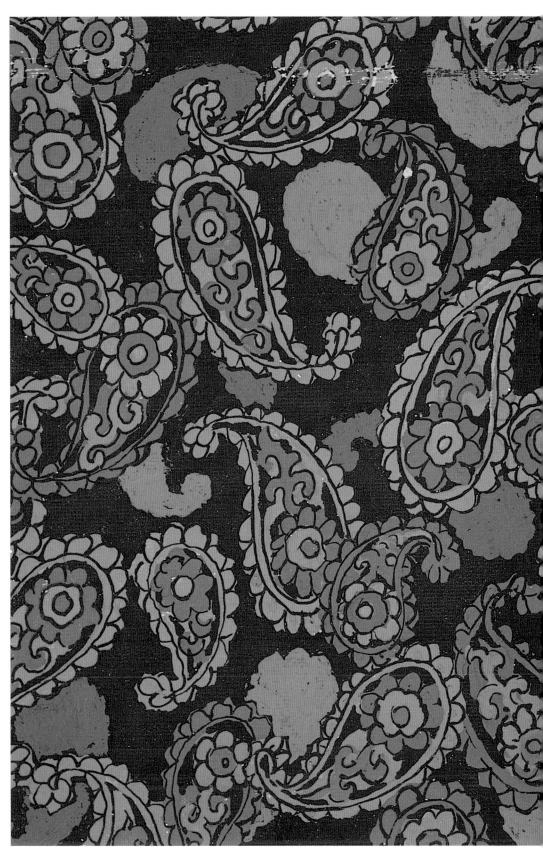

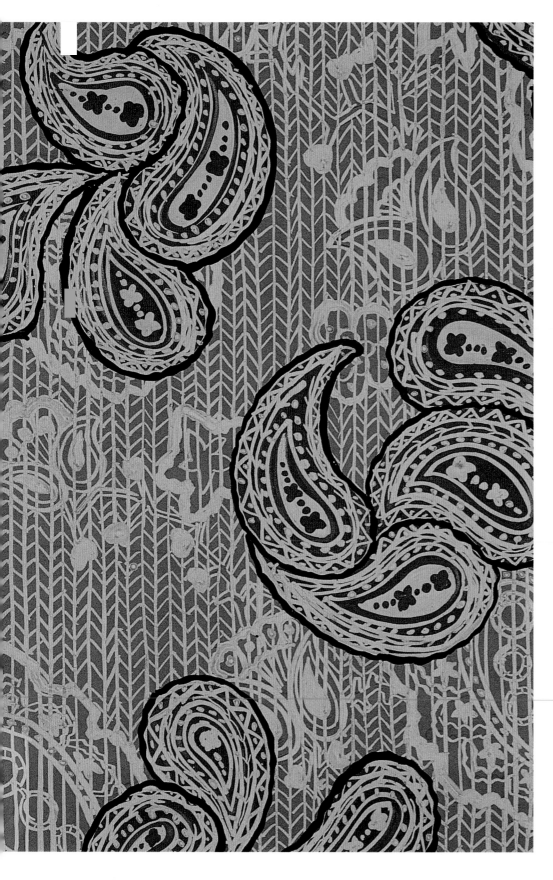
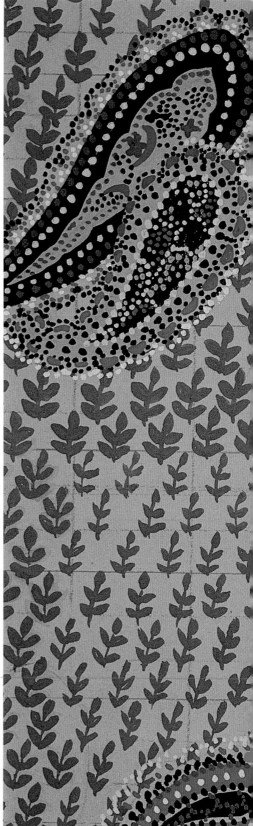

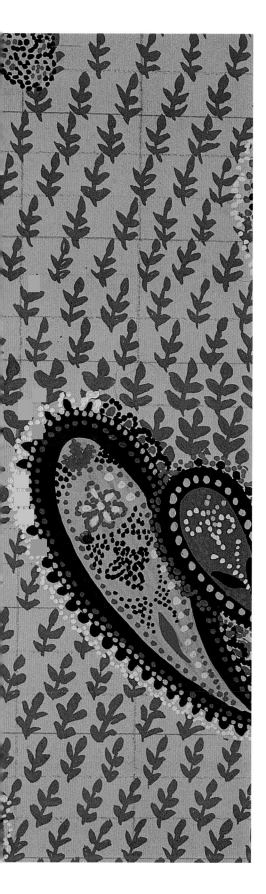
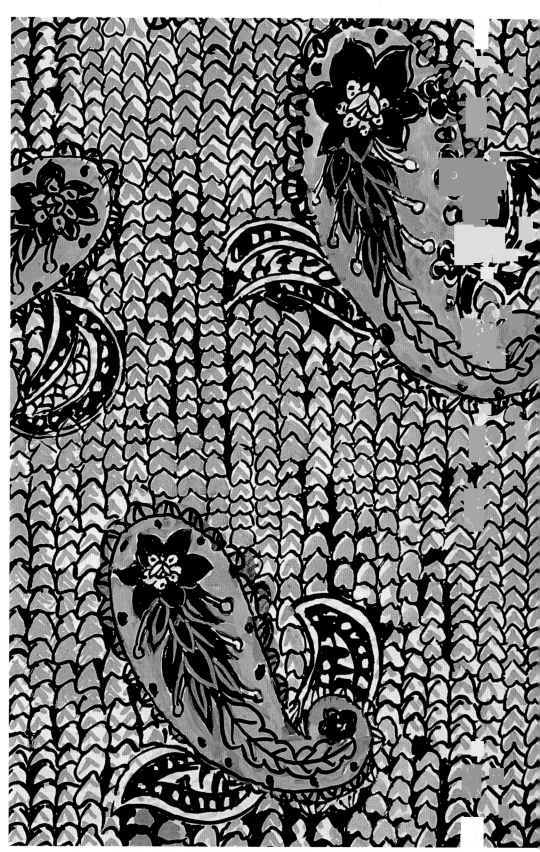

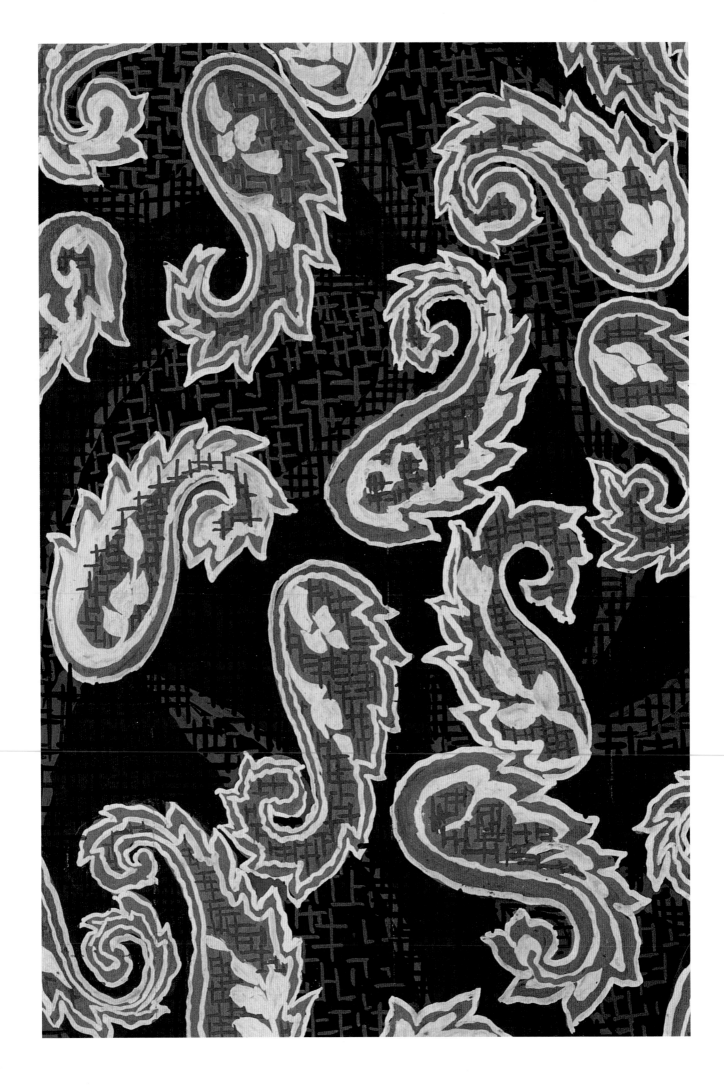

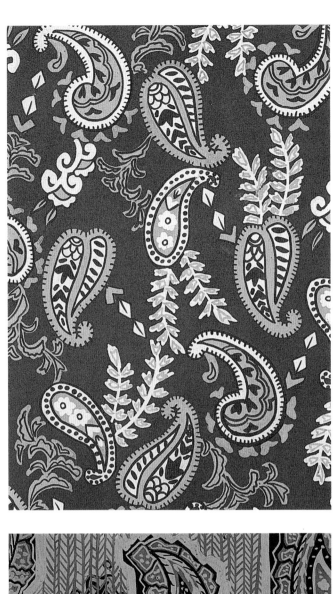
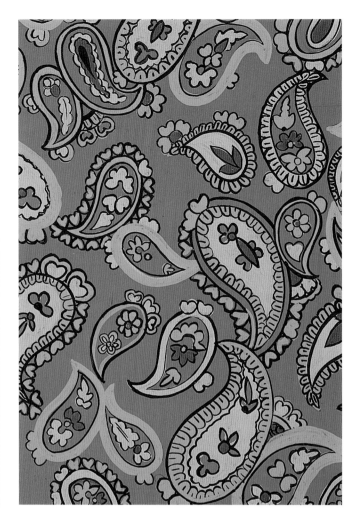
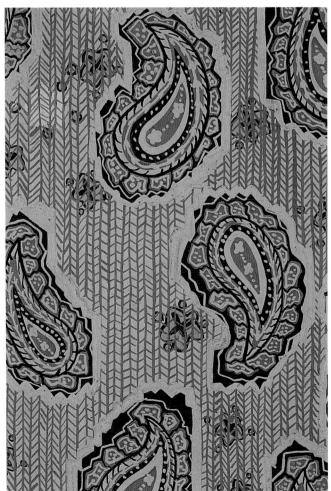
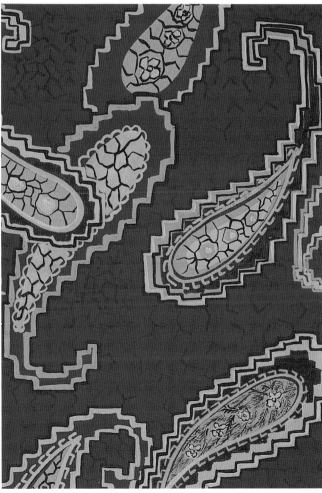

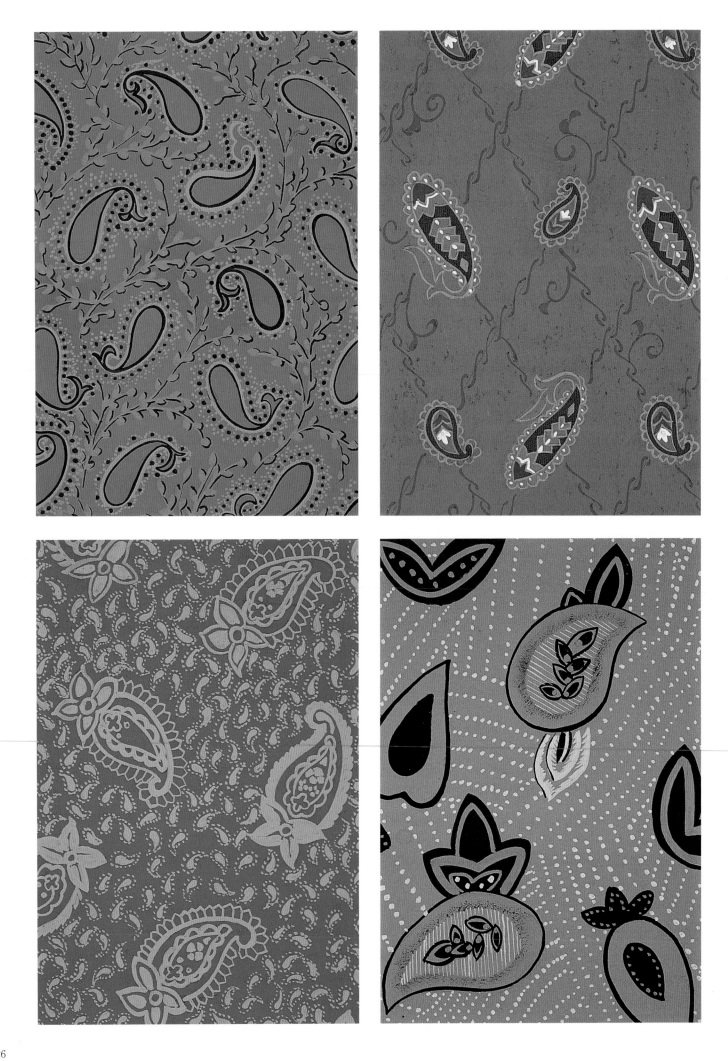

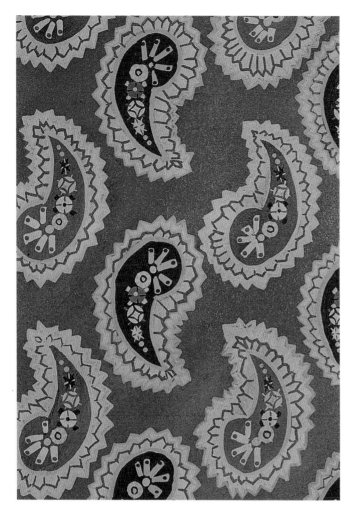

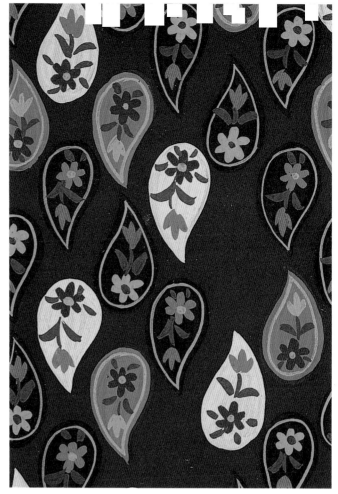

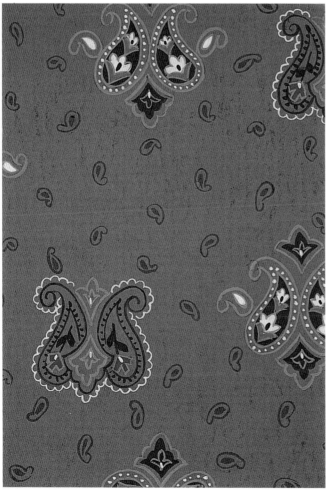

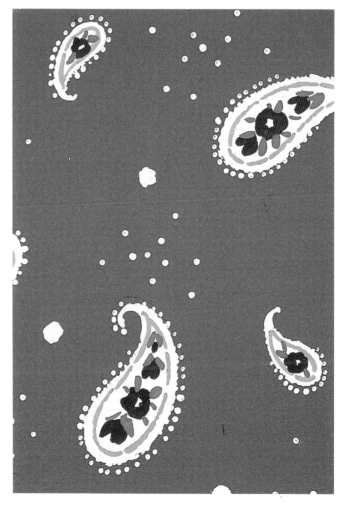

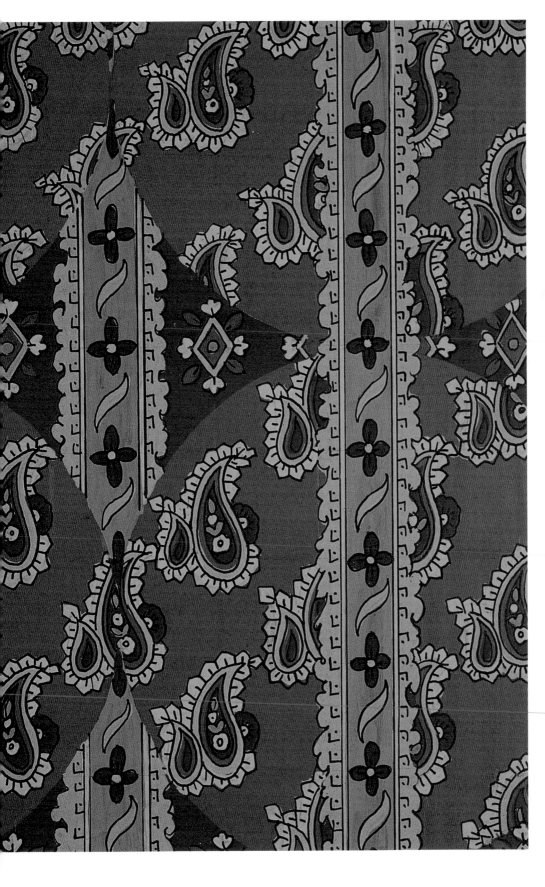

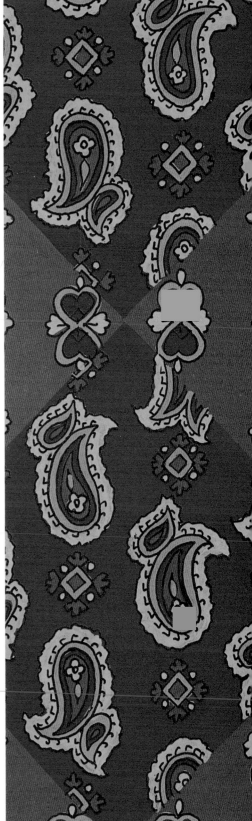

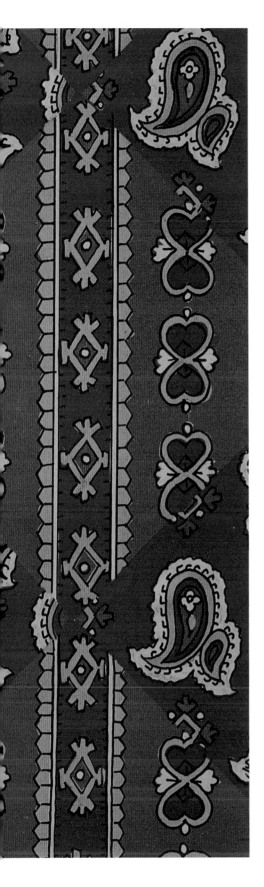
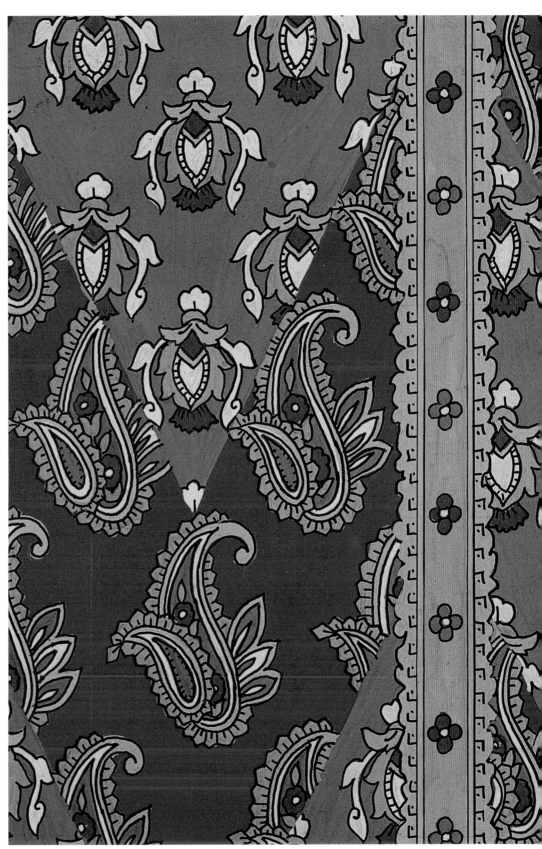

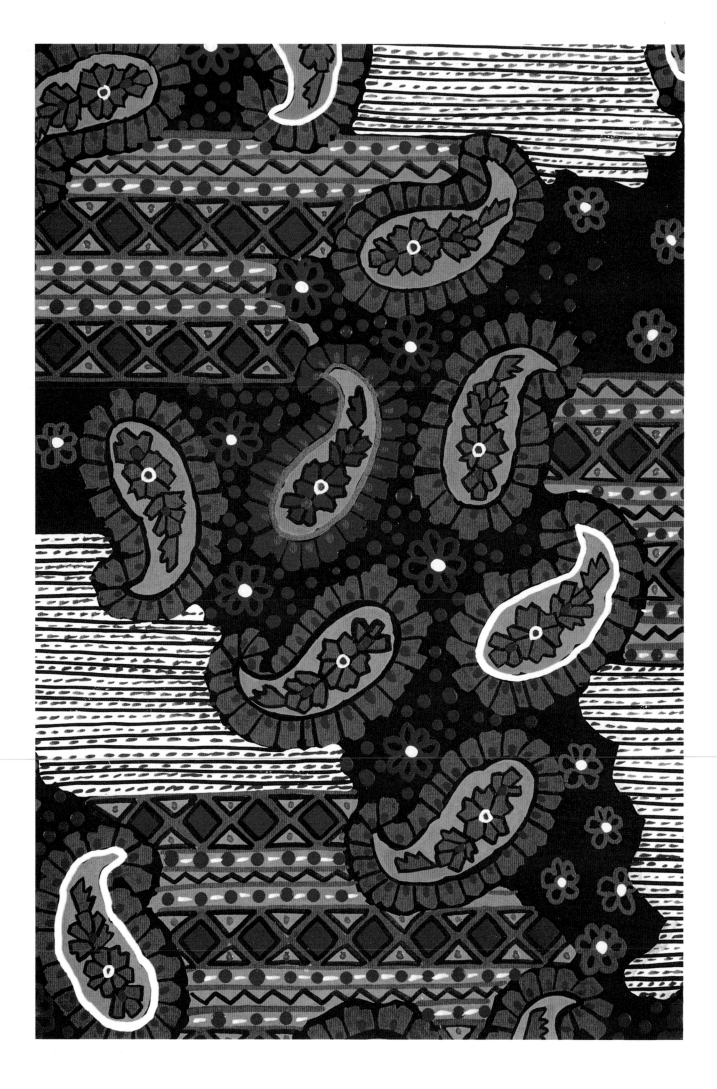

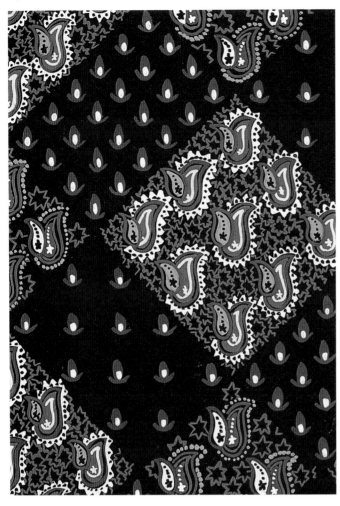
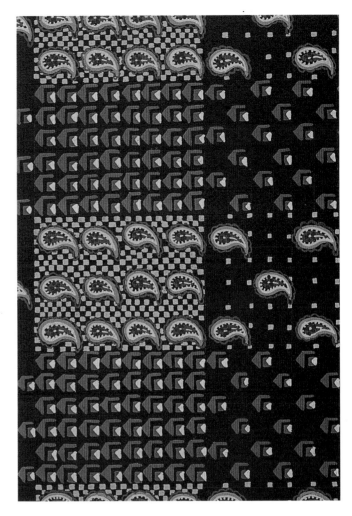
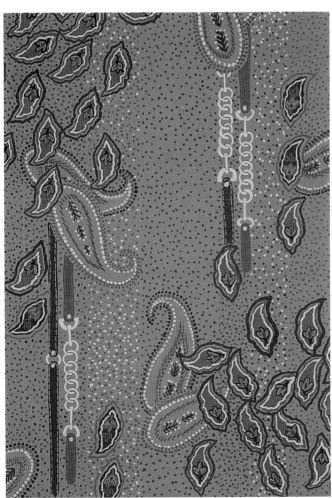
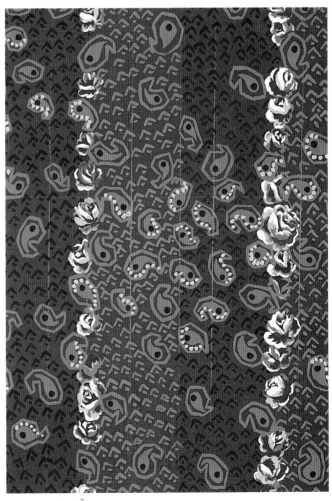